Columbia Books on Architecture
and the City

Everlasting Plastics

Edited by Tizziana Baldenebro,
Joanna Joseph, Isabelle Kirkham-Lewitt,
and Lauren Leving

Everlasting Plastics

Pliable Encounters

Tizziana Baldenebro, Lauren Leving, and Paula Volpato

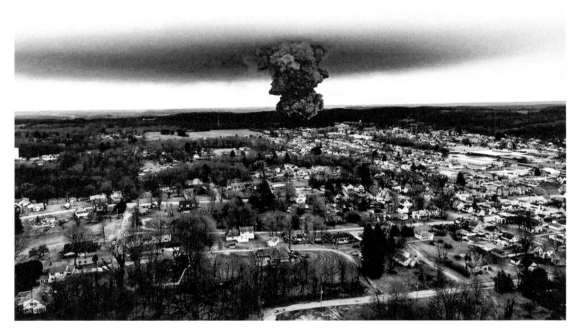

A large black cloud of toxic chemicals as seen by a drone above the town of East Palestine, Ohio. © RJ Bobin.

The global urgency to reframe our approach to the overabundance of plastic detritus in our waterways, landfills, and streets today is clear. Exploring our fraught yet enmeshed kinship with plastics, *Everlasting Plastics*—the on-going curatorial and editorial project and its network—highlights our unseen material dependencies; demonstrates how plasticity has created expec-tations for the behaviors of other materials; and points to plastic's unknown, long-term, and indelible impact on our futures.[1]

On February 3, 2023, a Norfolk Southern freight train derailed in East Palestine, Ohio, a village 90 miles southeast of Cleveland, Ohio—where we lived at the time—and 51 miles northwest of Pittsburgh, Pennsylvania. The freight carried, among other things, vinyl chloride, a chemical used in the production of the petrochemical polymer polyvinyl chloride, more commonly known as PVC. In a unilateral effort to contain the massive spill, local law en-forcement, the fire department, Norfolk Southern, and state government lit a controlled fire without consulting the Environmental Protection Agency, residents of East Palestine, or national experts. In Cleveland, we paused, wondering if we would be affected by the resulting malevolent cloud or if our water drew from the now contaminated Ohio River. We wondered if this was our Chernobyl. We were reassured, terrifyingly, that the airborne poisons were heading not toward us but east, past Pittsburgh, over central Pennsylvania and into New York, and that this cloud would disperse over the ocean. We learned that the watershed poison was also not heading toward us and was instead heading southwest, toward Cincinnati, Ohio, cresting over Kentucky and under Illinois, where it would yield its toxic contents into the Mississippi River.

Perfected in the United States in the early 1900s, petrochemical polymers, collectively and commonly known as plastics, were embraced as revolutionary materials. Intended to protect the so-called "natural world" and decrease socioeconomic barriers to accessing goods previously only available to the wealthy, plastics were imagined to mimic the materials plundered from the earth, like ivory, coral, and tortoiseshell—and, in many cases, they succeeded. In this way, plastics entered the consumer market as finished goods, ready to use. Plastic thinking abandoned material lineages; readymade goods, conjured from a perceived nothingness, seemed to erase the toxic legacies of extraction—of people, labor, and land—entrenched in settler colonial material culture.

From a promise to a poison—conceptually, there is much to learn from a material that stays with us. Plastic is born from a millions-year-old precursor that is extruded from deep within the earth, and, yet, it manifests as briefly functional, easily discardable objects. Yesterday's disposability is tomorrow's pollution inheritance. As plastics proliferated over the past century, alongside and in tandem with wars, viruses, and technological advancements, cultural attitudes shifted toward the ease and efficiency of single-usage. Today, plastics exist as both a feared anathema and an accessible material for experimentation and social welfare. Acutely visible yet unsettlingly unseeable traces of plastics course through our veins, waterways, and air molecules. Each year, over 22 million pounds of plastic pollution infiltrate the Great Lakes with a quarter of this debris entering via Lake Erie, the smallest of the Great Lakes, which frames Cleveland and runs across northern Ohio.

Tizziana Baldenebro, Lauren Leving, and Paula Volpato

Urgency and intervention emerge most often when toxins are perceivable, while passive pollutants pose silent dangers. The material exists all around us, simultaneously enabling and threatening every part of modern life. So, how can we live without plastics? But, also, how *can* we live without plastics? Each emphasis indexes a different set of concerns, kinships, values, actions.

As East Palestine and many other places show us, plastic both fuels and constricts our built environment. Its production, which began as a solution to a problem but has quickly become both the solution *and* the problem, embodies this fundamental contradiction. It is the putty of world-building, rich with possibility yet also a no-holds-barred destroyer. *Everlasting Plastics* finds a foothold in this paradox, eschewing a value judgment and entangling the demands and prohibitions of accumulation within material realities.[2] This project illuminates and unsettles our relationships with plastics, using an architectural perspective to cultivate a more expansive way to think about its materiality and evolution. At the same time, it embraces the plasticity of language to stretch definitions of architecture to include landfills brimming with synthetic polymers; plastiglomerates—material composites of sediment, organic debris, and molten plastic; and a vortex of trash the size of Texas commonly referred to as the "Great Pacific Garbage Patch." By highlighting our unseen dependency on plastics, demonstrating the ways in which plasticity has created expectations for the behaviors of other materials, and pointing to plastic's unknown, long-term, and indelible impact on our futures, *Everlasting Plastics* acknowledges that our toxic interdependency is now a global phenomenon, while also understanding plastic's possibilities as an agent of change.

While "Everlasting Plastics"—the exhibition first developed for the 2023 Venice Architecture Biennale—emerged across the Midwest region, it came to be anchored in Cleveland. Living in post-industrial cities that dot the so-called "Rust Belt" (Or maybe it's the Midwest? The Heartland? The Great Lakes region?) and moving among these landscapes, we found ourselves looking toward endogenous thinking. Endogenous thinking—emulating from within and extending outward—provided a method to consider domestic experiences and environments and extrapolate to larger, global conversations related to synthetics. Tupperware, Styrofoam, Little Tikes: these plastic brands radiated from our region and have come to define Americana and the fraught values—like those concerning tradition, family, and efficiency—embedded within. What other historical, social, industrial legacies, beliefs, stories, fictions emerged from this material culture? We, as inhabitants of this place, wanted to better understand our own relationship to this idea of the region whose own boundaries remain so loosely defined, drawn by evolving material relations. We worked with and learned from designers, architects, and artists practicing in the region moving through form, function, mass, and salvage, reshaping waste to develop contemporary critiques of Americana, consumerism, and global contemporary discourses around plastics and waste. We dove into our past conversations, studio visits, and intersections, to better understand the myriad natures of our connection to petrochemical materials and production in preparation for

what would become *Everlasting Plastics*. Some branches of this project mediated on the immediate social-cultural catastrophe in their communities; others, on the future consequences; while others still dwelled on the history of this region, inextricably linked as it is to modern waste. This waste invariably landed us with "the stuff of alchemy," as critic Roland Barthes says, and the stuff of this project—plastics.[3]

We found resonances with the anxieties of these petrochemical materials as we traced our own networks within the region. We developed a project with five practitioners—Xavi L. Aguirre and Simon Anton in Detroit, Ang Li and Norman Teague in Chicago, and Lauren Yeager in Cleveland—across the fields of art, design, and architecture. Their proximity to the heart of the region gave us a desire to dig deeper. Within this "flyover country," we were free to reflexively interpret our role within the global plastic condition as both a cultural phenomenon and social anathema. Within this space, creativity can operate more freely from expectations and precedents. The soft cultural isolation allowed us to sit with the tensions.

The proposal for "Everlasting Plastics," submitted to the Department of State for consideration to represent the United States at the 2023 Venice Architecture Biennale in Italy, was drafted in 2022 as an exercise, though we had been nurturing and evolving the concept since 2018. With a working proposal in hand, we sent each other a flood of excited texts, imagining this work being brought to life, while exchanging Google Docs edits about precise language and frameworks. In the weeks leading up to the due date of the application, we frantically got in touch with our would-be collaborators, hoping for an eager response, while simultaneously managing expectations about the likelihood of receiving this honor. This evolutionary impetus is etched in the ethos of the project, as we continue to sketch it.

"Everlasting Plastics" was accepted, and SPACES, a small alternative art organization in the heart of Cleveland, a city "oft-overlooked but blessed with a historically robust arts scene,"[4] was thrust into the spotlight.

Our curatorial research began with a deluge of books: historical writings on plastic's early beginnings; theoretical texts exploring petrochemical-bodily queering; personal accounts of material interactions; and news articles about microplastics in our tears, sweat, and urine. While we know much more than when we began, we are still at the metaphorical tip of the plastiglomerate. (Will our adages change as the synthetic subsumes the natural world?) Though the timeline played no small part in our rapid embrace of chance encounters and partnerships, we welcomed the fervor and exuberance with which we were met. We continue to work around the issues, to evolve the project, with an ever-explorative approach, allowing it to infuse other projects, other parts of our lives. It is crucial to expand on what we had begun with: to re-interrogate, re-situate, re-exhibit, as sketching mechanisms.

As we developed the curatorial premise of the exhibition that would be presented in Venice (and beyond), cultural critic Heather Davis's *Plastic Matter* arrived in our mailboxes, wrapped, predictably, in plastic. A wry irony, as a large moose, ensnared in tinsel, stared haplessly from the cover behind the glossy, protective film. "Petro-time," Davis states, is a compilation of "pasts piled up on top of each other [that] transmit unevenly

Tizziana Baldenebro, Lauren Leving, and Paula Volpato

into the future... The times of the petrochemical present mean that the effects of oil's haunting, its afterlife, are not necessarily immediate but involve the manipulation of generational forms in the future."[5] Inheritance, after all, is not equally distributed. Another memorable touchstone in our research was science and environmental writer Susan Freinkel's anecdote in *Plastic: A Toxic Love Story*, about her brief attempt to go a full twenty-four hours without touching plastic. But the toilet seat was plastic. She modified the exercise, instead keeping a list of everything plastic she touched. The following day, Freinkel kept a list of everything she touched that wasn't made of plastic. The result: a much shorter list.[6]

Like Davis, discard studies scholar and researcher Dr. Max Liboiron considers legacies of toxicity in their book *Pollution Is Colonialism,* unpacking colonialism's extractivist impact on the natural world.[7] Liboiron's multidisciplinary approach to writing is influenced by Indigenous, particularly Métis, concepts of land and ethics. Their practice moves beyond the body of the text and into the margins, which they understand as a space of gratitude, acknowledging histories of knowledge sharing, citing members of their communities and past bodies of work, and rejecting hierarchies rooted in Western academic rules of citation-making.

These texts, alongside the perspectives of countless others, shaped our curatorial approach to *Everlasting Plastics.* The experience of material inundation weaves through this project, manifesting as the mass of plastic flakes comprising the sculptures in Simon Anton's *This Will Kill _____ That*, and occupying our field of vision in Xavi L. Aguirre's *PROOFING: Resistant and Ready* film, which draws on exhibition design elements and the artist's own physical installation to construct a meta-experience of the area in which the work is situated. The compressed polystyrene in Ang Li's installation *Externalities* reveals an architecture of accumulation that, when examined through the lens of Davis's petro-time, becomes layers of strata that will outlast us, infused with an unknown impact on generations to come. Lauren Yeager's sculptures, made of salvaged goods, highlight the slow insidiousness of petro-time *in action*. Her work, aptly titled *Longevity,* acknowledges wear and tear as patina and honors the histories of these objects, while raising questions about the impacts of their material futures.

Alongside the contents of the exhibition, Liboiron's use of footnotes as a method of showing appreciation and minimizing hierarchical conventions perpetuated by institutions informed our own ways of working. This is perhaps best exemplified in the exhibition design of "Everlasting Plastics," expertly created by Faysal Altunbozar and Chloe Munkenbeck. Industrial strip curtains, aluminum didactic panels, and steel benches gestured to the aesthetics of petrochemical manufacturing facilities, serving as both contrast and complement to the plasticky installations. Further, Liboiron's embracing of the past to inform the present connects with Norman Teague's approach to *Re+Prise*. New to plastic as an artistic medium, Teague embraced the opportunity for material experimentation while drawing from Bolga and Agaseke basket-weaving techniques to perform cultural memory.

"Everlasting Plastics" materialized as a series of spatial sequences with immersive qualities and blurred boundaries between installation and sculpture. In order to consider provocations accessible to broader audien-

ces, it was important to critically examine the barriers that are sustained in the experience of an architecture biennial, or any architecture exhibition for that matter, and to attempt to break some of them. In mounting "Everlasting Plastics" in Venice, we were troubled by the ecological impacts of building an exhibition overseas. In the condensed timeline, we deliberated whether sourcing some of the recycled plastic materials for the installations in Italy would be a "greener" option. We concluded that the plastics brought to the United States Pavilion tell histories of local and cultural patterns of consumption; they are national exports. And so, we made the decision to ship via ocean freight a container full of American plastic waste to Venice. But our hyper-awareness around every speck of EPS foam that landed in the courtyard gravel beds forced us to reckon with the political ambivalence of events such as the Biennale, of the architecture industry, and of our own ways of living.

At the beginning of our collaboration with Altunbozar and Munkenbeck, they shared an image that quickly became a point of reference for much of the thinking surrounding the aesthetic qualities of *Everlasting Plastics*.[8] This simple photograph, of six stereo knobs, each oriented identically, in various shades of white, managed to concisely string together a range of ideas we had been conjuring. Their temporal condition was marked by their aging hues, demonstrating at once the longevity and obsolescence held within the promise of plastic. We used this image to launch a series of conversations with graphic designers Renata Graw and Lucas Reif of Normal.

These conversations, reflected in part through their "sketch" included in this publication, illuminated our own ways of thinking around systems of modularity, timelessness, and the ever-presentness within plastics. We toyed with the connotations the title might summon—"Everlasting Plastics" was an homage to Motown and the toxic love entanglements woven throughout the record label's catalog, at the same time that it cleverly sounded like a mysterious corporation akin to those that inhabit our surroundings, those that produce a wide array of products that reinforce our ways of living—The Rubber Company and PolyOne, for example, come to mind. Emerging from these conversations is the graphic design through which you read these very words, and which influences the ways audiences interpret the works: a thoroughly "normal" aesthetic, satirizing and unsettling this anonymity, layered with the many conversations and perspectives bound within *Everlasting Plastics*.

We collaborated with Isabelle Kirkham-Lewitt, Joanna Joseph, and Meriam Soltan, editors from Columbia Books on Architecture and the City, to push the boundaries of the discourse within *Everlasting Plastics* beyond the exhibition. *Sketches on Everlasting Plastics*, a suite of short texts that expressed a network of plastic kinships and which is reproduced here, lived in the galleries of the US Pavilion, expanding the conversation with the work on display. We participated in a weekly class with Dr. Andrea Wolk Rager, associate professor of art history at Case Western Reserve University, and her students for the course "Issues in 20th/21st Century Art: Plastocene Era: Art, Plastics, and the Future of the Planet"; the course syllabus, annotated and included here, further aided in our own digestion of

Tizziana Baldenebro, Lauren Leving, and Paula Volpato

the materials and ideas we consumed and produced. Throughout, we echoed Liboiron's methodology as we resisted the hierarchies often relied upon in traditional institutional settings. We thus present this book as something more than a traditional exhibition catalog, more than a static record of something past. We don't wish to conclude *Everlasting Plastics*. Like our curatorial approach, this book exists as another materialization of our collective praxis. It emerges from a place of eager learning; and it firmly resists equating ambivalence with inaction.

Architecture, design, and art play fundamental roles in how we craft exhibition narratives. *Everlasting Plastics*, by virtue of its everlasting nature, opens itself to new ways of thinking within exhibition- and book-making. With it, we celebrate the open-ended possibilities nested in the *everlasting*.

1 This text expands upon the original curatorial statement prepared and presented at the United States Pavilion at the 2023 Venice Architecture Biennale.

2 Sara Ahmed, "Becoming Straight," in *The Material Kinship Reader: Material beyond Extraction and Kinship beyond the Nuclear Family*, ed. Kris Dittel and Clementine Edwards (Eindhoven: Onomatopee, 2022), 114.

3 Roland Barthes, "Plastics," in *Mythologies* (New York: Hill and Wang, 1972), 97. In using "alchemy," we are alluding to the infinite promise of plastics at the turn of the century. Premodern Western writers and critics, however, satirized alchemy, acknowledging its power for corruption.

4 Matt Hickman, "SPACES Surveys Our Deep Entanglement with Plastic as Commissioner of the US Pavilion at the 2023 Venice Architecture Biennale," *Architect's Newspaper*, November 2, 2022, https://www.archpaper.com/2022/11/spaces-plastic-commissioner -us-pavilion-2023-venice-architecture-biennale.

5 Heather Davis, "Plastic Media," in *Plastic Matter* (Durham, NC: Duke University Press, 2022), 76.

6 Susan Freinkel, "Plasticville," in *Plastic: A Toxic Love Story* (Boston: Houghton Mifflin Harcourt, 2011), 2–3.

7 Max Liboiron, *Pollution Is Colonialism* (Durham, NC: Duke University Press, 2021).

8 "Aging plastic," *Project: Jazzmaster* (blog), June 6, 2013, https://projectjazzmaster.wordpress.com/2013/06/06/aging-knobs.

Sketches on
Everlasting Plastics

Edited by
Isabelle Kirkham-Lewitt
+ Joanna Joseph

Curated by
Tizziana Baldenebro
+ Lauren Leving

Columbia
Books on Architecture
and the City

cover of Vance Packar
he Waste Makers (New
rk: Pelican, 1960).

the Haskell Laboratory

The Notes Within My Blood
by RA Washington

RA Washington is a polymath
living on Cleveland's West Side.
Washington's work spans two
decades and several genres. His
most recent work includes the
novels *CITI* and *FOUR INTERIORS*
(Outlandish Press, 2017, 2018);
a collection of poems, *BLACK
EUNUCH* (Outlandish Press, 2018);
and two memoirs, *BODY* and
BALDWIN NOTES (Outlandish Press,
2018, 2021). He is the founder/
composer of the Afrofuturist
music collective Mourning [A]
BLKstar and is the co-curator of
the longstanding futurist record
label, CLEVELAND TAPES.

Any attempt to solve the ecological crisis within
a bourgeois framework must be dismissed as
chimerical. Capitalism is inherently anti-ecological.
Competition and accumulation constitute its
very law of life, a law... summarized in the phrase,
"production for the sake of production." Anything,
however hallowed or rare, "has its price" and
is fair game for the marketplace. In a society of
this kind, nature is necessarily treated as a mere
resource to be plundered and exploited. The
destruction of the natural world, far from being the
result of mere hubristic blunders, follows inex-
orably from the very logic of capitalist production.

Murray Bookchin

Within my blood [METADATA]
There are strains of promises
Made by a budding nation
To my once enslaved family

[Animal and human investigations indicate that
the impact of trauma experienced by mothers affects
early offspring development, but new research is
also discovering that it is also actually encoded
into the DNA of subsequent generations.]

19

Work is at the stitching
Of this ol' country flag
The buildings are upon my back
The land is underneath my nails.
Industry looms along history
We are the descendants of popular notions
Of advancement.

[A study looked at communities located within
2.5 miles of refineries, including those associated
with plastic production, and found that these
communities were disproportionately non-White, with
the result that BLACK people were being exposed
to about 1.5 times more particulate matter than
White people.]

And what will we build upon this legacy
Of torment?
Where land is expanded, it's BLACK oil
Blood is mined
Ingenuity is funded for barons
To make products to keep power.

We will power machines by burning blood
 Oh the engine!
We will make containers with the waste
Polymer hate needles without future regard.

[Microplastics have been found at the top of Mount
Everest and on the ocean floor. They've been
found in a large, remote European ice cap. They've
been found in the placenta of fetuses.]

The human invention celebrates our dominion
Over Earth

20

look at these Black bodies as property
Surely it is the land that is *ours* as well?
And over 200 years we see it plainly
Let us mortgage our future for capital's sake.

[In Sojourner dialect]

Corner store low
This is where I go
For there is no fresh grocery
Along the miles near me. JAZZ
 Cadence

Worked at a factory that closed its doors
So what I used to buy
Seems lavish compared to the choices
Left to me.

A bubble of plastic
Wrapping me
Memories not mine haunting me
The plastic of everything
Connected along this history.

Call on higher power

[Microplastics are small pieces of plastic—anything
that's less than 5 millimeters in size—that break
off from larger pieces of plastic. The fact that
they're so small makes them dangerous: they're able
to permeate tissue and get stuck in our organs,
finding their way into places that bigger pieces of
plastic can't access.]

Call on the holy
This everlasting plastic
Microparticles inside of me.
How's all this connected?
Ain't too plain to see?
So let me add a bit of metatext

Hints so you can follow me.

21

Eating the Future
by Heather Davis

What does it mean to say that plastic is "everlasting"? It is certainly chronophagic, a time-wasting—and even time-eating—material. Composed of fossil fuels, plastic requires millions of years to make. It is then often used for only a month in the form of packaging or, in the case of more durable consumer goods, like clothing, for only a few years before breaking or tearing. This cycle of production compresses deep time into an eternal—and eternally replicating—present. In fact, plastic encourages a fleeting present that consumes time. And then, what of the future?

How long plastic will endure is an open-ended question, unknown and subject to many variables, including chemical composition, exposure to sun and wind, erosion, the kinds of animals that encounter it, and where it ends up. While various forms of bacteria and mycelium have now evolved to feed off of the vast stores of energy contained in plastics, pointing to an unknown horizon for the potential decomposition of plastic, these are not solutions to the wider problem of plastic pollution.[1] The duration of most plastics and their chemical legacies are predicted to extend well beyond the lifespan of any person, and implicate all beings, many generations into the future. Plastic is thus central to worlds to come—even if production were to end

Heather Davis is assistant professor of culture and media at The New School in New York whose work draws on feminist and queer theory to examine ecology, materiality, and contemporary art in the context of settler colonialism. Her most recent book *Plastic Matter* (Duke University Press, 2022) explores the transformation of geology, media, and bodies in light of plastic's saturation. Davis is a member of the Synthetic Collective, an interdisciplinary team of scientists, humanities scholars, and artists, who investigate and make visible plastic pollution in the Great Lakes.

now. "Everlasting," then, could be understood not only in geologic time but also in the time of people's lives: "everlasting" as a kind of inheritance.

Due to this recalcitrance, plastic deeply conditions the possibilities of intergenerational time. The cultures of extractive capitalism and colonialism attendant to plastic will remain a material reality for a very long time. This is happening on an intimate level through the imposition of petrochemicals into people's bodies. Some endocrine-disrupting chemicals are known to alter the gametes of fetuses, meaning that a person two generations down the line could be affected by chemical exposure. Plastic is claiming and conditioning future bodies before they are even conceived, and this is happening differently, with Black, Indigenous, and low-income communities most affected. In this way, the ongoing realities of settler colonialism and the afterlives of slavery are being written into the future, eating the future just as they have ravaged the past.

People will no doubt find ways of thriving, but the material enmeshment of fossil fuels with racist, classist, and colonial policies persists in these chemical legacies. "Everlasting," then, might warn of the continued reinvestment in the production of plastics and its colonial frameworks: "everlasting" not as a statement of eternity but as a conditioning of the future for so many beings, the promise of a material that has come back to haunt our ongoing present.

1 For evidence of the various kinds of "plastic-eating" bacteria and fungi, alongside the limitations of this approach, see Carrie Arnold, "This Bug Can Eat Plastic: But Can It Clean Up Our Mess?" *National Geographic*, April 24, 2017, https://www.nationalgeographic.com/science/article/wax-worms-eat-plastic-polyethylene-trash-pollution-cleanup; Kumar Harshvardhan and Bhavanath Jha, "Biodegradation of Low-Density Polyethylene by Marine Bacteria from Pelagic Waters, Arabian Sea, India," *Marine Pollution Bulletin* 77, no. 1–2 (2013): 100–106; Jonathan Russell et al., "Biodegradation of Polyester Polyurethane by Endophytic Fungi," *Applied and Environmental Microbiology* 77, no. 17 (July 2011); Jun Yang et al., "Evidence of Polyethylene Biodegradation by Bacterial Strains from the Guts of Plastic-Eating Waxworms," *Environmental Science and Technology* 48, no. 23 (2014): 13776–13784; Shosuke Yoshida et al., "A Bacterium That Degrades and Assimilates Poly(Ethylene Terephthalate)," *Science* 351, no. 6278 (March 11, 2016): 1196–1199.

Crude Sedimentation
by Laleh Khalili

Laleh Khalili is the author
most recently of *Sinews
of War and Trade: Shipping
and Capitalism in the
Arabian Peninsula* (Verso,
2020). She is currently
working on a large project
on the entanglements of
oil in the worlds of finance,
banking, shipping, and work.

For two sweltering summers in 1989 and 1990, I worked as an engineer at Amoco's Chocolate Bayou plant in Alvin, Texas, near Galveston. The plant produced olefins and polypropylene, materials needed to manufacture high-performance plastics used in auto parts, fabrics, carpets, and other synthetic consumer products. It had a water filtration pond in the back where an alligator that the workers had named Oscar came and went at leisure. Everything about the plant is entangled in a palimpsest of histories that speak of extractive politics, exploitation, and a recklessness with human futures. Excavating these historical layers tells us something about the complexion and contours of power in each era and how they are built on violence near and far.

The plant's most recent history concerns its acquisition by British petrochemical company Ineos in 2005. Ineos has the dubious distinction of its CEO recently arguing for the necessity of fracking in the British Isles, despite the British government ending support for fracking in 2019.[1]

Immediately prior to the Ineos sale in 2005, there was an explosion in the Chocolate Bayou plant. There were no reported injuries, but "plumes of smoke" and toxic materials were released into the area.[2] While the flat wetlands surrounding the plant are not densely populated, there are a few local residents who have founded small towns in the interstices of the petrochemical plants in the area.

Peach Point Plantation, Fort North elevation, date unknown. Courtesy of the Texas Historical Commission.

25

Frequently, alligators and other wildlife wander across the roads and sometimes collide with automobiles driving through. The reports about the explosion said nothing about the resident alligators.

Digging further down, one finds a National Labor Relations Board case filed in 2000 by the union representing workers at the plant.[3] Employees had reported BP Amoco for the unlawful dismissal of some thirty workers when the two companies merged that same year. I remember from my time there how knowledgeable the men in the "back of the plant" were, how wonderfully sardonic, how forgiving of us inexperienced engineers, with our massive self-importance. My conservative peers in the "front of the house"—the engineering professionals soon to graduate from Schools of Mines and various Texas chemical engineering departments—meanwhile, whined about the difficulty of "getting anything done" with a union workforce that held its own. The case closed when the company settled with the workers. The terms of the settlement were not divulged.

Digging still deeper, one finds that the plant was first opened in 1978 by Standard Oil of Indiana (soon to be rebranded as Amoco). Graphs tracing the manufacture of plastics show a dramatic spike after 1975. Like so many other hydrocarbon ventures—refineries and transport networks, financial derivatives and options, new models of oil pricing and insurance, and ultra-large crude carriers—the manufacturing of plastic skyrocketed after the nationalization of Middle Eastern oil. In response to what historian Chris Dietrich has called "the most concentrated non-violent transfer of global wealth in human history," new modalities of accumulation of surplus value emerged in the Global North.[4] The manufacture of plastics was one such new modality, adding value to the crude oil extracted from sovereign nations of the Middle East, with the profits safely ensconced in the global North.

Still further, we discover that, in 1967, Amoco (which was still called Standard Oil of Indiana at the time) acquired the land in Alvin. That same year, because of the June War

between Israel and its neighbors and the closure of the Suez Canal, there was a brief reduction in the volume of oil produced. The US excess crude oil capacity had to make up for the Middle Eastern oil lost to the market. It was during this Texas oil bonanza that Amoco acquired the land for the plant.

There are layers and layers still to recover. There is the Texas City disaster of 1947, which occurred just a scant thirty miles away from Chocolate Bayou, and the Great Galveston hurricane of 1900. Both crises redrew the maps of life, work, labor, and community in the region. There is the fact that the area originally belonged to Stephen Austin, the city's namesake and the so-called "father of Texas." The acclaim bestowed on the man notwithstanding, he is best known for bringing slaves into Mexican-controlled Tejas, despite the Mexican government's opposition to slavery, and for his attempts at exterminating the Indigenous Karankawa people.[5] Enslaved Africans produced cotton on Austin's Peach Point Plantation (which was later passed on to his sister). There are still public buildings called "Peach Point" thirty miles away from Chocolate Bayou.

The political and legal indulgences that granted the manufacture of plastics in a specific place have an accumulated history and a leaden ideology that grow in a substrate of exploitation and cruelty, absent of care. Chocolate Bayou, the freshwater river that collects pollution from the densely placed petrochemical plants near it and dumps it in a bay near Galveston, lazily meanders through these strata of time and of social relation.

That I, an Iranian woman who arrived by sheer happenstance in Texas in 1985, would end up working on the shores of this river years later, also speaks to other buried histories that are inevitably tangled up with fossil extraction, imperial power, and political cataclysms.

1 PA Media, "Ineos Wants to Drill UK Fracking Test Site in Attempt to Show It Is Safe," *Guardian*, April 11, 2022, https://www.theguardian .com/environment/2022/apr/11/ineos-wants-to -drill-uk-fracking-test-site-in-attempt-to-show-it -is-safe-jim-ratcliffe.

2 "Fire at BP Subsidiary Nearly Extinguished in Texas," *Firehouse*, August 11, 2005, https: //www.firehouse.com/home/news/10507453/fire-at-b -subsidiary-nearly-extinguished-in-texas.

3 BP Amoco Chemical – Chocolate Bayou and its successor INEOS USA LLC, 16-CA-020258, https: //www.nlrb.gov/case/16-CA-020258.

4 Christopher Dietrich, *Oil Revolution: Anti-colonial Elites, Sovereign Rights, and the Economic Culture of Decolonization* (Cambridge: Cambridge University Press, 2017), 4.

5 Gerald Horne, *The Counter-Revolution of 1836: Texas Slavery & Jim Crow and the Roots of US Fascism* (New York: International Publishers, 2022).

Aesop Condoms
by Aurelia Guo

Aurelia Guo is a writer and
researcher based in London.
She is the author of *World
of Interiors* (Divided, 2022).
She is a lecturer in law at
London South Bank University.

One night, while dancing, she fell off the stage
and crashed onto a customer

a body clad in a resilient gleam

acting as a tantalizingly flimsy barrier

Strange hands. Inquisitive hands. Dirty hands.

A large number of fancy articles, such as chessmen,
thimbles, buttonhooks, umbrella and parasol handles,
paper knives, baby rattles, dolls' heads, pocket rules,
card receivers, etc. are also made from it.

Perhaps celluloid's greatest impact was serving as
the base for photographic film. Here celluloid's
gift for facsimile achieved its ultimate expression:
the complete transmutation of reality into illusion.

They were bombarded by images of all times and places,
the fantastic or exaggerated as well as the authentic

*that could take on bright colours, remain crystalline clear,
or be puffed up with air*

29

It is surprising how quickly human beings get used to
better circumstances

Masks, headgear, clothing, and costumes (ape, dragon,
banana)

how thoroughly plastic would permeate their lives,
even eventually their bodies

in hazy zone where balloons, UFOs, and missiles fly

the "trivial" and "futile" pleasure of inhabiting that moment

**A transformative mask is split along the vertical axis,
allowing the two halves to fold in to meet along
the dividing line, and to fold out to reveal another mask—
which can itself be similarly split and concealing**

A homemade abortion device based on a similar design
from the 1970s—Cabinet with implements—steel, glass,
rubber, & plastic

`shop-soiled storefront mannequins sourced from`
`surplus stores and charity shops`

Opium poppy exuding fresh latex from a cut

`[N]ature has been knitting polymers since the`
`beginning of life. Every living organism contains`
`these molecular daisy chains. The cellulose`
`that makes up the cell walls in plants is a polymer.`
`So are the proteins that make up our muscles and`
`our skin and the long spiraling ladders that hold`
`our genetic destiny, DNA.`

A material epitomizing inferiority

The mountains of waste in non-regulated dumps
are haunted by waste pickers who are often not efficient
in collecting plastic, which is sometimes as light as
the wind

"Plastic has climbed down, it is a household material."

Barthes, Roland. *Mythologies*. Translated by Annette
Lavers. New York: Farrar, Straus & Giroux, 1972.
Brown, Judith. *Glamour in Six Dimensions: Modernism
and the Radiance of Form*. Ithaca, NY: Cornell University
Press, 2009.
Celluloid Manufacturing Co. "1878: Fire Starter."
Lapham's Quarterly. https://www.laphamsquarterly.org
/technology/fire-starter.
Chalmin, Philippe. "The History of Plastics: From
the Capitol to the Tarpeian Rock." "Reinventing Plastics,"
special issue, *Field Actions Science Reports, The Journal of
Field Actions* 19 (2019): 6–11. https://journals.openedition
.org/factsreports/5071?lang=fr.
Cheng, Anne Anlin. *Ornamentalism*. Oxford: Oxford
University Press, 2019.
Freinkel, Susan. "A Brief History of Plastic's
Conquest of the World." *Scientific American*, May 29, 2011.
https://www.scientificamerican.com/article/a-brief-history
-of-plastic-world-conquest.
Lee, Dan P. "Paw Paw & Lady Love." *New York
Magazine*, June 3, 2011. https://nymag.com/news/features
/anna-nicole-smith-2011-6.
Meikle, Jeffrey L. *American Plastic: A Cultural
History*. New Brunswick, NJ: Rutgers University Press, 1995.
Protevi, John. Review of *Plasticity at the Dusk
of Writing: Dialectic, Destruction, Deconstruction*,
by Catherine Malabou. *Notre Dame Philosophical Reviews*,
February 22, 2010. https://ndpr.nd.edu/reviews
/plasticity-at-the-dusk-of-writing-dialectic-destruction
-deconstruction.
Muir, Gregor, Sophie von Olfers, and Beatrix
Ruf, eds. *Lutz Bacher: Snow*. Text by Caoimhin Mac Giolla
Léith. Dijon: les presses du reel, 2013.
Wong, Edward, Eric Schmitt, and Julian E. Barnes.
"US and China Vie in Hazy Zone Where Balloons, UFOs and
Missiles Fly," *New York Times*, February 17, 2023. https://
www.nytimes.com/2023/02/17/us/politics/china-us
-balloons-ufo.html.

The Making of a Synthetic World
by Adam Hanieh

In the decades immediately following World War II, the rapid spread of synthetic materials derived from petroleum colonized all aspects of everyday life. These new petrochemicals reshaped the cultural practices and material products associated with the "American Dream." At its core, the petrochemical industry represented a qualitative shift in *how we produce*. The functional attributes of natural materials, such as wood, glass, paper, natural rubber, natural fertilizers, soaps, cotton, wool, and metals, would now be served by plastics, synthetic fibers, detergents, and other petroleum-based chemicals. This was the beginning—proclaimed a *Fortune* magazine headline in 1950—of the "Chemical Century."[1]

As injection-molding machines were developed through the 1950s and 60s, plastics enabled the automated fabrication of cheaply reproducible components that transformed whole branches of industrial production. Akin to modern day alchemy, a bag of small pill-like thermoplastic pellets could be transformed into any simple commodity with the appropriate mold. Once a mold was set, there was little extra cost to manufacturing each item—not only dramatically reducing the need for labor but also encouraging enormous increases in commodity output.

As huge quantities of new and easily reproducible synthetic goods displaced natural materials, corporations

Adam Hanieh is professor of political economy and global development at the Institute for Arab and Islamic Studies, University of Exeter. He is author of *Money, Markets, and Monarchies: The Gulf Cooperation Council and the Political Economy of the Contemporary Middle East* (Cambridge University Press, 2018), which won the 2019 British International Studies Association, International Political Economy Group Book Prize.

were faced with the obstacles of limited market size and the restricted needs of the postwar consumer. Ever-accelerating quantities of waste, inbuilt obsolescence, and automated production became the hallmark of capitalist manufacture—a situation presciently narrated by Vance Packard in his 1960 classic, *The Waste Makers*. As Packard noted, the solution to this dilemma was closely connected to the emergence of another "new" industry: advertising, which aimed at inculcating the mass consumer "with plausible excuses for buying more of each product than might in earlier years have seemed rational or prudent."[2] Wants became needs, with the malleability of desire driving an ever-present disposability—a fickleness ultimately aimed at speeding up the circulation of commodities. But branding needed a "skin," and advertisers turned, once again, to plastics for a solution. The pervasive supply of cheap and pliable petrochemicals enabled a vast expansion in packaging and labeling, which soon came to encase all consumer goods. Packaging quickly became the largest end-use for plastics, now making up more than one-third of the current demand for global plastics.

This narrative points to the real problem with fossil fuels. Having become so accustomed to thinking about oil and gas as primarily an issue of energy and fuel choice, we have lost sight of how the basic materiality of our world *literally* rests upon the products of petroleum. These synthetic materials drove the postwar revolutions in productivity, labor-saving technologies, and massified consumption. Today, it is almost impossible to identify an area of life that has not been radically transformed by the presence of plastics and petrochemicals. These synthetic products have come to define the essential condition of life itself—they have become normalized as *natural* parts of our daily existence. This paradox must be fully confronted if we are to move beyond fossil fuels.

33

Advertisement for DuPont Cellophane c. 1955.
© The Advertising Archives/Bridgeman Images.

1 "The Chemical Century," *Fortune* 41, no. 3 (March 1950): 116–121.
2 Vance Packard, *The Waste Makers* (New York: David McKay, 1960), 29.

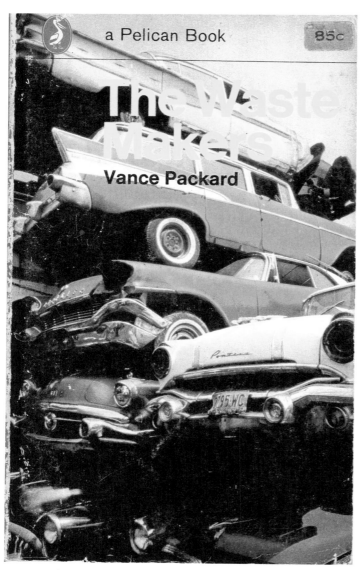

Cover of Vance Packard, *The Waste Makers* (New York: Pelican, 1960).

Hard Mother
by Anjuli Fatima Raza Kolb

Anjuli Fatima Raza Kolb is
associate professor at Dartmouth
College and author of *Epidemic
Empire: Colonialism, Contagion,
and Terror, 1817–2020* (Univer-
sity of Chicago Press, 2021).
Her research focuses on race and
racialization in the history
of science and the disciplines.
She is also a poet, translator,
and essayist.

Last night I was in them guts

Slimm Calhoun

You think I'd leave your side baby
You know me better than that

Sade

Most spinal catheters—for example, those used to deliver
epidural anesthesia during childbirth—are made of poly-
amide resin, polyurethane, and nylon block copolymers. By
the time my catheter was placed between the dura mater
(hard mother in Latin, from the Arabic al-'umm al-jāfiya) and
the ligamentum flavum, I also had in my body a dinoprostone
suppository encased in a "knitted polyester retrieval sys-
tem," an IV line (polyethelyne) in my forearm hooked up to a
bag (PVC) of saline, and a catheter (plastic) to eliminate
urine. I was girdled in a poly-blend "stockinette" (its plastic
packaging read "In-Place Queen") to hold the disposable
plastic-housed tocodynamometer tracking my contractions.
When she was out, the baby's cord was clamped with a dis-
posable plastic alligator clamp, and heart rate monitors
were taped to her chest with plastic tape. She was outfitted
in a standard-issue newborn hat (poly-blend) and weighed
in a plastic scale next to an (opened) AirLife Tri Flo Single
Use Suction Catheter (PVC) in case she needed naso-gastric

suction (she didn't). I needed two stiches (Vicryl, a dissolving polyglactin copolymer). I made everyone crazy looking for a pink ethylene-vinyl acetate slipper I lost during labor. When we couldn't find it, I threw the other one out. The placenta is in the freezer in a plastic take-out container, waiting to be planted under a tree when the ground thaws in "spring." The tree will remain long after we both die. So, of course, will the plastics.

This is my homoreproductive Anthropocene confession. I could do this same bit about pump parts, the baby's infinite stuff, my sex toys, the inconceivable volume of plastic I used to inject hormones while reading pamphlets in the fertility clinic about reducing exposure to plastic if you are having trouble conceiving. When I surveyed a group of mothers with same-age babies, all of whom had been living intentionally low-waste lives, they reported trashing an astonishing amount of plastic since giving birth. Every postpartum pad in a plastic wrapper, the tear-off tops of breastmilk bags, the packaging of premium "sustainable" diapers, the bubble wrap swaddling eco-friendly baby dishes, on and on. More arresting than the compendium of plastics was the intensity of affect around this waste: shame, panic, horror, guilt—a feeling of being trapped, of creating further inescapable traps. "Don't blame/ the Junk for being discarded," Tommy Pico reminds us.[1] Can we live without this stuff? Obviously. What is the material vanishing point of any individual effort? I wanted to give birth at home but couldn't. What is "couldn't"? What threshold of risk? Of pain? Hers, mine? What is an organic wooden exersaucer? Why does it cost 1001 dollars?

We've made things possible, we've made other things impossible. Reproductive freedom since the turn of the century has increasingly meant—especially for queers— less body, more plastic. The vial. The injection pens. The dish. The tubes. The romance—so many forevers. Almost none of this material, especially the medical waste, is recuperable. All of it will end up pulverized in the guts of living beings. Almost all of us have microplastics in our blood. They flow

alongside the cellular threads the baby left in me, and they will flow in her blood, where my cells linger also.

A single hysterectomy, the second most common surgical procedure among women in the US, produces nearly twenty pounds of waste.[2] Considering the formation of a "way out" in the absence of a way out (say, through a pelvis made plastic by relaxin), Catherine Malabou writes, "Plasticity appears diametrically opposed to form… [T]he formation of a new individual is indeed this explosion of form, an explosion that clears the way."[3] For birthing parents, this way-clearing is not just physical; it is also profoundly cognitive. We know full-time caregivers experience a radical return to accelerated neuroplasticity, almost as rapid as their own infants'—but how we metamorphose or decompose into elements-in-formation is as difficult to quantify as it is to describe. Our containers rip, our minds unravel and braid themselves into novel, unrecognizable patterns. Our senses transform, including heightened hearing acuity and a more focused and purposive sense of smell. This total liquidation is normal, we are told.

"The body, bearing something ordinary as light/ Opens," writes Aracelis Girmay, of childbirth. "This/ fact should make us fall all/ to our knees with awe." And so it does, in all the ways. We melt and merge, become our own guts, our legs go limp and plastic, bathed in the pink glow of a plastic LED light brought from home for vibes. Re-making the sense of what accumulation might mean, Girmay speaks of "the stacks and stacks of near misses/ & slim-mest chances that birthed one ancestor into the next and next… how improbable it is that this iteration of you or me might come to be at all.… —& even last a second."[4] The duration and vastness of climate change are hard for the mind to compass. Critics liken the trying of it to sublimity, an impossible and unmediated witnessing of nature in all its terror and all its perfection. The ancestors through her, the baby is born into a trash-filled world, beneath a bright elastic sky, amid a pile of trash—it dysregulates the mind, the climate sublime's inverse. Birth is a visceral experience

37

not just of the body's plasticity but also of time's—the golden hour, the first latch, the shortest joy, her long life, inshallah, the everlasting waste.

1 Tommy Pico, *Junk* (Portland, OR: Tin House, 2018), 7.
2 Cassandra L. Thiel et al., "Environmental Impacts of Surgical Procedures: Life Cycle Assessment of Hysterectomy in the United States," *Environmental Science and Technology* 49, no. 3 (2015): 1779–1786.
3 Catherine Malabou, *Plasticity at the Dusk of Writing: Dialectic, Destruction, Deconstruction*, trans. Carolyn Shread (New York: Columbia University Press, 2009), 68.
4 Aracelis Girmay, *the black maria* (Rochester, NY: BOA Editions, 2016), 100–101.

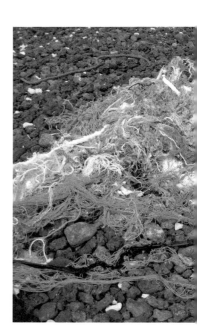

On the Plasticity of Plastics
by Carolyn L. Kane

Carolyn L. Kane is author of
Electrographic Architecture:
New York Color, Las Vegas Light,
and America's White Imaginary
and *High-Tech Trash: Glitch,*
Noise, and Aesthetic Failure
(University of California Press,
2023 and 2019); and *Chromatic*
Algorithms: Synthetic Color,
Computer Art, and Aesthetics
After Code (University of Chi-
cago Press, 2014).

The plastic configurations of our neural connections... are the forms of our identity. Plasticity, then, is the transcendental structure of our existential experience.
Catherine Malabou

No laboratory of the future is possible without the stuff of the past. The conditions of possibility for any "new" technology always derive from the present. Plastics are no exception.

Embraced by the Western world in the mid-twentieth century as something of a modern panacea, plastics promised to transform human nature and society through synthetic chemistry. Indeed, plastics have had enormous cultural, medical, and technological benefits, from electric wire insulation to vinyl blood bags for safe transfusions and light-emitting polymers for colored light in computing. And we might have failed to recognize just how radically they have reconfigured our everyday lives if they had not also come under the crosshairs of health and environmental advocates.

Critiques of plastic first emerged in the 1960s. Around the time pink flamingos and synthetic leather showed up on our lawns and our bodies, scientists began to link the so-called miraculous substance to acute environmental

39

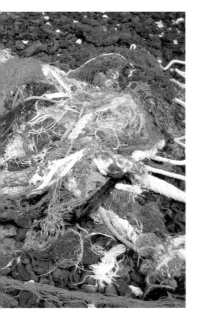

Ghost nets at Black Rock, Kaʻanapali Beach, Hawaiʻi,
August 2008. Photograph by Eric Johnson. Courtesy
of the National Oceanic and Atmospheric Administration.

and health hazards. The research surmounted but, despite its findings and oppositions, the production and consumption of plastic has continued to scale, increasing almost twenty-fold in the last sixty years, with an annual production reaching 390 million metric tons in 2021.[1] It is no longer a mystery where all this plastic goes: it ends up in our oceans, the same location that once supplied the fossil fuels to process natural gas, which, in turn, generated the byproducts used to develop plastics in the first place. Now these same oceans are haunted by our ghost gear, or "ghost nets," plastics that do not biodegrade (polyurethane takes a thousand years to break down)—littered with toxic debris that traps, chokes, contaminates, and entangles ocean life. Each year, approximately one billion seabirds and mammals die from eating plastic bags.[2] Ghost gear not only evidences how plastic waste is disposed of in deadly ways but also, in its very status as lasting waste, structures plastic "neural nets" that bind our psyches to a future-past of unresolved trash. There is no escaping this ghost, but it can be a source of transformation.

When the ancient Greeks proposed a rigorous pursuit of "the good life," the acquisition of endless streams of cheap plastic stuffs could not be further from what they had in mind. And yet, we have made the logic of consumption synonymous with "bettering" one's self, family, and country. Spiritually motivated or not, it is what we do and work for. Artists, intellectuals, and many others have been critiquing our culture's excessive consumption and plastic's key role in it. And still, the belly of the beast grows stronger with each new consumer report.

How can we change the fate of plastic in the next millennium? Over the last two centuries, some innovations in recycling have enabled consumers in the Global North to yield more energy and power from less resources, causing fewer forms of direct biological and environmental destruction. But who is forgotten in this so-called global march to progress? In the service of a world-being for all—versus

the postindustrial few—such questions must continually shape a truly progressive plastic laboratory of the future.

At the same time, a world-being in service of a future for all must start at home, with the individual's capacity to function as a creative, generative being (*homo faber*), to transform the detritus of our personal psyches into a new home for a novel future. French philosopher Catherine Malabou suggests as much in her recent work on neuroplasticity, insisting past destructions can be resuscitated to form ourselves anew, "to fold oneself, to take the fold, not to give it."[3] Granted, Malabou did not have consumer plastics in mind, but she nonetheless invokes the uniqueness of plastic in its capacity—like humans—to give and receive fresh shape and form from the already wounded and traumatized in personal and collective registers. This is the material essence of plastics and it must remain the real matter of the future. How else can we recuperate plastic's spiritual and ethereal fortitude, if not through its own plasticity?

1 "Annual production of plastics worldwide from 1950 to 2021," Statista Research Department, January 25, 2023, https://www.statista.com/statistics/282732/global-production-of-plastics-since-1950.
2 Murray R. Gregory, "Environmental Implications of Plastic Debris in Marine Settings—Entanglement, Ingestion, Smothering, Hangers-on, Hitch-hiking and Alien Invasions," Philosophical Transactions of the Royal Society of London. Series B, *Biological Sciences* 364, no. 1526 (2009): 2013–2025; Martin Wagner, Magnus Engwall, and Henner Hollert, "(Micro) Plastics and the Environment," *Environmental Sciences Europe* 26, no. 16 (2014): 16.
3 Catherine Malabou, *What Should We Do with Our Brain?*, trans. Sebastian Rand (New York: Fordham University Press, 2008), 13; see also Catherine Malabou, Tyler Williams, and Ian James, *Plasticity: The Promise of Explosion* (Edinburgh: Edinburgh University Press, 2022), 27, 164.

DuPont's Better Living, Working Women, and Industrial Toxicology
by Gabrielle Printz

It is 8:00pm. My baby has just settled in his crib, and I am doing a bit of work. While he sleeps, I scroll the Hagley Library and Museum's digital archives on my laptop from bed, while hooked up to two Medela breast pumps humming the silicone-softened song of mechanically expressed milk. Among my own tangle of tubing and power cords, I expand a black-and-white image of a woman operating an "electrically loaded" stationary bicycle in a temperature-controlled room.[1] She is outfitted in a sleeveless polyester set, a blood pressure cuff, and a thatch of nodes connecting her vitals to an adjoining room. The unnamed woman is a volunteer in a fatigue research study at the Haskell Laboratory for Toxicology and Industrial Medicine, the research institute established by the synthetics giant DuPont de Nemours, Inc. (DuPont) in 1935, initially to assess the occupational hazards of working in the pursuit of a "new world through chemistry."[2] This was the company slogan that debuted in 1939 alongside an exhibition of its products—including a new artificial rubber called neoprene and a silk-like fiber called nylon—at the New York World's Fair.[3] But the chemistry that wrought this new world was, by that time, already understood to be potentially volatile: a decade earlier, a concerning number of DuPont dye plant workers had been diagnosed with bladder cancer.

Gabrielle Printz is a PhD candidate in architecture history and theory at Yale. She studies correspondences between architecture, capital, labor, and state-making, with a focus on inter/national developments and expatriate work on the Arabian Peninsula. Outside of academia, she works through f-architecture, a research practice and alias shared with Virginia Black and Rosana Elkhatib.

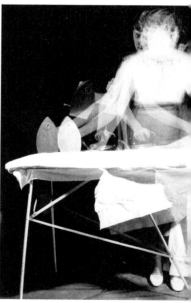

"Energy output in ironing," 1955. Photograph taken with a stroboscopic camera as part of a test at DuPont's Haskell Labs. The test revealed that a woman ironing a shirt uses twice as much peak energy as a man does painting the living room ceiling. 1972341_3891, Series XIV, Box 12, Folder 2 "Studies of Industrial Fatigue." DuPont Company Product Information photographs (Accession 1972.341), Audiovisual Collections and Digital Initiatives Department, Hagley Museum and Library, Wilmington, DE 19807.

42

The Haskell Laboratory opened in the intervening years in response, facilitating internal research on its own products and manufacturing processes, professing its motivating concern to be worker safety. To that end, DuPont's contribution to the twentieth-century pantheon of polymers was situated not only in petrochemical R&D but also the attendant field of toxicology. The creation of synthetics and the assessment of their unruly effects (or, in the company's positive terms, their "safety") would both be handled in controlled environments, separate from, but ever in relation to, the plant and the home.

Riding a bike, painting a ceiling, and ironing a shirt provided registers for manufacturing tasks in domestic labor. These activities have been recorded in stroboscopic photos which multiply the body performing already repetitive motions, and the archives of the Haskell Laboratory are replete with images that depict women working.

Better Living

By the late 1940s, DuPont's slogan exchanged the novelty of synthetic invention for one of convenient use. "Better living… through chemistry" tethered the good life to be had at home to the chemical enterprise with an ellipse (it reads to me now like an omission of relevant information rather than a dramatic pause). It referred to a lab-created and lab-maintained vision of a world of consumer goods: not only discrete objects, such as nylon stockings and grease-resistant neoprene gloves, but also coatings that integrated slick, non-stick, water-repellant, and unwrinklable surfaces into households and onto the bodies of American families.

The promise of "better living" was facilitated by DuPont's own notion of polymerization: not just the technical process from which its proprietary materials sprung forth to constitute an entirely modern world of things but also the means by which that modern world could be engaged in its

own self-reproduction *through* polymers. Plasticity was a social process: born in a lab, multiplied in a factory, and brought home by shoppers and factory line workers alike. Man-made and woman-worn, nylon, teflon, dacron, and other patented synthetics graced the bodies and the surfaces of everyday life, thus proliferating instances of exposure to them.

Forever Chemicals

DuPont's polymers of non-transfer—resistant to ordinary messes and "indifferent to time," as neoprene was introduced in 1939[4]—depended on the staying power of fluorocarbons, something Haskell was investigating as early as 1950.[5] In contemporary toxicology, these are PFAS (per- and polyfluoroalkyl substances) and "forever chemicals," the bonds of which are very difficult to break down and thus remain persistent parts of our environment and ourselves.[6]

 I'm only an amateur toxicologist, a specialization bred by the paranoia that accompanies new motherhood in the world of forever chemicals. I speak in millennial determinations of "that's toxic" and in the syntax of "free from" to navigate the badness of the world I rely on to live and to make life. But my training is in history, so I bring this paranoia to the DuPont archives and to a short text that Roland Barthes wrote more than half a century ago. Reflecting on a 1953 exhibition of plastics in Paris, Barthes remarked on the material's essential process of transformation—not plastic as object, but rather plasticity as an elemental force of production—as one that was conspicuously unpeopled: it was "nothing; nothing but a transit, hardly watched over by an attendant in a cloth cap, half-god, half-robot."[7] DuPont showed a vision of plasticity that was necessarily human, contrary to Barthes's observation. However, the idea of plastic as consisting in barely intelligible links—"nothing but a transit"—intuits something about the bodily thresholds that are only suggested by the TV parents and real life

44

employees of DuPont's "better living" media. While we are afforded glamor shots of artificial silk and microscopic images of mylar enhanced 25,000 times, what can't be shown is the evidence of exposure to a volatile polymer or an indissoluble F-C bond. The hard-to-bind consequences of such repeated exposure might appear on medical charts years later, but, in the meantime, DuPont offered up pictures of people working toward that evidence, as professional observers or with their own bodies as research subjects.

The social and physical reproduction of life in plastics has largely been born by women, and certainly at this black-and-white moment of DuPont's worldbuilding, when its fashioning of a new or better life was refracted through staid gender roles and corporate paternalism. The fatherly voice of mid-century advertising enunciated the convenience of its domestic products in the same breath as it assured houseworkers of the safety of synthetics in the home. Over footage of a mother at the sink with her small child, lathering her hands with a bar of soap (another DuPont offering), a gray-suited announcer effuses the importance of the "exhaustive tests" conducted by DuPont's researchers. In a home office, he addresses the camera as a kind of disciplinarian: "You know, like people, chemicals are of many different types. Now most present no special problem. But some do require special care and treatment to make sure they behave properly and normally."[8] The camera shifts back to Haskell space, where caretaking is shown to proceed in the lab, as it does at home.

DuPont no longer produces PFAS, it professes on a dedicated page on its website and in a 2019 corporate commitment. But it hasn't yet figured out how to decouple its processes from forever chemicals. The company, which has long pursued its own toxicology—for the products that still comprise and coat the world as we know it—instead leaves this decoupling up to people like me... a consumer, an academic, and a mother.

45

"Comparison of Teflon and plastic," 1945. From a boiling bath of hot sulfuric acid, a laboratory technician lifts two rods of plastic. One has charred and deteriorated. The other, a rod of DuPont's new Teflon tetrafluoroethylene resin, is not affected at all by the highly corrosive hot acid.1972341_2498B, Series VIII, Box 8, Folder 10 "The creation of 'Teflon' at the Richmond, Virginia Plant." DuPont Company Product Information photographs (Accession 1972.341), Audio-visual Collections and Digital Initiatives Department, Hagley Museum and Library, Wilmington, DE 19807.

1 "Fatigue studies at the Haskell Laboratory
for Toxicology and Industrial Medicine," c. 1950—
1959, DuPont Company Product Information photographs
(Accession 1972.341), Series XIV, Box 12, Folder 2
"Studies of Industrial Fatigue," Audiovisual Collec-
tions and Digital Initiatives Department, Hagley
Museum and Library, Wilmington, DE, https://digital
.hagley.org/1972341_3886.
2 "Haskell Laboratory for Toxicology and Indus-
trial Medicine records 2739," Finding Aid, December
11, 2022, Manuscripts and Archives Department,Hagley
Museum and Library, Wilmington, DE, https://hagley
-aspace-pdf.s3.amazonaws.com/2739.pdf.
3 "A New World Through Chemistry," 1939, FILM_
1995300_FC121, DuPont Company films and commercials
(Accession 1995.300), Audiovisual Collections and
Digital Initiatives Department, Hagley Museum and
Library, Wilmington, DE, https://digital.hagley.org
/FILM_1995300_FC121.
4 "A New World Through Chemistry."
5 "DuPont commercial featuring Haskell Labo-
ratories," 1950, FILM_1995300_FC12_02, DuPont
Company films and commercials (Accession 1995.300),
Audiovisual Collections and Digital Initiatives
Department, Hagley Museum and Library, Wilmington,
DE, https://digital.hagley.org/FILM_1995300_FC121.
6 The "F" and "C" of "forever chemicals,"
so named by the Harvard public health researcher
Joseph Allen in a 2018 op-ed, refer to their compo-
nent parts, fluorine and carbon; it's less a play on
words than a repackaging that he hoped would main-
tain concern about such toxins in the popular imagi-
nary. See Joseph G. Allen, "Opinion: These Toxic
Chemicals Are Everywhere—Even in Your Body. And They
Won't Ever Go Away," *Washington Post*, January 2,
2018, https://www.washingtonpost.com/opinions/these
-toxic-chemicals-are-everywhere-and-they-wont-ever
-go-away/2018/01/02/82e7e48a-e4ee-11e7-a65d-1ac0fd7f-
097e_story.html.
7 Roland Barthes, "Plastic," in *Mythologies*,
trans. Richard Howard and Annette Lavers (New York:
Hill and Wang, 2013), 194–195. DuPont's branding
language is invoked in an article about the exhibi-
tion and its female spectators: "'Do it by chemistry'
has now become a fashionable slogan in the feminine
circles of Paris; in "French Impressed by Plastics
Exhibit; Week's Program of Chemical Salon Introduces
Latest Developments to Women," *New York Times*,
July 11, 1953.
8 "DuPont commercial featuring Haskell
Laboratories."

Seduction Concentrate
A conversation with Ilana Harris-Babou
and Pallavi Sen

Ilana Harris-Babou's work is interdisciplinary; spanning sculpture and installation, and grounded in video. Her work explores the ways we seek connection and identity through everyday objects. She speaks the aspirational language of consumer culture and uses humor to digest painful realities.

Pallavi Sen is from Bombay, India. She works with installation, printmaking, textiles, and intuitive musical movement. She received her MFA in sculpture and extended media from the Virginia Commonwealth University, and is assistant professor of multiples and distributed art at Williams College. She is author of *Dead Planet Cookbook*, and is currently working on a second book about a garden-based curriculum.

Ilana Harris-Babou I wanted to talk to you, because we are collaborators. One of our biggest collaborations was being roommates during the first COVID lockdown in 2020. I learned a lot from you and your relationship with plastics and waste during that time.

We had very different experiences with plastic at home growing up. What was it like for you?

Pallavi Sen Yeah, I grew up in the 1990s in India, when, suddenly, a lot of packaged products were coming in. We didn't have big-box stores yet, but I remember my father describing the Container Store from his first trip to the US. We just couldn't believe that things could come in so many colors and sizes.

He brought back two small, plastic toothpick containers: a pink one and a blue one. At the time, everything in my home was mostly handmade. There were some plastic things, like water jugs, but almost everything else was made of a natural material with a coating.

Plastic was so special; when Ruffles Lays came to India, my grandmother would wash out every bag of chips and save them underneath her oven.

IHB I grew up in an environment where plastic was about expediency. It was special, but it was also everywhere.

47

My mom was born in the early 1940s and is very much a mid-twentieth-century American. She was also a pediatric nurse. I remember visiting her in the hospital and seeing plastic machines, IVs, and syringes everywhere.

My family are very much New Yorkers. We had takeout for dinner almost every night, and the containers were all over the house. We'd bond by going shopping in Manhattan on weekends and bringing back lots of branded plastic bags.

PS The novelty and promise of bringing something new home—I have memories of that too.

I feel that there was this moment in India when our plastic use could have gone one way or another. In my childhood I saw many products becoming available in tiny sizes, all held in crimped plastic. You could buy a one-time use shampoo or a snack for not very much money. Now when you're on the train or walking along the road, you can see small, silver rectangles of plastic everywhere.

Still, even though plastic waste is very visible in India, the same amount exists in the US. It's hidden, because of the way it's discarded, but just as revolting. And a curtain has been pulled away from the magic of a material, because we now understand the composition and fallout.

IHB I like making videos, because they allow me to make materials unfamiliar again.

I can take a plastic bag, put it under studio lighting, reframe it through different angles, and feel the joy of transformation. I can suspend a material in the constant flux that exists on the screen. I relish it! I can have new experiences with the stuff that's already there.

PS I was recently watching a video you made and was reminded of how, when I was younger, I used to love playing with wet mud after the rain, because of how it felt, the squishing sounds of it, so delicious but you cannot eat it. It was lovely and chocolatey and glossy, and I think that, in

your work, there's also that same loveliness of something spreading, the temptation of something setting and then becoming shiny again.

IHB Yeah, being an artist gives us an excuse to return to the same material experiments we loved as children.

PS I think about the work of artists from the early twentieth century, when there were synthetics coming in, like Annie Albers and her weavings. She worked with so many new fibers, testing how they each move, how they feel, how you can combine materials, synthetic with organic.

IHB Synthetics are just concentrated seduction! How do they do it?

PS Yeah, I wonder if it's the glossiness. There's a gloss to the surface of stuff that doesn't disintegrate—something that organic substances in their raw form just don't have. And maybe it's how light hits something that can't break down.
 The very vibrantly colorful, like something at its peak ripeness, has the same draw as plastic, and we want to move close to it. I don't know if there's an equivalent to it, but it's like the molded letters on a keyboard going *clack clack* with the touch of acrylic nails.
 Maybe a lusciousness beyond plastic is sonic! Like a conversation or song. Or it's interaction; it's dance; it's a motion that makes you feel excited.

IHB Or a meal that's about to be consumed. Or the shine in the eyes of someone you love. Right?

Currants near the garden; tofu marinated according to a recipe in a short story; toast with mayonnaise and tomato harvest; rhubarb crisp; Alice Waters's kale soup; dal roti with arbi and hari sabzi. Photographs by Pallavi Sen.

Whither the Forty Ounce?
by Naa Oyo A. Kwate

At the end of *Boyz n the Hood*, Doughboy crosses the street to talk to Tre. It's morning—we don't know what time, exactly, but Doughboy confesses that he hasn't been up this early in a long time. It's the day after his brother Ricky was gunned down in cold blood in an alley just blocks from their home, followed by Doughboy avenging his death with another volley of bullets. Doughboy carries a 40-ounce glass bottle of St. Ides malt liquor, two-thirds of his breakfast already consumed. It was probably purchased on location in South Central (now just called South) Los Angeles by the film's prop department. The big red price sticker remains on the front: $1.49. The bullet-shaped bottle cuts an iconic silhouette, one that, in the 1990s, became a visual shorthand for young Black male masculinity.

Two summers ago, I saw a bottle of Olde English 800 in a supermarket in Philadelphia. It was plastic. At some point in the 2010s, the bottle changed from glass to plastic. This smaller, squat bottle actually contained more liquor: 42 ounces. It had a label that turned blue when the liquid was appropriately cold—necessary for a drink that is otherwise unpalatable. Plastic is cheaper than glass, but why give up a design that is so recognizable, even by people born long after the drink's heyday, even by winemakers in other countries, such as the French Domaine Julien Braud, which sold its blend of Muscadelle, Loin de l'Oeil, and Muscat

Naa Oyo A. Kwate is an interdisciplinary social scientist with wide ranging interests in racial inequality. Her research has been funded by grants and fellowships from the National Institutes of Health, the Smithsonian Institution, and others. She is currently writing a book about corner liquor stores in Black urban life.

white wine in the iconic 40-ounce bottle shape and labeled it "Forty Ounce White"? And why market the *terroir* of southwest France in the visual language of a drink meant to be drunk to get drunk?

The new Olde English 800 had a big, fat, graspable plastic cap like soda, like juice, like iced tea, like Gatorade. It's deceptive, but malt liquor is deceptive. Because packaged drinks are meant to taste good, but this is just meant to be swallowed. Malt liquor's *terroir* is the shop floor, not south-facing calciferous parcels of earth that come through in a taste of crisp minerality. But the Olde English doesn't deceive. The 42-ounce never promised anything but a math problem of percent alcohol by volume and what the liver can metabolize. Meanwhile, the planet cannot digest the container, and it takes revenge. Plastic is ill-suited to beer: the air oxidizes the brew; UV rays skunk it—still digestible, but ever more unpalatable sitting in the cold case.

42 ounces of 7.5 percent malt liquor meant to be a single serving, meant to be drunk quickly before you can actually taste it, before room temperature sets in. If you're drunk—when you're drunk—and your fine motor control is less than state of the art, and you drop it, the bottle won't send up a fine spray of corn sweet malt and glass shards. And you won't be out the couple of bucks you spent on it. The bottle won't shatter, but the planet will.

The bottle says,

> — I'm just trying to save you money!
> I'm just trying to save you disappointment.
> — Well, inasmuch as...
> The bottle says,
> — I will not shatter.
> — I may shatter you.

51

Doughboy walking down the street. Film still from *Boyz n the Hood*. © 1991, 1992 Columbia Pictures Industries, Inc. Courtesy of Columbia Pictures.

Edges, Ends of Worlds, and Plastic Oceans
by Jennifer Gabrys

Edges and ends of worlds are encountered frequently in the films of Harun Farocki.[1] They form recurrent courses of navigation, tugging along ships and airplanes, riders and avatars, waves and clouds, memories and simulations. In one sequence in the nine-minute-long film *Parallel II* (2014), a rider on horseback charges toward a horizon that at once recedes and refreshes. In this scene from *Parallel II*, the narrator relates:

> Galloping swiftly out from the gate,
> how far can the rider ride?
> Where does this world end?
> This world appears infinite,
> a world generated by the gaze that falls upon it.[2]

World-ending is by now a pervasive topic. It is the default script written into the story of environmental change. Yet it is also a concept and event with a longer history. Worlds are projected to end in the face of climate breakdown, with people displaced and dispossessed from melting landscapes and submerged communities. Worlds have also continually been ending, with settler colonialism, environmental racism, and ecological exhaustion wreaking terminal destruction over the span of several centuries. The worlds and endings that are conjoining and collapsing are then many, with

Jennifer Gabrys is Chair in Media, Culture, and Environment in the Department of Sociology at the University of Cambridge, where she leads the Planetary Praxis research group. Her plastics-related research includes *Digital Rubbish: A Natural History of Electronics*, and the co-edited collection, *Accumulation: The Material Politics of Plastic*. Her work can be found at jennifergabrys.net.

different consequences for the inhabitants and relations of those worlds.

The worlds I explore here are ocean worlds. Located across the world's oceans are several sizeable concentrations of plastic debris that have variously earned the title of "garbage patches." The Great Pacific Garbage Patch in particular has become an object of popular and scientific interest. It is an environmental anecdote that confirms our worst fears about overconsumption—and the dark side of the durable wonders of plastics that were promoted in so many post-war contexts. It is also an imagined indicator of what may even outlive humans, given the lengths of time that plastics require to degrade. The garbage patch is in many ways an amorphous object, drifting through oceanic and media spaces as an ominous sign that focuses attention toward the ways in which oceans have become planet-sized land-fills. Yet it also signals a certain world-ending moment, arriving as the oceans become saturated with this synthetic and disposable material.

Popular imaginings of the Great Pacific Garbage Patch have included comparisons of its size to the state of Texas, or suggestions that it is an island that might be named an eighth continent, formed of anthropogenic debris. Upon hearing of the concentration of plastic wastes in the Pacific, many people search for visual evidence of this environmental contamination on Google Earth. Surely a human-induced geological formation of this magnitude must be visible from a satellite or aerial view? However, because plastic wastes are largely present as microplastics in the form of photo-degraded and weathered particles, the debris exists more as a suspended soup of microscopic specks that is mostly undetectable at the surface of the ocean.

While Google Earth may be a platform for visu-alizing and locating ocean data, this visualization technique presents a much different approach to "sensing" than seeing the patch as a photographic object.[3] The inability to

53

locate the garbage patches on Google Earth, a tool for scanning the seas through a conjunction of remote sensing, aerial photography, and online interfaces, even gives rise to popular controversy about how to locate the patch and whether the plastic conglomerations are actually present in the oceans—and, if so, how to address the issue. The relative invisibility and inaccessibility of the patches render them as looming imaginative figures of environmental decline that are yet relatively amorphous and unlocatable and so seemingly resistant to incentives toward environmental action. All of which raises the question: To what extent do environmental problems need to be visible in order to be actionable? Or do they instead become sense-able and navigable in different ways, less as images that raise concern and more as shifting conditions that unevenly surface and require unfolding and expanded sensing practices and tactics? As Farocki's computer game investigations indicate, modes of navigation and sensing can also become ways of constructing these worlds, including their edge conditions.

If a Google Earth or satellite view of the garbage patch proves to be an impossible undertaking, it is because the plastics suspended in oceans are not a thick choking layer of identifiable objects but more a confetti-type array of suspended plastic bits. Locating the garbage patch is on one level bound up with determining what types of plastic objects collect within it and what effects they have. Yet, on another level, locating the garbage patch involves monitoring its shifting distribution and extent in the ocean. The garbage patch is not a fixed or singular object but a society of objects in process. The composition of the garbage patch consists of plastics interacting across organisms and environments. But it also moves and collects in distinct and changing ways due to ocean currents, which are influenced by weather and climate change, as well as the turning of the earth (in the form of the Coriolis effect) and the wind-influenced direction of waves (in the form of Ekman transport). As an oceanic gyre, the garbage patch moves as

a sort of weather system, shifting during El Niño events, and changing with storms and other disturbances.[4] Ocean sensing then requires forms of monitoring that work within these fluid and changeable conditions.

The garbage patch as a figure does not directly come into view through ocean-sensing practices and technologies, but instead registers in a more indirect way, through proxy sensing. Environmental monitoring techniques, often developed for purposes other than sensing plastics, are subsequently tuned in to the drift of oceanic debris. Most sensors are set to detect the salinity, temperature, and movement of ocean currents, in order to bring patterns of climate change into view, a similarly elusive event that is not easily visualized. Rather than a *visual* fix on plastic pollution, sensing practices and technologies for monitoring environmental change instead indirectly register plastics within the mix of other environmental processes, geopolitical infrastructures, and digital devices.

The material occasions of oceans are not only a remote object of digital study, but also an actual occasion in which we are now participating and through which we will continue to be affected. Here, new societies of objects emerge from the remains of techno-scientific pursuits and in turn give rise to new monitoring practices for studying these residual and yet generative objects with unknown and indeterminate effects. A key question arises from monitoring the oceans as generative techno-scientific and computational objects: What experimental forms of politics and environmental practices might materialize that are able to attend to these indeterminate and emergent effects, which also portend the end of a world, if not this world?

Harun Farocki (with Matthias Rajmann), *Parallel II*, 2014. HD video; color, sound; 9 min (loop); Germany. © Harun Farocki GbR.

1 This is an edited excerpt. Previously
published in *e-flux journal*, no. 101 (June 2019),
https://www.e-flux.com/journal/101/272633
/ocean-sensing-and-navigating-the-end-of-this-world;
also revised and reprinted from chapter 5 of
Gabrys, *Program Earth: Environmental Sensing Tech-
nology and the Making of a Computational Planet*
(Minneapolis: University of Minnesota Press, 2016).
Courtesy of e-flux and the University of Minnesota
Press.
2 Harun Farocki, *Parallel II*, 2014. HD video;
color, sound; 8:38 min.
3 For example, see National Center for
Ecological Analysis and Synthesis, "A Global Map of
Human Impacts to Marine Ecosystems," https://
www.nceas.ucsb.edu/globalmarine. Not to be confined
to surface views of the ocean, Google Earth has
also added a "Street View" for navigating underwater.
See Underwater Earth, "Underwater Google Street
View," https://www.underwater.earth/google-under-
water-street-view; and Google Maps, Street View
Gallery #oceans, https://www.google.com/streetview
/gallery/#oceans.
4 Evan A. Howell et al., "On North Pacific
Circulation and Associated Marine Debris Con-
centration," *Marine Pollution Bulletin* 65, no. 1–3
(2012): 16–22.

ARGO buoys over the western Pacific from the ARGO Float Animation #2.
Courtesy of NASA/Goddard Space Flight Center Scientific Visualization Studio.

Seed Bead Inheritances and Other Toxicities
by Kristen Bos

Kristen Bos is assistant professor at the University of Toronto and co-director of the Technoscience Research Unit. She is an Indigenous feminist researcher trained in archaeological approaches to material culture as well as an Indigenous science, technology, and society researcher concerned with the relationship between colonial, gendered, and environmental violence. Kristen is urban Métis based in Toronto, but her homeland is northern Alberta where prairie transitions into boreal forest.

Years before I would turn to seed beads and beading as a research subject and co-conspirator, I learned, while beading with an Elder in a beading circle at the Native Women's Resource Centre of Toronto, that we did not *just* get seed beads from colonizers as is commonly thought. She shared that glass seed beads could be found long before the colonizers arrived, shimmering in the waves and washing up on the shores at water's edge. I believed her. After all, beading circles are spaces for grandmothers to share their knowledge, in person or in the beadwork themselves, across time and space *as we have always done.*[1] Evoking a time wherein "the rivers acted as our Internet—though undoubtedly at dial-up speed—and beadwork served as a guide for the territories we navigated, a map for our bloodlines, a coded knowledge for prayers and good thoughts embedded in the clothing of our loved ones."[2] Stoking time after time wherein resistance must be centered and balanced like in a good floral.

 I have been changed before in this and in other spaces, that is, "if the thread doesn't tangle and the needles don't break"—though broken needles tell us something too.[3] I don't need to reference the written records or even the genetic analyses that support "pre-colonial" and "prehistoric" relations between Indigenous peoples and others—other peoples, other lifeforms, other kin—to understand that

57

it is possible to find glass seed beads at the meetings of the water. These exchanges continue, with and without our consent.

I think of our conversation as I doomscroll through the headlines—

"Microplastics from European rivers spreading to Arctic seas, research shows," says the *Guardian*.

"Microplastics have moved into virtually every crevice on Earth," says *National Geographic*.

"Microplastics found in human blood for first time," says the *Guardian*, again.

Since time immemorial, pierced materials such as shells, turquoise, native copper, and meteoric iron have circulated between Indigenous relations. Following colonization, our beads took on new materials and relations in the form of glass. Though in English, these were known as glass seed beads, they were often "given the older names" of either *mekis* (shells) or *manidoo minens* or *mines* (spirit seeds).[4] I learn later from Jennifer Meness that the spirits of the seed beads are in their capacities for bringing us together and in how, in their loose forms, they offer us infinite possibilities. In Michif, it's *pèrl* (pearl) or *dé mémoyr dno zansèt* (stories of our ancestors).

I wonder how much of microplastics count as micro-beads. Microbeads, or "Ugelstad particles," named after the Norwegian chemist who invented and then patented his method of producing uniform polymer particulars in the late 1970s, are used as exfoliating agents in products like toothpaste, soap, and face wash. Microbeads replaced other materials like pumice, oatmeal, and walnut husks. As far as I know, they have not been given any older names. Though I think something like *oochaywaahtamwuk* (swarm), *ka pakwatutt* (enemy), or *ahkosôwin* (disease) might work.

I think of our conversation whenever I remember that microplastics refuse to dissolve and, so, they are found everywhere, especially shimmering in the waves and washing up on the shores at water's edge.

1 Leanne Betasamsoake Simpson, *As We Have Always Done: Indigenous Freedom through Radical Resistance* (Minneapolis: University of Minnesota Press, 2017).
2 Adrienne Huard, "Beads They're Sewn So Tight," *Public* 30, no. 60 (2020): 278–281.
3 Sherry Farrell Racette, "If the Thread Doesn't Tangle and the Needles Don't Break: Beading Utopia" (paper, Manidoominensagemin Toronto [we are beading in Toronto], Textile Museum of Canada, Toronto, January 25, 2019).
4 Sherry Farrell Racette, "My Grandmothers Loved to Trade: The Indigenization of European Trade Goods in Historic and Contemporary Canada," *Journal of Museum Ethnography* 20 (2008): 71.

White rabbit fur; smoked deer hide bag; Métis floral beadwork consisting of pre-1920s vintage Venetian and Parisian beads, 1920s French steel cut beads, and contemporary charlotte cut beads from India, on a piece of smoked deer hide that will become an iPhone case; beaded needle case by the artist and designed by their mentor and Master Beadworker Jennine Krauchi; beaded pin template on smoked moose hide that the artist is beading for Métis Elder and Matriarch Maria Campbell; four vials of pre-1920s French vintage seed beads; Wolf willow seed beads harvested by the artist in downtown Winnipeg; Snail shells the artist collected on the shores of Greenwater Lake in Treaty 3 Territory; Lake trout vertebrae beads from a trout caught by the artist in Treaty 3 Territory at Sherwood Lake where their dad lives; Manitoba choke-cherry dyed pickerel vertebrae beads handmade by the artist; thread cutters. Courtesy of Claire Johnston.

Imperial Serial
by Esther Leslie

"Arctic Junky: Plastic Sugar Puffs toy from 1958 washes up in the Arctic 59 years later to give a chilling warning about plastics in our ocean," declared a 2017 headline in *The Sun*.[1] The miniature replica of the RMS Mauretania had bobbed 1,500 miles from Britain to Jan Mayen Island in the Arctic, from cereal box to gutter to dump, adrift in a sea for which it was never destined. "Ahoy! A Free Toy!" was the advertising tagline, and millions of children rummaged through cereal for this booty. However insignificant and throwaway its design, the material body of this giveaway has persisted, decaying only gradually, fading from pink to cream. In fact, it outlasted the original: the (roughly) 30,000-ton Cunard-White Star. A transatlantic ocean liner, built in Birkenhead and launched in 1938, which was scrapped at Thos. W. Ward's shipbreaking yard in Fife in the mid-1960s.

Synthetic garments, like those made from Imperial Chemical Industry's Terylene—the first 100-percent synthetic fiber invented in the UK—were sold on the promise of their durability, on their ability to keep shape. Yet, with each wash, their microfibers escape into water, into the world. Plastics drift and travel, depositing on the ground, in the sea, the air, and bodies. They have a way of finding their way back to where they came from (before they were plastic, before a thousand complex processes divided and recombined them)—to the sea where crude oil is siphoned,

Esther Leslie is professor of political aesthetics at Birkbeck. Her recent work explores the biopolitical economy of dairy. She is author, in collaboration with Melanie Jackson, of *Deeper in the Pyramid* (Banner Repeater, 2018 and 2023) and *The Inextinguishable* (Limerick Biennial, 2020–2021). Her future work includes a study of Imperial Chemical Industries (ICI) and its impact in Teesside with Palgrave Pivot.

"The World of Toys," *ICI Magazine* 36, no. 266 (December 1958): 414–417.

into the rocks where natural gas is extracted, or into the ground, concentrated in landfill, where they meet the now almost exhausted stocks of coal. Burned plastic waste reappears, like geological replicas, almost indistinguishable from stones and pebbles ("plastiglomerates" or "pyroplastics") floating in the sea, washing up on beaches.[2] This, too, is a truth of plastic items—for, as much as they are durable, they are also cheap and made to be thrown away.

As the plastics disperse, so too does each item's promise of a better life. Their bold colors, their resistance to the environment, to water, wind, and sun, their capacity to form anything and everything, by tricking nature or outwitting it—and holding all this for us forever—proves to be a lie. That they persist, even as they endlessly transform or shed themselves into the environment, becomes a problem in waiting.

The December 1958 issue of Imperial Chemical Industry's in-house magazine included a three-spread graphic titled "The World of Toys."[3] Crowing about the competitive advantage of ICI's plastic toys, which beat the historically dominant German toy industry, the feature revels in new playthings on the market. Rendered in miniature, in foam, nylon, and polythene, is a world of cowboys and wild animals, of war, of speed. A build-it-yourself polythene two-masted schooner called the "Black Falcon" sits next to a B.O.A.C. Britannia airplane. A Nike rocket launcher sits next to a space missile gun with darts that "stick to their objective." Cheap, disposable toys do not disappear with childhood but rather persist, just like the imperial legacies they play at.

Vintage cars *assembled from construction kit*

The all-conquering Vanwall racing car assembled from construction kit

61

1 Holly Christodoulou, "Arctic Junky,"
The Sun, December 20, 2017, https://www.thesun.co.uk
/news/5178336/sugar-puffs-plastic-toy-1958-warning
-oceans.
2 See Madeleine Stone, "New Plastic Pollu-
tion Formed by Fire Looks like Rocks," *National
Geographic*, August 16, 2019, https://www.national-
geographic.com/environment/article/new-plastic
-polllution-formed-fire-looks-like-rocks; and Angus
Chen, "Rocks Made of Plastic Found on Hawaiian
Beach, *Science*, June 4, 2014, https://www.science
.org/content/article/rocks-made-plastic-found
-hawaiian-beach.
3 "The World of Toys," *ICI Magazine* 36, no.
266 (December 1958): 414–417.

Stone Now Cuts Like Cheese
by Adie Mitchell and Timothy Mitchell

Adie Mitchell graduated Magna
Cum Laude from Williams College,
where he was awarded the
Bruce Sanderson 1956 Prize in
Architecture. He has worked
at Yestermorrow, a design/build
school in Waitsfield, Vermont
and at Gluck+, an architect led
design build firm in New York
City. He is currently a grad-
uate student at the Princeton
University School of
Architecture.

Timothy Mitchell is a professor
at Columbia University. He
teaches and writes about colo-
nialism, political economy, the
politics of energy, and the
making of expert knowledge. His
books include *Colonising Egypt*
(University of California Press,
1991); *Rule of Experts: Egypt,
Techno-Politics, Modernity*
(University of California Press,
1991 and 2002); and *Carbon
Democracy: Political Power in
the Age of Oil* (Verso, 2011).

In November 1851, the German architect Gottfried Semper articulated the material crisis facing the arts. Semper had spent the previous year in London, helping design the Canadian, Danish, Swedish, and Ottoman pavilions at the Great Exhibition. The exhibition displayed industrial machinery and industrially-produced goods against colonial subjects and their crafts—maintaining a juxtaposition between the industrial and the primitive, colonizer and colonized. While this display of imperial confidence aimed to assert the superiority of the West, it also disguised a profound uncertainty about the materials produced by industrial civilization and the consequences of such malleable matter.

Of the industrially produced objects, Semper observed:

> We can accomplish the most intractable and laborious things with playful ease by the application of technical means borrowed from science; the hardest porphyry and granite can be cut like chalk and polished like wax, ivory can be softened and pressed into shapes, india rubber and gutta-percha can be vulcanized and used to produce deceptive imitations of carvings in wood, metal and stone, in ways which far transcend the natural domain of fabricated materials.[1]

63

Semper understood architecture's power to lie partly in the durable local customs of material use, lost now in the face of rapid industrial invention, and partly in the encounter between the "harsh, resistant material itself and the softness of the human hand"—asking what role material plays "now, when we can cut through the hardest stone like bread and cheese?" Industry rendered all materials plastic: effortlessly moldable in the hand of the architect and devoid of connection to history or place. To reveal the double impact of plasticity—that materials have lost both their resistance and their situatedness—Semper relies upon a racialized framework. "For a complete historical picture, for cultural cross-comparison, and for general reflection alike," he writes, "one only has to consider... all those works... which have been produced by peoples at a most basic level of human culture." For Semper, the plight of the arts in modern times is defined in part by their comparison to the modes of primitive production also on display at the Great Exhibition.

The Great Exhibition imagined an age of plenty that depended not only on a command of new materials but also on their ability to command the imagination. For modern architecture, this power derived from the embrace of industrial production and materials, as Le Corbusier put forward in his 1923 book *Toward a New Architecture*.[2] The power to shape the imagination was also strongly exemplified by the development of plastics. The mentality of progress—the timelessness and placelessness of the material that Semper identified—is the same one exploited by the oil industry in converting its own forms of excess and waste into ubiquitous and disposable plastics.

In *Plastic Matter,* Heather Davis explores "the ways that matter is understood to be plastic, in both the metaphorical and material senses, [and] the kinds of philosophical assumptions that fostered the conditions for plastic to emerge in the world in the first place." The concept of plastic matter, Davis writes, "speaks to how the materiality of plastic has been imposed on to our expectations of matter

more broadly, how matter itself has come to be produced as inherently pliable, disposable, and consumable."[3] This mentality results in a spatial dislocation organized along the same colonial lines as the 1851 Great Exhibition; the places and races of colonial subjugation in Semper's day now bear the brunt of the environmental and health burden of our plastic mentality, in which the perceived malleability and disposability of matter underwrite an ethics of discard and waste. Since architects, too, are guilty of plastic thinking, and have indeed largely embraced it since the rise of modernism, architecture itself depends upon a willful blindness around these spatial arrangements.

Our spatial blindness around plastic is accompanied by a temporal blindness. In her study of synthetic chemistry, the scientific discipline that grew up around making use of the waste products of the petroleum industry, Bernadette Bensaude-Vincent observes that plastic has been labeled as both malleable and ephemeral. These properties of plastic, however, are largely epistemic rather than physical. Most plastics are, in fact, long-lasting and difficult to remold. Bensaude-Vincent writes,

> The ephemeral present of plastics, is not just an instant detached from the past and the future. It is the tip of a heap of memory, the upper layer of many layers of the past that have resulted in crude oil stored in the depths of the soil and the sea. The cult of impermanence and change has been built on a deliberate blindness regarding the continuity between the past and the future.[4]

Recognizing the temporal connections of the materials we use, then, becomes a way to work against plastic thinking.

The oil industry is banking on the failure of political institutions and the discipline of architecture to engage with the temporal and spatial blindness of plastic thinking. In *The Future of Petrochemicals,* the International Energy Agency estimates that, in the United States and Europe, the per capita consumption of fossil fuels due to the use of plastic will, by 2050, far outstrip consumption for transporta-

tion.[5] The oil major BP recently predicted that 95 percent of the growth in demand for oil between now and the year 2040 will come from plastics.[6] It may seem that the discourse around the future of architecture in 1851 could hardly resemble contemporary debates. However, the concerns with materials and production that preoccupied Semper after the Great Exhibition offer a way to understand how architecture is embedded in the world today: its material networks and its connections to colonial pasts, imperial presents, and environmental futures.

1 Gottfried Semper, "Science, Industry and Art," in *The Four Elements of Architecture and Other Writings*, trans. Harry Francis Mallgrave and Wolfgang Herrmann (Cambridge: Cambridge University Press, 2011), 130–167.
2 Le Corbusier, *Toward a New Architecture* (Mineola, NY: Dover Publications, 2013), 18.
3 Heather Davis, *Plastic Matter* (Durham, NC: Duke University Press, 2022), 9.
4 Bernadette Bensaude-Vincent, "Plastics, Materials and Dreams of Dematerialization," in *Accumulation: The Material Politics of Plastic*, ed. Jennifer Gabrys, Gay Hawkins, and Mike Michael (London: Routledge, 2017), 24.
5 International Energy Agency, *The Future of Petrochemicals: Towards More Sustainable Plastics and Fertilisers* (Paris: International Energy Agency, 2018), 97.
6 David Roberts, "Big Oil's Hopes Are Pinned on Plastics. It Won't End Well," *Vox*, October 28, 2020, https://www.vox.com/energy-and-environment/21419505/oil-gas-price-plastics-peak-climate-change.

In Place Of
by Terry Schwarz

Terry Schwarz is Director
of the Cleveland Urban Design
Collaborative at Kent State
University. Her work includes
neighborhood planning, commer-
cial design guidelines, and
ecological strategies for land
reuse. She leads the CUDC's
Shrinking Cities Institute,
which focuses on the implica-
tions of population decline
and large-scale urban vacancy
in Northeast Ohio.

In *Cradle to Cradle*, architect William McDonough describes pollutants as misplaced materials.[1] Carbon, for example, doesn't belong in the atmosphere, where it traps the sun's energy and contributes to global warming. Carbon belongs in the soil, where it supports plant life and, by extension, feeds the entire world. This framework of belonging—for understanding the harms and possibilities of materials as they relate to place—echoes the work of anthropologist Mary Douglas who argues that what we classify as "waste" is determined by context, rather than by the intrinsic characteristics of the materials in question.[2]

So what is the place of plastic? Unlike carbon, plastic is a human invention, one that has become both deeply embedded in the built environment and increasingly unwelcome, especially when used in the wrong forms and concentrations and in all the wrong places. We've constructed our own reliance on it without much attention to context, or to where it might belong and not belong. When plastics emerged in the 1920s, they often mimicked the appearance and function of wood, glass, ivory, and other natural building materials in ways that conformed to consumer preferences. Over time, however, the adaptability and low cost of plastic led to its widespread use, not just because of what it could replace (or displace) but also because of what it could enable.

67

PVC pipes deliver water efficiently and affordably to millions of people every day; plastic particles contaminate the water supply, infiltrate our blood streams, and damage our DNA. Plastics encase the fiber optic cables and power grids that make modern telecommunications possible; discarded devices accumulate in landfills and leach carcinogens into the water table. Airplanes, trains, and cars made of durable, lightweight plastics move people and products across great distances; hazardous fumes from the plastics manufacturing process cause respiratory illnesses, eye irritation, and nervous system damage. People rely on plastic and ignore, or tacitly accept, the negative consequences. How do we reconcile the harm and possibilities attendant to these materials, or the opposing but interconnected forces at work in plastic cities?

Perhaps it's too late. Plastic is everywhere. Buildings may be clad in wood, metal, or masonry, but plastic is always there—in the walls, windows, structural members, coatings, fasteners, furnishings, plumbing, and mechanical systems. City trees and urban landscapes depend on plastic for irrigation and drainage, and plastic permeates urban infrastructure networks. Cities also manage and export vast amounts of plastic waste. Most of this plastic will never fully disappear; it just gets smaller and smaller, infiltrating water bodies and human bodies at an alarming rate.

If the boundaries between people and plastic have been irretrievably breached, are there ways to embrace, contain, and transform plastics—and by extension, our cities—differently, away from harm? Would it be possible, for instance, to filter plastic particles out of the Great Lakes and aggregate them into building materials to address global housing shortages? Could single-use plastic bags be extracted from landfills and woven into landscape fabrics that protect against shoreline erosion and sea level rise in coastal communities? With all respect for reality, can we envision a radically different future in which plastics are used sparingly, responsibly, and with a full reckoning of their costs and their benefits? This would require not only

remaking or retrofitting almost every aspect of the built environment but also rethinking our entire relationship to "use." Is changing the context of plastic waste or redirecting the processes for which plastic is useful a place to start?

In addition to changes at the urban scale, perhaps humans need to become more malleable in response to our increasingly plasticized communities. Phenotypic plasticity refers to the ways that organisms change their behavior, shape, and physiology in response to a unique environment. In other words, if people are to flourish in plastic cities, we may need to remold ourselves and adapt to new realities. Plastic in many ways is humble and versatile—virtues to embrace as we reorganize the world and adapt to altered environments.

1 William McDonough and Michael Braungart, *Cradle to Cradle: Remaking the Way We Make Things* (London: Vintage Classics, 2009).
2 Mary Douglas, *Purity and Danger: An Analysis of Concepts of Pollution and Taboo* (London: Routledge Classics, 1966).

The Racial Logic of Impressibility
by Kyla Schuller

Plasticity comprises the capacity to change, to be molded, to radically deform and transform under pressure while miraculously retaining self-sameness. Instead of falling apart, plasticity persists in the face of destruction. It may even condense the miracle of life itself—potentiality crystallized, the materialization of growth and change.

 As a concept, plasticity describes these fantastical capacities of matter. Yet plasticity simultaneously has a politics. Ideas about the qualities of matter and the potentiality of life itself are far from neutral. Rather, they are foundational to the modern practice of power and sovereignty, to what Michel Foucault called "biopolitics," which grants life to some and leaves others to die.[1] Western metaphysics depends upon a plastic body, as articulated most famously in the Lockean idea that babies arrive as impressible blank slates. In this schema, growth and progress depend on a person's responsiveness to the environment around them, as well as their capacity to absorb the effects of these sensory impressions over time. Yet qualities praised as "human" in the abstract have often been restricted (i.e. limited to only some humans) in practice. Plasticity is a battleground.

 Plasticity structures the modern, biological logic of race. When nineteenth-century race scientists, including Louis Agassiz and Edward Drinker Cope, codified race as a state of profound physical difference, they relied on an

Kyla Schuller is associate professor of women's, gender, and sexuality studies at Rutgers University—New Brunswick. She is author of *The Biopolitics of Feeling: Race, Sex, and Science in the Nineteenth Century* (Duke University Press, 2018) and *The Trouble with White Women: A Counterhistory of Feminism* (Bold Type, 2021).

70

alleged unequal capacity to receive impressions. For Cope, "fine nervous susceptibility" and "mental force" were the exclusive features of Indo-Europeans.[2] Whiteness came to signify "the capacity for capacity," writes queer theorist Jasbir Puar—pure potentiality rendered in human form.[3]

This modern framework of biological racial difference—used to justify racism and white supremacy—denied the capacity of plasticity to colonial subjects and non-white people. People of color were considered immutable in body and mind, insensitive and incapable of absorbing impressions over time. Cope, for example, condemned African American bodies as "dead material" housing a "mind stagnated" by a life of "fleshly instincts."[4] Blackness became allegedly inert or hyperreactive matter, raw material (at best) capable of being molded and manipulated, especially through labor, but incapable of dynamic change on its own. Rather than a blank slate, Black life came to signify "flesh." "Before the 'body,' there is 'flesh,'" writes Black feminist theorist Hortense Spillers, "that zero degree of social conceptualization," the state of being stripped of social meaning, that attempted to hold captive and deny the possibility of growth.[5] Envisioned as unable to accumulate experience, captive Black flesh became capitalism's "living laboratory," a site of "total objectification," for extraction, in the form of slavery, of medical experimentation, and of the economies which they built. Meanwhile, the scientific theory that Blackness was a hardened state benumbed to progress radiated outward, shaping an anti-Black modernity that stigmatized and delimited, among other aspects, Black people's relation to pain, intellect, and criminality.

Plastic materials and environments extend the racist and colonial dynamics of plasticity into new arenas. Currently, the toxic burden of plastic accumulates in the Global South as islands in the ocean and as endocrine disrupters in the glands. Yet this movement can also open up ways to reconceptualize the body and power altogether. Anthropologist Vanessa Agard-Jones draws on interviews with people in Martinique concerned about the little-

71

regulated flow of toxins throughout their bodies and land. In her hands, plasticity becomes a tool of interrogating, rather than reproducing, power. How bodies take shape in dynamic relation with the chemical products of the post-colonial economy exposes "the multiple levels at which our material entanglements—be they cellular, chemical, or commercial—might be connected to global politics."[6] As it forms and deforms, blending the line between bodies and materials, plasticity crystallizes as the interface between life and power.

1 Michel Foucault, *"Society Must Be Defended": Lectures at the Collège de France, 1975–1976*, trans. David Macey (New York: Picador, 2003).
2 E. D. Cope, "Two Perils of the Indo-European" (part 1 of 2), *Open Court* 3, no. 126 (1889): 2054.
3 Jasbir K. Puar, *Terrorist Assemblages: Homonationalism in Queer Times* (Durham, NC: Duke University Press, 2007), 199.
4 Cope, "Two Perils," 2054.
5 Hortense Spillers, "Mama's Baby, Papa's Maybe: An American Grammar Book," *Diacritics* 17, no. 2 (1987): 67–68.
6 Vanessa Agard-Jones, "Bodies in the System," *Small Axe* 17, no. 3 (2013): 192.

Rebirth Garments
by Sky Cubacub

Sky Cubacub (They/Them/Xey/
Xem/Xyr) is a nonbinary
disabled Filipinx neuroqueer
from Chicago, IL. Xey are
the creator of Rebirth
Garments, an activewear line
for trans and queer disabled
people of all sizes and
ages, which started in summer
2014. Named *Chicago Tribune*'s
2018 Chicagoan of the Year.

Rebirth Garments specializes in making swimwear, dance-wear, and athleticwear for queer and trans disabled folks of all sizes and ages. I started the clothing line in the summer of 2014, when there were very few gender-affirming under-garment options and even fewer swimwear options available. In surveys I've both seen and conducted, the number one desire from trans folks that is still unmet by the fashion industry is gender-affirming swimwear. Trying to meet this need, Rebirth Garments almost exclusively uses spandex and a compression material called powernet (a nylon/spandex blend).

I first dreamed of this clothing line when I was in my sophomore year of high school in 2008. I was under eighteen, and I couldn't find a place to buy a chest binder (a garment for compressing the chest). I also didn't have access to a credit card to buy one online. At the time, all the leading trans undergarment lines adhered to now out-dated pre-/post-operative surgical thinking, using categori-zations like FTM (female to male) or MTF (male to female) that conformed to binary frameworks. I was also unsatisfied with how boring the options were. Everything was largely white, black, or beige. I wanted something that was celebra-tory of my identities, something that made me feel cute and seen at the same time. Later, when I turned twenty-one, I gained a stomach/digestion disability tied to my polycystic

ovarian syndrome. I was unable to wear most of my clothing because of their lack of stretch, or their very tight elastic waistbands that aggravated my stomach. I started making myself soft stretchy things to wear, sometimes with the seams on the outside in order to accommodate my lifelong sensory sensitivities. I figured that if I, a nonbinary disabled person, was struggling to have both my physical and emotional needs met by mainstream fashion, then maybe others were too. Maybe others would want custom-made clothing that celebrated all of their identities.

While we should all do what we can to use fewer petroleum products, there are just some things that we currently don't have the option of making in a truly eco-friendly way. Disability access should be the last place to eliminate plastics as we work toward cutting them out in other parts of life. We might work with powernet, but Rebirth Garments makes less than 1,000 garments a year in our own studio, by myself and a couple of neurodivergent and/or disabled queers. Compared to companies like Zara, which produce over 1 million garments a day on their own, in sweatshops, with primarily white, cis, thin, nondisabled people in mind, Rebirth Garments takes a more collective and intimate approach to accessibility. By staying small, our process is able to honor the needs of every individual while resisting the often individualized burden of self-care. Models and clients who are interested are interviewed; they are asked what their custom dream clothing would be, what would make clothing more accessible to them, what would make clothing more gender affirming. Every garment is handmade, every piece custom designed to the client's measurements, accessibility needs, and aesthetic preferences.

The fashion industry has purposely separated us from the knowledge needed to create and tailor our own garments in order to force a reliance on it; it lacks transparency, devalues the labor put into garment-making, and designs garments to fall apart after a season so that we can't escape the cycle. Fashion schools are just as guilty: they teach you not to question the status quo.

In the last year, I have been pivoting the focus of my work to teaching youth how to create their own intersectional clothing lines. I gained myalgic encephalomyelitis/chronic fatigue syndrome (ME/CFS) in December 2019, which has impacted my energy and production, and I have had to severely limit my offerings and close my shop often in order to try to not exacerbate my health. Focusing on teaching the new generation of designers is what is giving me hope for the future and makes me feel like they can fill in the gaps that I am currently leaving.

75

Photograph by Colectivo Multipolar.
Courtesy of the author.

Intimate Synthetic Entanglements
by Ani Liu

Shortly after I finished breastfeeding my son, I learned that researchers had found microplastics in human breastmilk.[1] It was a startling revelation; like many mothers, I went to great lengths to breastfeed. Considered one of the most nutritious foods for a baby, breastmilk is custom made by the lactating body for each individual baby. In addition to calories and vitamins, it contains antibodies and culture-specific flavor molecules.[2] And as I now know, also tiny particles of polyethylene, polyvinyl chloride, and polypropylene.

We have colonized the Earth with plastics, and now these plastics are colonizing our bodies in the most intimate of ways. Microplastics have been found in our blood,[3] our lungs, even our placentas.[4] Even more intimately, some plastic molecules mimic the shape of our own hormones, becoming endocrine disruptors. Bisphenol A (BPA), polyfluoroalkyl substances (PFAS), and phthalates have a molecular shape so similar to hormone structures that our bodies are tricked into thinking they *are* hormones. This is a kind of simulation with real implications—it can block our hormones from functioning correctly and can cause cancer, diabetes, neurological impairment, and reproductive disorders.

While the effects of our industrial processes on climate change and ecological destruction are well known, most people turn a blind eye until the realization that plastic colonization has infiltrated their own bodies. These

Ani Liu is an internationally exhibiting research-based artist working at the intersection of art and science. Ani's work examines the reciprocal relationships between science, technology, human subjectivity, culture, and identity. Reoccurring themes in the work include gender politics, bio-politics, labor, reproduction, simulation, and sexuality.

individualistic beliefs are harmful: after all, we live in a complexly woven net of interdependence. What is considered an individual body is actually a rich community of other species we call a microbiome, which we could not survive without. To thrive, we exist in an ecology of cooperation, in complex relationships beyond human to human: with plants, animals, fungi, microorganisms, minerals, climate. The impact of our activities on these entities should be enough to awaken us to change, but perhaps it is not until our own bodies are notably impacted that we feel compelled to change.

That microplastics exist in placentas and breastmilk entered my news feed around the same time that abortion rights were challenged in the United States. Where I live, the constitutional right to abortion ended in 2022 when the Supreme Court abandoned its duty to protect this fundamental right. So, what of plastics and bans? These two simultaneous realities swirl together in my head: we are forcing people with uteruses to bear and care for children as our capacity to care for our planet—and even for ourselves—is strained. In the context of both plastics and reproductive rights, seemingly intimate acts between bodies are urgently re-entangled into the larger systems they exist in. The private body *and* the social body are both compromised in these toxic transgressions.

In recent years, the rallying cry for bodily autonomy, "My Body My Choice!," has come to mean many things for many people across the political spectrum. For some, it remains the ability to choose healthcare for one's own uterus, including abortion; for others, the ability to choose whether or not to receive a vaccine. And yet, as microplastics and endocrine disruptors course through our bodies, it also signifies no choice at all—or, rather, to what shouldn't be a choice at all: the collective, shared *right* to parent or remain childfree "in safe and healthy environments."[5]

1 In a study published last year in *Polymers*, researchers detected microplastic contamination in the majority of breastmilk samples from healthy mothers. See Antonio Ragusa et al., "Raman Microspectroscopy Detection and Characterisation of Microplastics in Human Breast Milk," *Polymers* 14, no. 13 (2022): 2700–2713.

2 Joanne M. Spahn et al., "Influence of Maternal Diet on Flavor Transfer to Amniotic Fluid and Breast Milk and Children's Responses: A Systematic Review," *The American Journal of Clinical Nutrition* 109, no. 1 (2019): 1003–1026.

3 R. L. Kuhlman, "Discovery and Quantification of Plastic Particle Pollution in Human Blood," *Environment International* 167 (2022): 107199–107206.

4 Antonio Ragusa et al., "Plasticenta: First Evidence of Microplastics in Human Placenta," *Environment International* 146 (2021): 106274–106281.

5 Loretta J. Ross and Rickie Solinger, *Reproductive Justice: An Introduction* (Berkeley: University of California Press, 2017), 9.

Picking Our Poison
by Ayesha A. Siddiqi

Ayesha A. Siddiqi is a writer
and creative strategist special-
izing in trend forecasting.
Called a "wunderkind producer"
and "cultural oracle," she
has been profiled in the *New York
Times*, *Politico*, the *Guardian*,
Elle magazine, and the Columbia
Journal of Literary Criticism.
She has developed projects for
film and television and provi-
des art direction and strategy
for brands. Ayesha is the editor
in chief of *The New Inquiry*.

Plastics have a long history and, evidently, an even longer future. The word "microplastic" was coined in 2004, fifty-one years after General Electric and Bayer began developing polycarbonate, fifty-four years after DuPont began manufacturing polyester, and sixty-two years after Dow Chemical built a polystyrene plant. These innovations changed the world. And the post-World War II boom in manufacturing and consumption would only accelerate that change. Plastic was always known to have a range of forms and uses— the discovery of microplastics has proven the material can swirl like wind, fall like rain, be absorbed like nutrients, all while invisible to us. Microplastics have been found in the ground and in our blood. One can imagine them atomizing in the air with every twist of a plastic bottle cap, every snap of a Styrofoam clamshell food container.

Microplastics are everywhere, because plastic is everywhere and it reduces into specks so small they become aerosol. This fact lends microplastics an air of inevitability, which can come as a kind of bitter relief. To remain nourished as a human is challenging enough without the added rigor of avoiding poison. Microplastics join "heavy metals" and other toxins on the list of ambient threats to health I can only shrug at or close my hands in prayer against. The average body in the United States is a testament to the absence of regulations and consumer protections in this

79

country. My parents live in an area where the tap water isn't safe to drink. They rely on water delivered in plastic bottles. Indeed, within the free market economy, the phrase "pick your poison" can be applied literally to any choice those in the US might make regarding what we put on, in, or near our bodies. Disrupting our internal systems, creating cancer in our cells, microplastics may prove to be to our human bodies what human bodies are to Earth. Wouldn't that be a tidy metaphor? It's an exculpatory impulse, to imbue environmental stressors with the wisdom of karma—as if it were our choices creating the consequences, as if the consequences were delivered equitably.

The US is among the top producers of plastic waste in the world. The highest concentration of microplastics in the world are in the beaches and waters of the Maldives, a tiny archipelago in the Indian Ocean. In addition to an ecosystem being choked by plastic, the Maldives are at risk of drowning in sea levels rising as a result of climate change, driven by consumption habits that occur far from them. Ancient civilizations can be tracked along water routes. Likewise, the flow of plastics reveals a historical record too: who eats and who gets shit on.

before / another
by Stephanie Ginese

Stephanie Ginese is an author,
workshop instructor, and stand-
up comedian from South Lorain,
Ohio. Her debut collection of
poetry, *Unto Dogs*, was released
in July of 2022 on Grieveland.
She currently lives in Cleveland
with her two children. She
can be found at www.sginese.com.

birds & flowers make for better poems than this /
especially ones with names that require some research
when read or heard / everyone wants to read about
the bird perching or cooing in the novelty of morning /
what if instead of cooing / the bird coughed /
the moment before its petty heart seized / the moment
after the explosion / the moment the smoke plumed
unlike any feathers you've seen before /

the only truth: a grim plastic nebula has swallowed
the sky

& what of the water below

sterling fish bloat to the surface / of the sheened river /
the moment before the rain poisons / down on this town /
automobiles peel like eager fruit / small eyes burn
from the gas of a strange future / that only guarantees a
vacant field jeweled with the orange pill bottles / the
eyes' father left behind—

in another moment / in another part / in another
explosion / there's another bird / too choked
to whistle a last song / flakes of alloy alley oop like
seed pods in the wind /

 past a window where Ziploc bags are
 being washed in hot leaded water
 / reduce / reuse / residue /
 on the counter, plastic butter containers
 cupping day-old beans
 white clumps of rice
 leftover ensalada de papas
 memories of a home hugged by water
 never any butter in them
 like the cookie tin that promised the riches
 & distance of Danish cookies
 but there were never any inside
 just needle, thread & the pin cushion that
 looks like a tomato / red as the light

 of a railroad signal in Ohio.

The Ontological Slippage and the Amassing Utility of Blackness
by Zakiyyah Iman Jackson

Zakiyyah Iman Jackson is
associate professor of English
at the University of South-
ern California and author of
the multi-award winning book,
*Becoming Human: Matter and
Meaning in an Antiblack World*
(NYU Press, 2020). Professor
Jackson is at work on a new book,
*Obscure Light: Blackness and
the Derangement of Sex/Gender*.
Her articles can be found at:
www.zakiyyahimanjackson.com.

While scholars of race have critiqued the conflation of black-
(ened) humans with animals, objects, and machines in
Enlightenment discourses, my concept of ontologized plasti-
cization reframes the confluence of blackness and the
nonhuman. My book *Becoming Human: Matter and Meaning
in an Antiblack World* reinterprets Enlightenment thought
not as black "exclusion" or "denied humanity" but rather as
the violent imposition and appropriation—inclusion and
recognition—of black(ened) humanity in the interest of plas-
ticizing that very humanity, whereby "the animal" or "the
machine" is one among many possible forms that blackness
is thought to encompass.

Ontologized plasticization does not refer to the
unnatural ordering of man and beast, simple objectification,
or interchangeability, replaceability, or exchangeability.
It is not the conceptualization of how an asset is understood
as being of equal value to another. In other words, it is
not a conception of the commodity and its uses. It is not a
conceptualization of property—but of the properties of
form. Ontologized plasticization critically engages the philo-
sophical concept of "hylomorphism," or the form-matter
distinction. Ontologized plasticization is a conceptualization
of form itself rather than a conceptualization of how a
form is taken up within the logics of law, economic markets,
or political economies. It is a mode of transmogrification

83

whereby the fleshy being of blackness is experimented with as if it were infinitely malleable lexical and biological matter— a form where form shall not hold. Consequently, blackness is produced as human, subhuman, and suprahuman at once. The "at once" here is important: it denotes immediacy and simultaneity. Blackness, in this case, functions not simply as negative relation but as a plastic, fleshy being that stabilizes and gives form to "human" and "nonhuman" as categories. It is precisely via blackness's inability to access conceptual and material stability other than by functioning *as* ontological instability for the reigning order that categorical forms such as "animal" and "machine" amass the semblance of both definitional clarity and endogenous coherence.

To put it another way, the concept of ontologized plasticization maintains that black(ened) people are not so much dehumanized, cast as nonhumans or as liminal humans, nor framed as animal-like or machine-like or simply exchangeable with these nonhuman forms, as they are rather cast as subhuman, suprahuman, and human *simultaneously* and in a manner that puts being in peril—because the operations of simultaneously being any-thing and no-thing for a given order constructs black(ened) humanity as the privation and exorbitance of form. The demand for willed *privation and exorbitance* that I describe does not take the structure of serialized demands for serialized states but rather demands that black(ened) humanity be all forms and no form simultaneously: human, animal, machine, object... In other words, plasticization, here, is a mode of ontologizing not at all deterred by the self-regulation of matter or its limits, nor by the fragility and finitude of the corporeal form we call "black."

Black studies scholars have often interpreted the predicament of black(ened) being in relation to either liminality (movement from one state to another state), interstice (being in between states), or partial states. What the concept of ontologized plasticization suggests is that these appearances are undergirded by a demand that

tends towards the fluidification of state or ontology. This demand for statelessness collapses a distinction between the virtual and the actual, and abstract potential and situated possibility, whereby the abstraction of blackness is enfleshed through an ongoing process of wresting form from matter. Antiblackness's materialization is that of a de-materializing virtuality.

Hartman, Saidiya. *Scenes of Subjection: Terror, Slavery, and Self-Making in Nineteenth-Century America*. New York: Oxford University Press, 1997.

Jackson, Zakiyyah Iman. "Animal: New Directions in the Theorization of Race and Posthumanism." *Feminist Studies* 39, no. 3 (2013): 669–685.

Jackson, Zakiyyah Iman. "Outer Worlds: The Persistence of Race in Movement 'Beyond the Human.'" *GLQ: A Journal of Lesbian and Gay Studies* 21, no. 2 (2015): 215–218.

Jackson, Zakiyyah Iman. *Becoming Human: Matter and Meaning in an Antiblack World*. New York: New York University Press, 2020.

Malabou, Catherine. *Plasticity at the Dusk of Writing: Dialectic, Destruction, Deconstruction*. Translated by Carolyn Shread. New York: Columbia University Press, 2009.

Moten, Fred. *In the Break: The Aesthetics of the Black Radical Tradition*. Minneapolis: University of Minnesota Press, 2003.

Spillers, Hortense. "Interstices: A Small Drama of Words." In *Pleasure and Danger: Exploring Female Sexuality*, edited by Carole S. Vance, 73–100. Boston: Routledge & K. Paul, 1984.

Weheliye, Alexander G. *Habeas Viscus: Racializing Assemblages, Biopolitics, and Black Feminist Theories of the Human*. Durham, NC: Duke University Press, 2014.

Wynter, Sylvia. "Unsettling the Coloniality of Being/Power/Truth/Freedom: Towards the Human, after Man, Its Overrepresentation—An Argument." *CR: The New Centennial Review* 3, no. 3 (2003): 257–337.

LeCreebusier Encounters the Plastic "Other"
by K. Jake Chakasim

LeCreebusier, the Indigenous Trickster, unearths a discarded phoropter, a thing of the past that can quickly determine the exact vision correction needed to readjust the twenty-first century Indigenous gaze.[1] What the plastic-lens space-age visor reveals is a contemporary "resistance structure" of a different kind, one that still carries remnants of "Otherness"—that is, the "white male" construct that *layers* and *speaks to* (but not from) Indigenous lands, all the while informed by the resurgence and reclamation of Indigenous identity that seeks to mediate the impact of global civilization.[2] This is a structure that comes to terms with not only the proliferation of twenty-first-century materiality but also a settler and diasporic ideology that is scattered across the Native American Indigenous landscape. An extractive resource industry has provided very little relief to temporary comforts in the form of standardized building products and a plethora of discarded "plastic emotions and emotives." Plastic is informed by the quality of disbarment (by the wayside, discarded, packaged, barcoded, and shipped throughout the world). It's no wonder LeCreebusier is left standing on their head trying to make sense of the realities on the ground, all while those holding the economic reconciliation purse strings in federal positions continue to make uninformed policy decisions about the preservation of culture and livelihood of Indigenous peoples. Is it a coincidence

K. Jake Chakasim is a Cree designer from the Mushkegowuk Territory, located in Northern Ontario, Canada. His approach to community design is interdisciplinary, informed by architecture, engineering and Indigenous planning principles. He is cross-appointed with Carleton University's Azrieli School of Architecture and the School of Indigenous and Canadian Studies.

that LeCreebusier dually questions and exposes a financial sleight-of-hand, that is, the tokenistic flip side of truth and reconciliation, which happens to be nothing more than the latest form of trickery offered up by the Canadian government? I think not!

For many Indigenous communities, there is a certain way of being in the world that is built upon intergenerational Indigenous knowledge. From a Cree perspective, to practice one's *wapimisow*[3] is a way to think of the phoropter as a "reflexive strategy'"—again a kind of Indigenous "resistance structure" born out of an awareness of time that draws our attention back to the northern landscape and then forward in the direction of the metropolis, only to repeat itself from place to place, from generation to generation, from existence to near extinction, and, finally, from adaptation to survival. And that's only a surface analysis based on what LeCreebusier sees taking place "inside the community," that is, the federally regulated Indian Reservation border— deemed emotive constructs of the mind—or the attitude that Indians need and continue to be contained. What occurs outside the community, beyond the borderlands out on the land, is where the real cultural action (and inaction) takes place.

I emphasize "inaction" because there has been an influx of unnatural materials, foreign assemblages, and consumerism into Indigenous communities that has disparagingly contaminated, gamified, and altered our way of life and supporting ecosystems. These discarded items never seem to recede, be reclaimed, or recycled through acts of Indigenous stewardship. In fact, many communities believe it's far more valuable to extract and export natural resources than it is to reclaim and restore the landscape that seeded our Indigenous knowledge. What results is a further decentering of Indigenous living, away from the natural and into an abysmal synthetic sea of compounds, components, and heterogeneous elements imported and made elsewhere. Take, for instance, the Canada Goose jacket: a luxury brand worn everywhere around the world from urban

business districts to major cultural festivals.[4] Akin to trick-
ster narratives, it's often hard to sort out truth from fiction
when it comes to accurate information about how synthetic
down vis-à-vis natural feathers are sourced. This further
problematizes not only the sustenance of Cree societies and
their ecological relationship to the migratory goose (*niska*)
but also how the company ethically goes about sourcing
goose down feathers, not to mention coyote fur (the coyote
happens to be trickster archetype too) for its jackets. As
the popularity of Canada Goose jackets continues to grow,
so too has the backlash against them. Especially when
the jacket has become a diasporic status symbol predicated
on an embroidered sleeve patch that has nothing to do
with *Kanata* (the name "Canada" is derived from this Huron-
Iroquois word, meaning "village" or "settlement") as a place
but, rather, with the onslaught of a meaningless synthetic
material culture that, for one, is dominated by animal cruelty
and, secondly, overshadows the genocidal atrocities
inflicted upon Indigenous peoples in the form of American
Indian boarding schools and Indian Residential Schools,
institutions that were established and carried out by US and
Canadian state governments with aid from Vatican Christian
Missionaries. Thank you very much, plastic Jesus!

 As we Indigenous people strive to live and maintain
our semi-nomadic lifestyles between seasonal hunting
camps and inadequate housing on Indian Reservation lands
often funded by the federal government, one must wonder
how we can maintain our Indigenous sensibility when we
are assailants in the environmental crises that lay before us.
Whether by way of shotgun shells and their plastic casings,
forever scattered across Indigenous lands, or discarded
Jerry gas cans used as target practice devices, we too have
become a detriment to the environment. We also use
plastic-laden (oil-based) geese, deer, and duck decoys in
place of the handmade artifacts that preserve the tactile
importance and wisdom of Indigenous knowledge. Indeed,
as Indigenous hunters grapple with the demands of global
commodification and standardization—using plastic lumi-

nant materials, camouflage tarps in place of (animal) skins, and plastic laminate flooring in place of natural flooring materials—Indigenous communities are under increasing pressure to alter and adapt their Indigeneity in the hope of keeping pace with an ever-changing world. But the situation is one in which Indigenous hunter-gatherers have haphazardly warpainted themselves into the center of the circle and can't seem to get out.

Embracing change, the Cree trickster must discard the phoropter to adjust their gaze—*from the oral to the tactile, the tactical to the visual, and now the visual to the digital*. LeCreebusier hears an "unceded voice from the land" come through on Spotify. "Is anybody out there?" A voice of adolescence emerges—it is Chakabush, another Cree Trickster. "I've got the latest LG tablet with my sketches in. Got a St. Anne's Indian Residential School bag, a plastic toothbrush, and a comb. When I'm a good boy the augurs sometimes throw me a bone. I got elastic bands keeping my moccasins on. Got swollen hand blues. I've got thirteen channels of shit on my plastic Smart TV to choose from. I've got electric lights. And I've got second sight. I've got amazing powers of observation."[5] Imagination. Transformation. Reclamation. "But oh, lately, that addictive impulse to pick up the phone says, 'There's nobody home.'" And should we be surprised when, in fact, the plastic Other is here to stay?

89

K. Jake Chakasim, *WAPIMISOW: Trickster Builds A Nest for the End of the World* (detail), 2020. Charred tipi poles with locally sourced materials. Installation view of *Nest for the End of the World*, Alberta Gallery of Alberta, 2020. Photographs by Charles Cousins.

1 The concept of the "gaze" within Indigenous
architecture interrogates it from historical, cultu-
ral, and ontological standpoints—addressing the
Indigenization of the architectural image as a means
for decolonizing the field of design and contem-
porary architecture studies.
2 Kenneth Frampton's "critical regionalism"
proposes a segue into Indigenous architecture
as a register for dialogue between Indigeneity and
the forces of globalism. As John McMinn and Marco
L. Polo suggest, it serves as an important model for
a contemporary (Indigenous) architectural criticism
that not only challenges the status quo but also
reinforces cultural practices. Parentheses added are
my own. The framework participates in a broader
critical discourse by engaging with sustainability
not only as a technique or method but also as a
cultural paradigm inspiring contemporary theorists
to establish their own distinctive cultural forms,
voices, and identities, and reacting to those who
already do so. Hence, the imaginary Cree Trickster
LeCreebusier. See John McMinn and Marco L. Polo, *41°
to 66°: Regional Response to Sustainable Architec-
ture in Canada* (Cambridge, ON: Cambridge Galleries/
Design at Riverside, 2005).
3 The cultural term applied, *wapimisow,* is an
Omushkegowuk Cree term used to describe the ability
to see a reflection of oneself physically, mentally,
and/or in a premeditated form.
4 Our Changing Climate, "The Problem with
Canada Goose," video, 7:03, *YouTube*, July 15, 2019,
https://www.youtube.com/watch?v=v-Ik89bbHRk.
5 Quote inspired by Pink Floyd's "Is There
Anybody out There?" and "Nobody Home" from their
concept album *The Wall*, which explores abandonment
and isolation. Severing family relations, leading to
cultural isolation and feelings of abandonment, was
a procedure and psychological practice used by the
Church and state governments to isolate Indigenous
children from the influence of their own culture and
spirituality, in order to assimilate them into the
dominant US and Canadian cultures.

K. Jake Chakasim, *WAPIMISOW: Trickster Builds A Nest for the End of
the World*, 2020. Chakabush, Cree Trickster. The amber Cree syllabics
translate to *wapimisow*. Courtesy of the author.

Plastic: A Life Sketch
by Rania Ghosn

Rania Ghosn is associate pro-
fessor of architecture and
urbanism at the Massachusetts
Institute of Technology and
founding partner, with El
Hadi Jazairy, of DESIGN EARTH.
The work of DESIGN EARTH has
been published and exhibit-
ed internationally—recently
at the Venice Architecture
Biennale, Bauhaus Museum
Dessau, and San Francisco
Museum of Modern Art—and is
in the New York Museum of
Modern Art permanent collec-
tion. Ghosn and Jazairy
are authors of *Geostories:
Another Architecture for the
Environment* (3rd ed. 2022;
2018); *Geographies of Trash*
(2015); *The Planet After
Geoengineering* (2021); and
Climate Inheritance (2023).
Ghosn is a founding member of
the journal *New Geographies*
and editor-in-chief of its
issue *Landscapes of Energy*.

A life sketch is a document developed immediately after a person's death, usually by the deceased's family. Read during the funeral program, the sketch usually provides significant insight into the life of the departed—written with just enough humor to prevent listeners from falling into the excessive melancholy of what is at stake. To record an ancestor's life is particularly challenging when the figure is at the thresholds of respectability, when they are assigned and enmeshed in monstrous qualities that can become more pronounced in the liminal state between life and death. This is a life sketch of plastics: a speech act for a future post-fossil fuel, one that learns to live with the inheritance of petro-matter as a legitimate element of design—if only to speculate on its possible afterlives. By accounting for the plastic stuff around us, this life sketch invites readers (some of whom are designers) to consider plastic matter as something that matters, as cultural artifacts worthy of critical attention and care.

In the essay "Love Your Monsters," Bruno Latour poses the problem of *Frankenstein* as a parable for political ecology.[1] When Dr. Frankenstein meets his creation on a glacier in the Alps, the monster claims that they were not born a monster at all; they only became one after being left alone, abandoned in the laboratory by their horrified creator the moment he saw them twitch to life. Written at the

91

dawn of the great technological revolutions that would define the nineteenth and twentieth centuries, *Frankenstein* presciently describes how technological creations might, without proper care, wreak havoc—how they might become forces and forms of destruction. Herein lies a story about responsibility. According to Latour, we confuse the creator for the monster and blame his sins upon the things he's made. But modernity's sin is not the creation of technologies. It is the "creator's" failure to love and care for their technologies. Latour argues that we cannot stop being involved in the world we have created, that political ecology must engage present technologies with patience and commitment.

Future Frankensteins account for planetary externalities and remains, or the heritage that Western petrochemical societies have bequeathed to the world. The heritage of the Anthropocene assembles, along the customary fault lines of spatial and social inequalities, a variety of things: polluted sludge, lingering CO_2 in the atmosphere, sick building syndrome, the David H. Koch Hall of Fossils, the Great Pacific Garbage Patch, and plastic—lots of it. The heritage of the Anthropocene is replete with objects and monuments that might be uncommon or suppressed, or impoverish their heirs. Plastic inheritance begs the question of one's ability to respond: how one is made or chooses to inhabit the legacies of environmental destruction shapes their ability to figure out what is to be done—particularly with matters that are dismissed, undervalued, or demonized in the design imagination.

The work of inheriting responsibly, particularly when what needs to be inherited is a difficult history, is also the work of mourning and of bearing witness to sites of violence. Inheritance offers a conceptual tool to reconcile the valued aspects of heritage with the unjust processes on which they are predicated. Such inherited matters are plastic figures. Readers are entrusted with the salvages—the residues, shadows, echoes, and ghosts—

and with shaping this heritage into forms for which to care and to which to respond in the present. We don't choose what we inherit, whether we like it or not. The political act is in how we deal with what we've inherited. The task of inheritance is how we stay with the shadow of destructive forces, not to demonize or eulogize, but to craft a life sketch, one with the power to transform their afterlives; pollinate it with other assemblies, uses, and symbols; and to break away from the cycles of idealization and subsequent neglect. To be a responsible attentive ancestor is to be able to hold the immensity of destruction and to bequeath through that the promises of regenerative worlds and values. To write a life sketch of plastic is to ask how the salvages of plastic modernity might be worth offering to our descendants, for them to have life and to have it abundantly.

1 Bruno Latour, "Love your Monsters: Why We Must Care for our Technologies as We Do Our Children," *Breakthrough Journal* (Fall 2011): 19–26, http://www.bruno-latour.fr/sites/default/files/downloads/107-BREAKTHROUGH-REDUXpdf.pdf.

Unsettled Matter[1]
by Theodossis Issaias and Ala Tannir

A roaring sound reverberated across the deep valley at the western edge of Pittsburgh's Low Plateau. Following the rumble, the smell of burning gas overwhelmed the atmosphere, which was already blanketed by a thick haze of smoke that had made its way south as wildfires burned in Canada. It was March 15, 2023, at 9:45pm. A ground flare fire had erupted at the ethane cracker plant on the bank of the Ohio River in Beaver County. Flaming clouds lit the dark sky; night turned to dusk. The leviathan plant—now operated and owned by Shell at the scale of 150 Astroturf-covered soccer fields—processes petrochemical byproducts and turns them into plastic "nurdles." The size of a small pearl, these "pre-production plastic pellets" are the elementary unit for most of the plastic products that surround, seal, build, protect, disrupt, and pollute life on this planet. Equipment malfunctions, compressor failures, nurdle spills, contaminated water, and hazardous emissions are daily occurrences at the Beaver cracker plant. Yet, the mid-March blast that fused the burning skies of Canada with the fumed atmosphere of Western Pennsylvania, made clear the vulnerability of the categorical distinction between *fenceline* and *frontline* communities. Those who live immediately adjacent to highly polluting facilities and those who experience "the first and worst" consequences of climate change, respectively, have here geographically, temporally,

94

Theodossis Issaias is an architect and educator. He serves as the associate curator of the Heinz Architectural Center at the Carnegie Museum of Art and special faculty at Carnegie Mellon University School of Architecture. Since 2009, he has been a co-founder FATURA Collaborative, an architecture and research collective. Their work has been exhibited at the Venice Architecture Biennale, Manifesta, the Benaki Museum in Athens, among others. Issaias studied architecture in Athens, Greece, holds a Master of Science in Architecture and Urbanism from the Massachusetts Institute of Technology, and earned his PhD in History, Theory, Criticism of Architecture from Yale University.

and corporeally converged into a community sharing a unified struggle for environmental justice.

Abundant in anthracite and bituminous coal, the mines of Western Pennsylvania fueled the proverbial Second Industrial Revolution during the late nineteenth century and subsequently played an essential role in the mechanisms of material and power production. With gas trapped in the sedimentary rock of the Marcellus Shale, which stretches throughout most of the Appalachian Basin, the region became, once again, a productive node in the intimately connected global energy network. The cracker plant, strategically positioned on top of this gas reserve, was presented by the fossil fuel industry as a solution to managing byproducts of extractive processes. In other words, it was a coercive gift that promised to convert ethane (a fracking byproduct that cannot be used for energy purposes) into polyethylene (a commonly used plastic). Oil and gas corporations like Shell turned to plastics to generate profits at a time, close to a decade ago, when their primary business—oil and gas extraction—struggled with volatile energy markets and consistently low prices. Fracking lands were forced into a destructive irrational cycle in which more wells are drilled to supply petrochemical plants, and, vice versa, more plants are built to expand drilling.

Like smoke, plastic is transferred to peoples, critters, and places that, as Heather Davis argues, do not consent to all the consequences of its production and waste.[2] Plastic is designed to be divorced from a specific location, Davis adds. It appears to come from and be of nowhere. At the same time, it coats a particular place with the sheen of a globalized product without regard for local cultures and ecologies.[3] Today's readings of petrocultures stress plastics' bodily intimacies and molecular ubiquity instead of their infrastructures of production, distribution, and consumption. To look, however, at the ethane cracker plant—the flare stacks, oil pads, pipelines, drills, and the dependency of plastics on natural gas production byproducts—is to situate and ground plastics within fossil fuel economies along the *continuum*

Ala Tannir is an architect and curator from Beirut. She is the inaugural curatorial research fellow at the Carnegie Museum of Art's Heinz Architectural Center, and currently teaches at the Carnegie Mellon University School of Architecture. She was part of the curatorial team and managing editor of publications for the 2021 Venice Architecture Biennale, and co-organized the 2019 Triennale di Milano, *Broken Nature*. Her upcoming project utilizes exhibition-making as a process to record and rehabilitate a 1930s coastal house in Beirut to transform it into a research and cultural platform for the study of the Eastern and Southern Mediterranean landscape.

95

of extractivism.[4] It is where matter is split, divided, and separated from its geological context for the extraction of value and the creation of the commodity form. But, as Kathryn Yusoff explains, this process is paradigmatic of the "psychic splitting of the world": it realizes the material, social, and political segregations of the inhuman, nonhuman, and human; it also produces the mechanisms of controlling and governing this split.[5] The cracker's tentacles unfold hundreds of miles across the region with pipelines and rail systems of freight cars to meet drilling sites that extend thousands of feet below the ground. It is this nexus where reproductive violence is enacted, maintained, and governed, but it is also where it is most exposed and, perhaps, vulnerable. It is the site where solidarities among communities that face extractive labor, industrial pollution, and extreme weather events are being mapped, enacted, and reinforced. Uncovering successive and entangled phases and forms of extraction can hold clues for different modes and scales of disentanglement from these systems. To put it differently, it is within this split that we can begin to plot and chart paths forward for moving away from fossil fuels.[6]

1 The research for this text draws from
Unsettling Matter, Gaining Ground, an exhibition
co-organized by Theodossis Issaias and Ala
Tannir and presented at the Carnegie Museum of Art,
Pittsburgh, PA, August 19, 2023–January 7, 2024.
2 Heather Davis, *Plastic Matter* (Durham,
NC: Duke University Press, 2022), 5.
3 Davis, *Plastic Matter*, 5.
4 Artist and activist Imani Jacqueline Brown
has been working on a long-term investigation
into the "continuum of extractivism," which entwines
settler colonial genocide, slavery, and mass in-
carceration with fossil fuel industries and environ-
mental degradation in the context of Louisiana.
5 Kathryn Yusoff, "Mine as Paradigm," *e-flux
Architecture*, June 2021, https://www.e-flux.com
/architecture/survivance/381867/mine-as-paradigm.
6 In "Mine as Paradigm," Yusoff urges us to
look at these sites of extraction to "*dig in
and plot.*" See Yusoff, "Mine as Paradigm." Emphasis
in the original.

At the Edge of the
Usual

Marisa Solomon

Marisa Solomon is assistant professor of Women's, Gender and Sexuality Studies at Barnard College, Columbia University, where she teaches courses in feminist intersectional science studies, environmental humanities, Black geographies, and feminist theory. Her work considers ecological politics from the position of Black dispossessed life. She has written a number of articles on the relationship between waste and Black life in the US, including "The Ghetto is a Gold Mine" for the *Journal of Labor and Working-Class History* and "Ecologies Elsewhere" for *GLQ: A Journal of Gay and Lesbian Studies*. She is the author of *The Elsewhere is Black: Ecological Improvisations of Discarded Living* (forthcoming with Duke University Press) and is the former co-director of Black Atlantic Ecologies at the Columbia Center for the Study of Social Difference, where she was affiliated with the Earth Institute.

In January of 2022, New York City Mayor Eric Adams began a series of "sweeps." Under the Get Stuff Clean Initiative, Adams's administration committed $14.5 million to clean what he called "No Man's Land" areas across the city. By invoking a colonial trope to marshal a "Rat Tsar," expanding the camera surveillance used to enforce "illegal" dumping laws, and deploying the New York City Department of Sanitation (DSNY) to clear houseless encampments, Adams framed his initiative as an intervention into the city's "neglected" environments.[1] However, policing does not intervene in waste-filled environments; rather, it reinforces violence as environmental management. This cross-agency initiative, in which the NYPD sanitizes the city and the DSNY helps police it, reinforces houselessness as a waste problem and waste "management" as a logic of policing. A clean city, as former Mayor Rudolph Giuliani's broken windows policing enshrined in the 1990s, means that the abundance of life lived on the street—often *with waste*—is swiftly and violently eliminated.[2] It presumes the status quo belief that protecting "the quality of life" of property-owning New Yorkers is what the environment needs.

As the photos of cops throwing homes into DSNY trucks evidence, "cleaning" is a racial mechanism of environmental control.[3] "Quality of life," within the logics of settler racial capitalism, is secured through an economic logic whereby racialized and other marginalized peoples' living is construed as dirty and their ways of life are policed as a threat to the accumulation of capital and property value. While Mayor Adams might believe—as so many do—that "cleanliness" equates to "safety," more often than not, cleaning is a geographic mandate to *clear*: a settler colonial process that relentlessly produces racialized communities to render them maimable, killable, and displaceable for property.

At the heart of this policing initiative is an underacknowledged violence. The protection of property is an anti-Black, anti-poor, settler colonial environmental project. And clearing land to make way for property has ongoing environmental effects. Disappearing "neglect"—a broken window, a houseless person, or trash on the street—does not rid environments of the ecological risks of capitalism, such as the conditions that promote the spread of disease; exposure to particulate matter, soot, dust, and standing water; and accumulation of waste. Instead, the violent spatialities that facilitate "disappearance" (i.e., removing waste off the street) express the logic of a political economy that concentrates "risk" to an elsewhere that is mundanely Black. Locally unwanted land uses (LULUs), such as landfills, waste-to-energy plants, and leachate treatment sites, are concentrated in poor Black and Brown neighborhoods. Prisons are built on top of landfills or superfund sites, and the conditions of prisons are themselves toxic. The collusion between sanitation and policing materializes colonial land relations, as well as points to settler racial capitalism's common-sense ecopolitics: Black dispossessed life managed as a waste problem.

The white environmental imaginary that equates the "urban disorder" of houselessness with *environmental* contamination is the same logic we use to bury toxic accumulations in the landfill and in the future. The fallacy of "out of sight and out of mind" preserves white environmental "peace"[4] (at least in the present) and secures what environmental engineer

Marisa Solomon

and decolonial theorist Malcom Ferdinand has called a "colonial habitation."[5] Even a cursory look at the language of Mayor Adams's initiative draws attention to how "ordering practices" maintain the systems of power that "discard people, places, and things that threaten [their] order."[6] "No Man's Land" recursively authorizes the disappearance of the people who live on the street, as the police sweep away the threat of degradation. The presumptive "cleaning" function of the police is to provide a colonial model of a life supposedly worth living and to define, through violence, whose living and whose ideas about the environment matter.

In service of an abolitionist project, one that is otherwise to racial capitalism's environmental order, the "dirt" of racialized poverty might very well be an intervention into the whiteness that defines "quality of life." Yet, "dirt/y" life's threat to the order of racial capitalism is politically in-structive. Dirt/iness and trash/iness are already part of environments, and, even if we were to stop producing trash today, trash is already central to our future (it isn't going anywhere). So, what if we saw dirt/iness as a po-litically useful environmental ethic? What if dirt/iness and trash/iness disrupted racial capitalism's intuitions that take for granted that "property" and "cleanliness" are ecologically sound? The violence of clearing house-less people from the city does nothing to address the systemic lack of affordable housing in NYC, and it occludes the way Black houseless life is, itself, a *material intervention* into the inhabitable world that colonial habitation—policing, ecological destruction, the racialization and concen-tration of environmental risk—has wrought.

Writer and Black studies scholar Christina Sharpe notes that "anti-blackness is pervasive as climate," a "weather" that produces "new ecol-ogies."[7] These ecologies are waste-filled and risk-filled; they are the product of what Italian historian Marco Armiero has called "the wasting relation-ships" that shape our material world.[8] As feminist theorist M. Murphy has noted, these are the conditions of "alteration," whereby exposure to violence and toxicity are the uneven conditions for "living, eating, and breathing," demanding new ethics, politics, and forms of living "alterwise."[9] Living *with* —and the forms of being that emanate *from*—settler colonialism's atmos-phere and the weather of anti-Blackness is an affront to calls for "clean up." That people are forced to live with/as waste is a product of unfreedom and thus a reminder that the mundane disappearance of discards requires the ongoing theft of Indigenous lands and anti-Black placemaking to police the environments of sanitary settlement. But it is also true that this en-vironmental management of people, place, and matter is always producing an unruly set of relations—of matter, of futures, of knowledge elsewhere— that challenge racial capitalism's very colonial foundations. What if there are things to learn about the environment from the dispossession wrought by capital, like how to live with risk, waste, and the toxicity of racial capital-ism? What if we took seriously that the protection of colonial habitation *is ecologically destructive* and that "the elsewhere" to which waste accumu-lates is an environmental future already here?

The "elsewhere" is a fecund space-time of Black ecological thought. It is an elsewhere that is everywhere at the edge of the usual, demanding that we name the everyday violence that manages our collective environments,

while simultaneously centering dispossession as a site of ecological ethics, politics, and knowledge. If proximity to waste is part of the uneven condition of "vulnerability to death,"[10] it is also part of the creative resource that gender and Black studies scholar Katherine McKittrick calls a Black geography materially sourced by the dispossessed to wrench open *ways to be*.[11] Elsewhere, where environmental risk is concentrated, unruly material relations gather, and fecund ecosystems support an abundance of life-ways, even if those are described as deplorable, contagious, abject, dirty.

When we look at plastic from the mundane elsewhere of disposable life, plastic is, as Heather Davis might say, already conditioning our future.[12] But it is also an abundant materiality with which alternative ways of living emerge. Between the sanitation truck routes and the police sweeps of houseless encampments, between looking away and penetrating stares, between the language of "safety" and the whiteness of sustainability, between garbage bin technologies designed to keep people *out* and the criminalization of broken windows that turn the visibility of poverty into environmental signs of decay, a fugitive map of matter can emerge: a map of abundance. Repurposing found objects is the stuff of discarded living. It's a practice in which the disposable dances the dance of disorder, in which we dispose of our common-sense beliefs that law and order serve our environmental future and that reforms to capitalism will prepare us for a future inundated by plastic's unruly presence. In the altered lives lived on the street, elsewhere, plastic finds new meaning in houseless hands siphoning water. The cellophane that holds the end of a sandwich might be the vessel that holds sustenance for nonhuman friends.

The elsewhere is everywhere at the edge of the usual; it's a space-time of ecological possibility that lingers. While, for some, waste is an *a priori* category of matter, for others, it's the relentless time and place of being surplus to the value(s) of property and whiteness. The quotidian violence of producing "surpluses" (people, places, land, and matter) is sutured to racial capitalism's spatial violence. But perhaps the fecundity of unruly relations—to waste, to plastic, to risk—is a site of anti-capitalist political becoming. After all, if discards and dirt/iness are a threat to order, might there be an abolitionist lesson lying in wait? The fecundity of waste (and its plastic forms) is not separate from the violent relations of *wasting*, but the material abundance of waste could be a site of capitalism's undoing. The scale of waste-filled landscapes might very well require a kind of plastic marronage, a choreography and way of living that is already generated by "dancing with the disposable"[13] right here and right now.

There is something ironic about the way plastic makes up the stuff we use briefly, like packaging, single-use take-out containers, and water bottles. These objects, which inspire derision and moral condemnation, might be temporary in some hands, but plastic is millennia of earth's historical flesh ripped out of time. The same logics that guide the sweeping of houselessness from cities guide plastic's endurance in the Black lives lived elsewhere. While the durability of plastic might be part of its danger, so too is the endurance of Black living dangerous to settler racial capitalism. There are lessons to be learned in the "wastelands" of racial capitalism's disabling conditions of Black life.[14] The durability of plastic is a problem of racial

capitalism's wasteful relations, producing both matter and people out of time and out of place. But elsewhere, where plastic and people endure, plastic's ubiquity is fecund with possibility. In the multiple elsewheres of discarded life, waste might be the insurgent matter—tarps, tents, jackets, and discarded umbrellas—with which to protect oneself from the manifest forms of violent atmospheres. Learning how to relate to waste just might be what we need to weather the weather—a crisis that is already here.

1 Office of the Mayor, NYC, "Mayor Adams Consolidates Citywide Cleaning Functions to 'Get Stuff Clean,' Announces $14.5 Million in New Funding for Clean Streets and Parks," news release, November 10, 2022, https://www.nyc.gov/office-of-the-mayor/news/824-22/mayor-adams-consolidates-citywide-cleaning-functions-get-stuff-clean-14-5-million#/0.

2 Mayor Rudolph Giuliani introduced New York City to broken windows policing in the 1990s. First theorized by James Q. Wilson and George L. Kelling, the broken windows theory argued that "degenerative" environments, typified by broken windows, lead to asocial behavior (crime). This criminological theory was put into action by police chief commissioner William Bratton of the NYPD under the Giuliani administration. See George L. Kelling and James Q. Wilson, "Broken Windows: The Police and Neighborhood Safety," *Atlantic*, March 1982, https://www.theatlantic.com/magazine/archive/1982/03/broken-windows/304465.

3 These photos circulate widely and are consumed so easily. I ask you (the reader) to refuse the need to see them. These photos are part of the way we make poverty a waste problem, comfortably consuming anti-Black representations of the poor and "degraded" from a distance. Out of respect for people and the trauma they experienced, these photos are not reproduced here.

4 Teona Williams, "For 'Peace, Quiet, and Respect': Race, Policing and Land Grabbing on Chicago's South Side: The 2018 Clyde Woods Black Geographies Specialty Group Graduate Student Paper Award," *Antipode* 53, no. 2 (2021): 497–523.

5 Malcom Ferdinand and Paul Anthony Smith, *Decolonial Ecology: Thinking from the Caribbean World*, Critical South (Cambridge, UK: Polity Press, 2022).

6 Max Liboiron and Josh Lepawsky, *Discard Studies: Wasting, Systems, and Power* (Cambridge, MA: MIT Press, 2022), 61.

7 Christina Sharpe, *In the Wake: On Blackness and Being* (Durham, NC: Duke University Press, 2016), 106.

8 Marco Armiero, *Wasteocene: Stories from the Global Dump*, Cambridge Elements in Environmental Humanities (Cambridge, UK: Cambridge University Press, 2021).

9 Michelle Murphy, "Alterlife and Decolonial Chemical Relations," *Cultural Anthropology* 32, no. 4 (2017): 494–503.

10 Ruth Wilson Gilmore, *Golden Gulag: Prisons, Surplus, Crisis, and Opposition in Globalizing California* (Berkeley: University of California Press, 2007), 50.

11 Katherine McKittrick, *Demonic Grounds: Black Women and the Cartographies of Struggle* (Minneapolis: University of Minnesota Press, 2006).

12 Heather Davis, *Plastic Matter* (Durham, NC: Duke University Press, 2022), 7–11.

13 Christopher Paul Harris, *To Build a Black Future: The Radical Politics of Joy, Pain, and Care* (Princeton: Princeton University Press, 2023).

14 La Marr Jurelle Bruce, *How to Go Mad without Losing Your Mind: Madness and Black Radical Creativity* (Durham, NC: Duke University Press, 2021).

Function | Funzione
Xavi L. Aguirre,
PROOFING: Resistant and Ready

Matter | Materia
Simon Anton,
This Will Kill _____ *That*

Mass | Massa
Ang Li,
Externalities

Form | Forma
Norman Teague,
Re+Prise

Salvage | Recupero
Lauren Yeager,
Longevity

Materia

Function | Funzione

Form | Forma

Salvage | Recupero

Function | Funzione

Mass | Mass

Chiara Barbieri

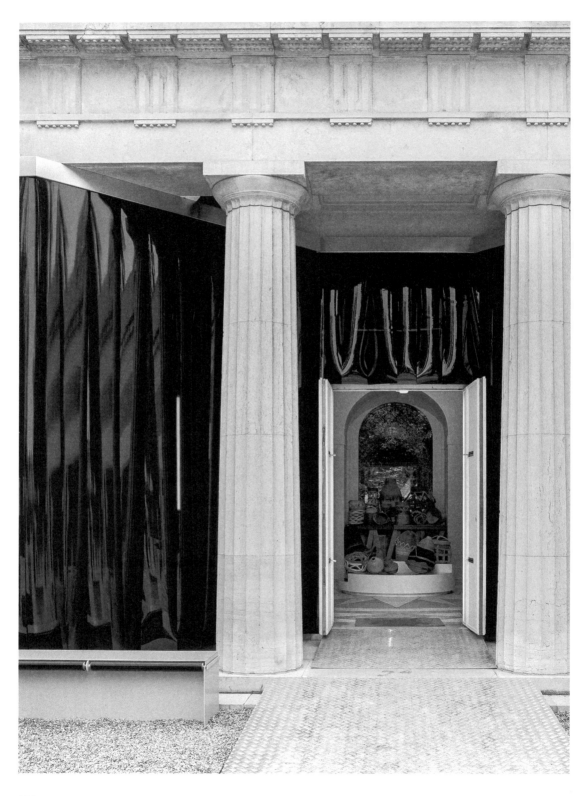

Longevity

Lauren Yeager

Lauren Yeager (Cleveland, OH; she/her) is a conceptual
artist and sculptor. Her work has been highlighted in
several national exhibitions including Sculpture Milwaukee
2021, FRONT International, and at moCa Cleveland as well
as within the Progressive Art Collection, the Cleveland
Clinic Foundation, and other prominent private col-
lections. Yeager received her Bachelor of Fine Arts from
the Cleveland Institute of Art.

Acknowledgments

Abattoir Gallery
Ernst Construction Services
Hildebrandt Provisions Company

Using salvaged consumer material, Lauren Yeager creates sculptural assemblages that at once reference classical and modernist architectural forms and recall the ordinary routines of everyday life. Yeager transforms once-loved items into relics of personal histories. By elevating waste into art, she challenges us to reconsider the ways we establish value. Familiar plastic objects replace traditional stone and plaster columns and monuments in the courtyard of the United States Pavilion. These sculptures assembled from remnants of US cultural production—like Coleman coolers and children's toys from the Ohio-based company Little Tikes—demonstrate our deeply enmeshed relationships with plastic.

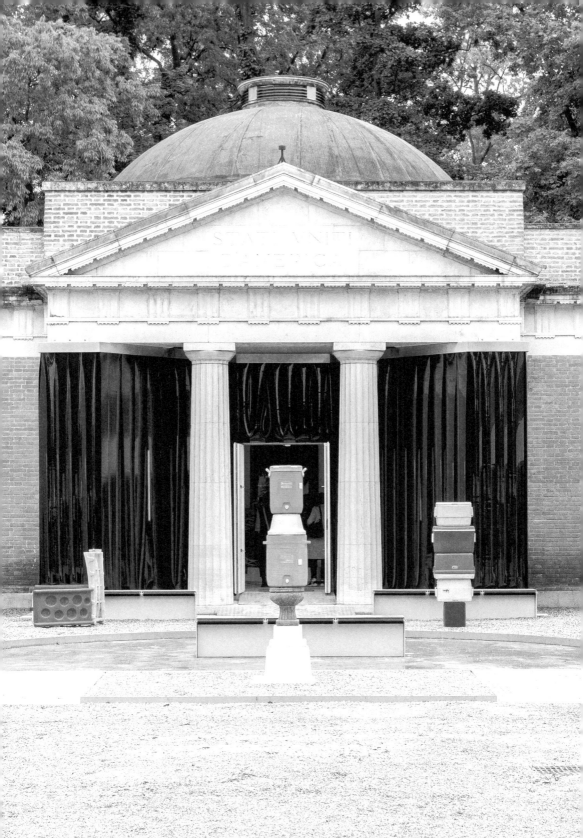

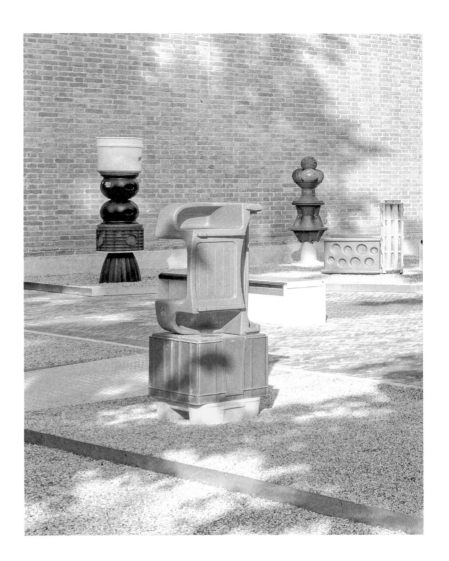

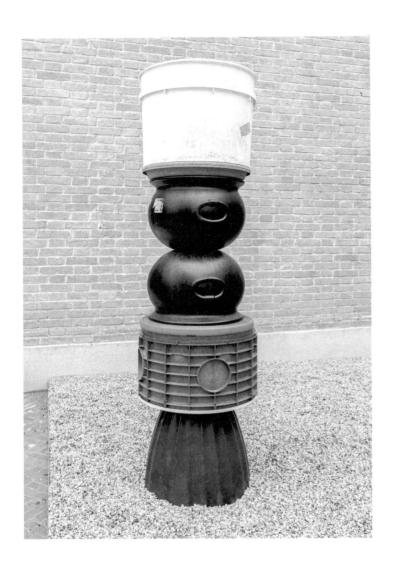

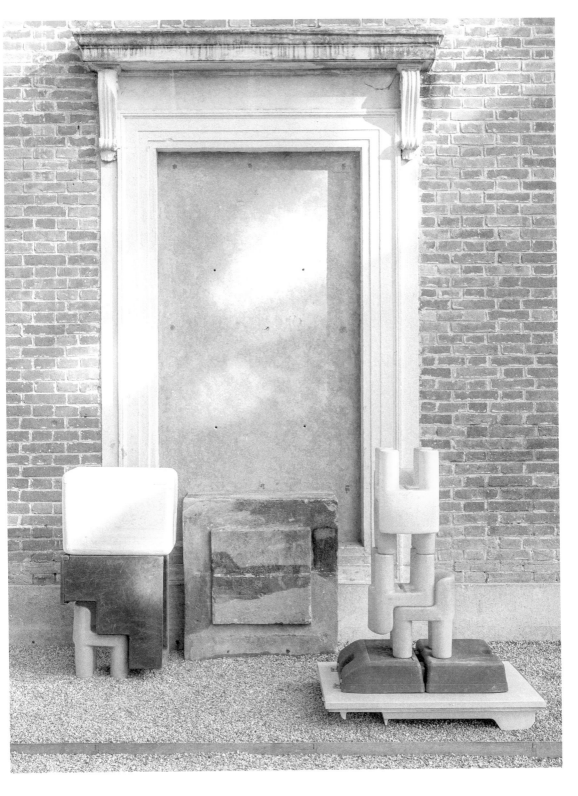

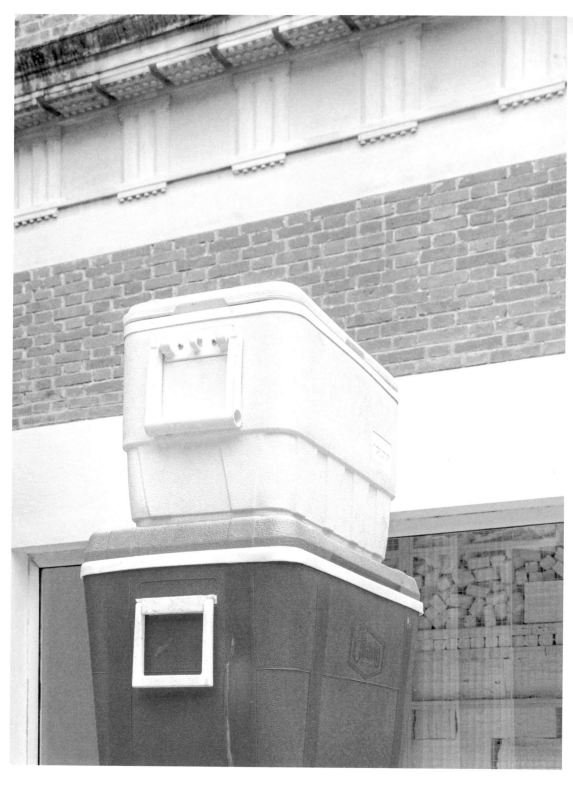

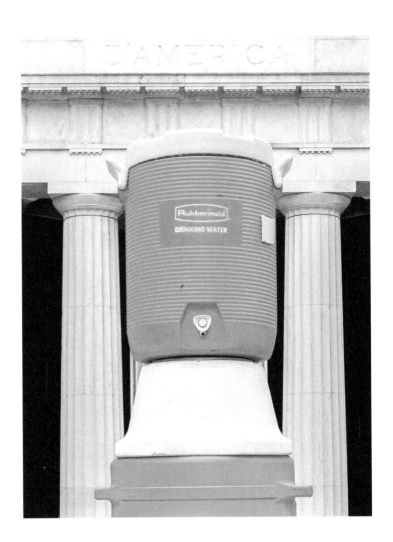

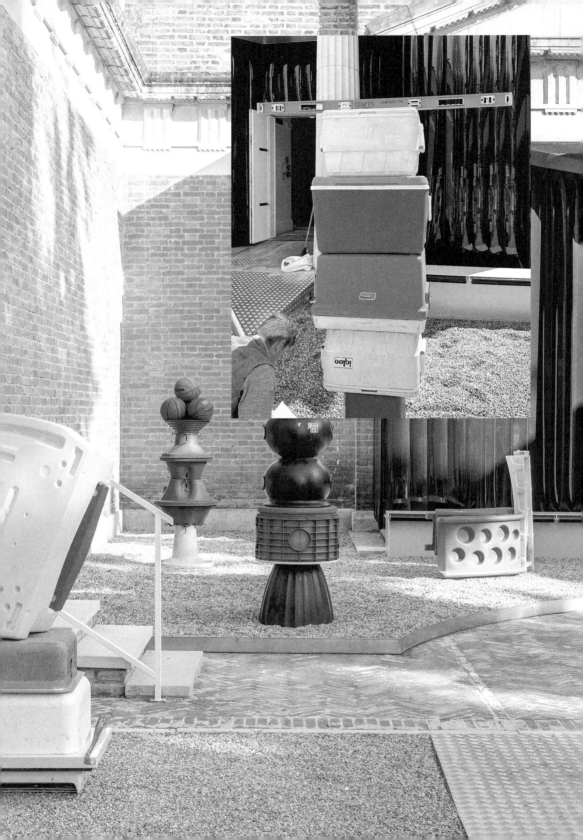

On the Formerly Useful and the Everpresentness of History

Laura Raicovich

Laura Raicovich is a New York City—based writer and curator. Her book *Culture Strike: Art and Museums in an Age of Protest* was published in 2021 by Verso. She is also editor and curator of *Protodispatch*, a digital publication featuring artists' takes on the local and global conditions that make their work necessary; she initiated the forum with Mari Spirito and Protocinema in 2022. With a collective of artists, musicians, and culture workers, Raicovich cofounded The Francis Kite Club, a bar/cultural/activist space in NYC's East Village, in 2023. Prior to these projects, Raicovich served as director of the Queens Museum and interim director of the Leslie Lohman Museum of Art; she was a Rockefeller Foundation Fellow at the Bellagio Center, and the Tremaine Curatorial Fellow for Journalism at *Hyperallergic*.

The discarded, the formerly useful, the once-needed but now unwanted, comprises a massive, unthinkable quantity of waste. Very often, it is made of plastic, hard or soft: a toothbrush, a trinket, a toy, a bottle of tonic. Maybe I left it there—maybe I breathed it, or drank it, or ate it, but now it is here—in landfills, on the curb, in gutters on city streets, as massive flotillas in the middle of oceans. Far from land, close to home: an indelible mark of the twentieth century's most lasting invention in my bloodstream... in the bloodstreams of all living creatures.

> Waste is our immediate unwanted past.
> Mierle Laderman Ukeles[1]

Desire and utility have a fascinating relationship. Sometimes fleeting, sometimes verging on permanent, the relationship between what is desired and what is useful is inevitably tied to time. When and why objects come into our lives often defines their longevity. They occupy different spaces of desire and usefulness *for a period*. A pie, for instance, disappears quickly, as we consume it around the dinner table. A couch, on the other hand, hopefully lasts a lot longer than that. And while the pie might be eaten in only a few minutes and then processed by organic digestion and elimination, the couch remains, either to be reused by someone else or, perhaps more likely, if it is worn, to be thrown out.

The phrase "to throw away" conveys more than a no-longer-usefulness. It implies a denial; it creates distance between me and the object; it expresses a need to get the thing out of my orbit, out of the way. Its beauty or functionality is no longer visible; it is unwanted. Formerly useful, formerly wanted, relegated to the curb.

The entire US economic model is based on convincing people, particularly members of the American middle class, that we *need* things that are certainly not necessities. Wants slip into needs. Ravenous consumerism is this nation's bread and butter, particularly of the kinds of leisure items that often end up discarded before they are actually unusable. But, the unwanted tends to stick around. We may relegate items to the dustbin, but this act doesn't eliminate them from existence. Gone but not gone, they become someone else's problem, and ultimately our collective problem.

The status of the objects of daily life, from a beach cooler to a plastic witch's cauldron, have a relationship not only to desire but to utility as well. While my need for a cooler might outdo and outlast my need for a plastic cauldron (which isn't much use beyond its atmospheric effect), their relative utility is a reflection of me in the moment that I want and use them. And this doesn't even address the time and resources these objects might take to produce in the first place. A classic feature of bourgeois Americana. I suspect that these objects could never really be "used up," and this adds another poignant and wasteful aspect to their unwantedness, yielding a greater complexity to the societal portrait created by piles of collective trash.

Sara Ahmed's book *What's the Use?* provides a bevy of thinking about how use determines an object's value in society and what its usefulness might tell us about ourselves. She paves a path from Marx's suggestion that "when something becomes a commodity, it becomes transcendental:

Laura Raicovich

when it is exchanged, a table ceases to be a mundane object... To make use of the table is to bring it back down to earth."[2] Use of an object grounds it in our lives and in reality, taking it out of the circulation of ideas or resources into the realm of the material. Moving through Jacques Derrida's return to Marx, Ahmed writes, "the table becomes worn down by use whether or not it is in use. The scratches on the table might tell us something about what the table was used for. We might think of the scratches left behind from use not as signs of degradation or the loss of value as testimony. The table might testify to its own history."[3] The history of the object, the used object, therefore, is something that has to be examined and followed beyond its excision from our lives. After all, it is with these objects that life is lived and that our daily political, social, economic, and environmental realities exist. These objects are then made unknown to us again when they "disappear" into the realm of sanitation collection. But something stays behind. Think about how many warnings have been made about the off-gassing of certain products, the dangers of lead paint, the toxicity of particular plastics. The impacts of these objects may remain in our systems far longer than they are used—our individual systems and the ecosystems of the planet. They cannot be made to un-exist.

Discards are portraits of former selves, of needs and desires that might have been over a period of time. The landfill, as artist Mierle Laderman Ukeles often notes, is a portrait of society. Maybe I, or my circumstances, or my tastes have changed. I may feel nostalgic for this version of myself, and I may save some elements of that past. Or I may want or need to remove this past from my present surroundings. And my neighbors are all doing the same thing, adding to those unfathomable heaps at the dump. These thoughts of utility and desire have been central in thinking about the work of the artist Lauren Yeager, particularly as she has spent much time examining the schedules of curbside trash pick-up, preempting the formerly wanted from entering this massive social portrait. She intervenes in this moment of material and social transition to make art.

Lauren Yeager's installation *Longevity* is situated within the courtyard of the United States Pavilion as part of a larger exhibition titled "Everlasting Plastics," organized for the 2023 Venice Architecture Biennale. Her intervention at the curb, and the materialization of her artwork, is a proposed reparation for those societal conditions of waste described by Ukeles. Yeager delves into the unwanted—practicing a form of dumpster diving—making use of what is discarded. Roaming exurban sidewalks to see what people throw away and locating readymade elements that might be forged into something new, Yeager is a forager of specific objects, all of them plastic. She is not searching out *particular* items; rather, she is interested in typologies of material, formerly wanted items that reflect an interest in the hard plastics of American leisure. She is interested in the forms that show evidence of their usefulness, that have a particular design based on their former function, some legible, others unrecognizable. They, too, are the markers of fantasies of American leisure, remnants of what living in the US is narrated to be, that all too often is completely unattainable and false.

Among the most specific and recognizable items identifiable within Yeager's sculptures are, as I summoned earlier, large black plastic witch's

cauldrons that I imagine once sat on someone's porch as part of a Halloween display and a pile of basketballs, maybe found abandoned in the leafy corners of a playground. These items are stacked into vertical forms that take me back to childhood experiences of Halloween evenings, at dusk, leaves swirling, that fall chill. At first, the recognizability of the elements Yeager utilizes distracts me from their formal arrangement. But upon closer examination, I see that they are unaltered from how she finds them, not even cleaned. Their disregarded, garbage, abject status is clear. She wants me to recognize this. And I cannot move on from these sculptures—which bring together the touchstones of Halloween trick-or-treating fun, basketball on blacktop, coolers at beaches or the ballgame, kitty litter, kids' furniture, suburban back-yards—without seeing a texture and image of a very particular, normative narrative of American consumerism and leisure.

Ahmed speaks of queer use as defined by "something being used by those for whom it was not intended... Describing what something is for is a partial account of what it can be. *Forness helps reveal the partiality of an existence.*"[4] Yeager uses the items she finds and adheres them to one another creating new objects, reorienting their presence in society, re-grounding them, reanimating and revaluing them. Following Ahmed, Yeager's sculptures make the familiar unfamiliar, by re-relating one element to the other, unsettling their original "forness," and revealing possibilities of an alternate existence. "Queer as reused; reuse as queer use," Ahmed writes.[5] Yeager culls the landscape of the formerly-useful, formerly-wanted, recuperating the undesired.

> Desire has passed, and with it goes value. The value of the object evaporates. We are quite expert at this; in consumerist society, we're trained to lose desire as fast as possible to buy again, more and more. To call something "garbage" means stripping the ma-terials of their inherent characteristics... The entire culture colludes in this un-naming.
> Mierle Laderman Ukeles[6]

I did not see this exhibition in person. And yet, based on past visits to Venice, I can imagine it. By constructing or inventing my own encounter with the work, I hope to stage new relationships with the material objects that constitute Yeager's work; to consider what baggage from their former lives on Cleveland curbs they bring to Venice; "to reorientate [my] relation to a scene that holds its place, as memory, as container, however leaky."[7]

I imagine landing in the Venice airport, on the mainland, and taking a boat into the city. The blue, grey, green waves of the lagoon bear me to the Giardini. I crunch the dusty pebbled paths of the park to arrive at the US Pavilion. It is one of the few green spaces in Venice, all of them constructed for experiencing nature in a city that has no such unconstructed space beyond the waterways that flow through, around, and under the archipelago. The buildings edge the waterways and lagoon on all sides, and anything that isn't water is paved in stone. Any visible earth is intentionally recovered for leisure.

Before me, the neoclassical Pavilion's open courtyard holds fami-liar objects forged into unfamiliar forms. They are yellow and black and white,

and also green. They call attention to themselves, and they are occasionally accompanied by security guards. In the same way that uniformed security presents as safety to some and danger to others, so too do Yeager's sentinels embody an ambivalence. Human-scaled, they both welcome and warn. They are available for inspection but determinedly return the gaze: they implicate me.

The installation of the sculptures is both elegant and weird. The courtyard has been set up to create the feeling of a small sculpture garden. Each sculpture sits on a bed of gravel, similar to that which paves the walkways of the Giardini, but contained within a metal edging. Pale gray benches are arranged intentionally throughout to provide places of rest and contemplation. A tree that long occupied the right side of the courtyard died and had to be removed just before the installation of the sculptures, necessitating a rearrangement from the original plan that likely benefits the contrast between the existing architecture and the odd forms that foreground it.

On the left side of the Pavilion, two sentinel forms confer with one another. They speak in contradictions. They talk of accommodation, and simultaneously of danger. Maybe because the most recognizable component of the sculptures is a bright yellow kid's chair: hazard yellow—as Walter de Maria called it, "the color men use when they attack the earth."[8] This is the kind of furniture sold at IKEA, that sits around a low plastic table in the backyard, perfect for making mud pies, as it can easily be hosed down. The banality and even cuteness of this small, chunky chair made for children's play belies its toxicity, in relation to both the resources and processes used in its making and the reality of its longevity. Once it was made, it became useful and desired; then, it became garbage; and, while no longer fulfilling its designed-for function, it has now shape-shifted to become art.

Ukeles, de Maria, Yeager send up flairs, warnings, calls for humanity to pay attention, to do something about the relationship between that which we desire and find useful in one moment and the production and consumption of those things that may result in the end of us. Again, over time: it all takes time.

By taking up Ukeles's call and naming the connections between consumerist society and the objects it produces through remaking them, Yeager is also naming how this society is culturally, economically, and racially constructed. Where would these discards end up if not in Yeager's artworks? Likely, in a landfill. Likely, in places and neighborhoods that have the least power to resist an affiliation with trash. Garbage depots are not desirable: they are often eyesores and are malodorous. And they are not safe. These mountains of trash, most of which will never degrade, leech toxic tears into the earth after each rainfall, into drinking water, into farmland, into bodies. And they remind us of who we were, what we wanted—pasts that we may or may not want to remember.

Yeager's sentinel forms, constructed with the benign tools of amusement, seem friendly, anti-monumental, and accessible. And yet, they are not configured for play, they are alienated from their former functions, now performing the role of abstract ready-made elements for sculpture. A pair of works greets me. The sculpture on the right comprises four of the

stout yellow chairs, stacked one on top of the other, playfully arranged with seats meeting seats and legs meeting legs in a not-too-tall, *Tetris*-like tower. They sit atop a two-tiered plinth of similar plastic: one tier, dark charcoal gray; the other, white. The notches, bulbous edges, and cavities of these plinths were surely intended to accommodate their assembly with other identical pieces in their former lives, or they indicate the objects were light enough to be lifted, or more easily mass produced. Being disused, and disassembled, the specificity of the indented notches and protrusions become obscure, and open space for alternate uses. Here, in the face of abandonment in the forever space of the landfill, Yeager invites an imagined future for such objects. Perhaps they are holding places for seeds, or perches for small birds. I think of Ahmed's thread about birds nesting in post boxes.[9] About alternate potentialities.

The placement of Yeager's sentinels is significant in relation to the architecture of the Pavilion itself. Positioned in front of what appear to be plastered-over former doorways (they are false relics, in fact, built into the original 1930s design), the sculptures are framed by decorative, carved white marble rectangular backdrops, which interrupt the red-brick facade. There is something uncanny and telling about the relationship between the ersatz nature of neocolonial architecture, and the hollowness of the plastic elements that comprise the sculptures, set within the social and political realities they represent. I will return to this later.

The central sculpture recalls a fountain form, although no water emerges from it. On a white base that looks like an inverted plastic sink sits a moss green plastic planter (or bird bath?) molded with neoclassical fluting and decorations. On top are two orange, Rubbermaid, cylindrical beverage coolers that you might see on the sidelines of a suburban soccer game, or on the field at a football stadium. The planter (or bird feeder?) evokes a fountain shape, and the spigots of the coolers above are lined up perfectly, so I can imagine that, if they were held open, they would issue a waterfall of bright yellow or pink or clear liquid flowing onto the gravel below. The orange plastic is horizontally ridged, providing a counterpoint to the planter's verticals. The vertical fluting evokes another translation: the classical column, which appears not only here in plastic but also in the four columns that support the Pavilion's triangular pediment that is the backdrop to Yeager's work. This stone fluting, of course, isn't an "original" either, but an attempt to evoke yet another version of the classical. This neo-neoclassical detail, in its strange plastic nod to the ancient architectures that are copied in the design of the Pavilion itself, signal a relation to social and economic histories.

> If we are standing on the edge of a pit that is separating us from a possible future here, where, perhaps, we still are having a short time to change the way that we do business with the air, the earth, and the water, can art do something on this edge besides teeter?
> Mierle Laderman Ukeles[10]

The US Pavilion was designed by architect William Adams Delano and constructed in 1930. It is a Palladian-style building, meaning it is inspired

Laura Raicovich

by the work of sixteenth-century Venetian architect Andrea Palladio, whose famed villas are nestled throughout the rolling hills of the Veneto. Characterized by classical columns, pediments, symmetry, and the balance of proportions prized by Ancient Greek and Roman architecture, the Pavilion embodies the motifs and orders essential to neoclassical design. Adams Delano's reflection of both Palladian and neoclassical architecture is an attempt to link the US cultural production that might be displayed within its walls to the Veneto of the Renaissance, as well as to broader European cultural legacies. Likewise, the fluted decorative details rendered in plastic on some of Yeager's sculptures evoke a similar iteration of the classical, this one signaling the stolidity of marble in perhaps an even more indelible material.

This is far from the first or last time an architect has employed neoclassical architecture to evoke such cultural symbolism. Early in US history, the connection to European cultural and economic power was essential in establishing viability as a nation. The solidity of and everpresentness of marble and stone, reincarnating ancient Greek and Roman beliefs and ideologies, became a way to evoke stolid roots, legitimacy, and future prospects. A visit to many official US government buildings or courthouses, from the Capitol to the Supreme Court, will attest to this. Thomas Jefferson's famed home, Monticello, which he designed himself, is also an homage to Palladio. Construction began in 1768, and, while he continued to modify the complex throughout the early 1800s, Monticello was largely completed in the mid-1770s. The cultural symbolism connecting this early American building, created by a "founding father" and completed as the new nation was born, is a powerful story. It links Jefferson himself, and his crucial participation in the American Revolution and subsequent governance, with the intellectual, cultural, and social history of the Renaissance and the Italy of Palladio, as well that of Ancient Greece and Rome. These are grand narratives that served him and his compatriots well. The United States as a nation is built on them. It relies on these mythologies and symbolism for much of its power, and certainly for its political and economic policies both internally and internationally.

However, such stolid buildings are necessarily steeped in *all* aspects of US history. Monticello was a slave-holding plantation, Jefferson someone who owned other people. And slavery was, and remains, the economic and social backbone of the United States in its founding and evolution as a nation.[11] The hyper-capitalism practiced by the United States today has its roots in slavery. And so too, necessarily, does this form of US architecture embody these histories.[12] In the context of the Biennale, the exploration of such capitalist consumerism back to Europe is indeed striking, and this backdrop is what adds such a biting edge to Yeager's discrete, mini sculpture park.

Her recuperated forms, comprising discarded plastics of American life and leisure, the once abject garbage that has returned in another form, thus embody a critique of the systems that brought these items into existence and that motivate their disposal. Her designs, rooted in the consumer cycles of American capitalism, which is itself inextricably enmeshed with extractivism and racist enslavement, sitting in the embrace of the

neoclassical, American Pavilion, implicates these mundane, benign pieces of trash in an ugly past and present. Packaged in the formal language of sculpture, Yeager's work asks naggingly pointed questions about what "august" American traditions have wrought.

If, as Mierle Laderman Ukeles suggests, garbage is a collective portrait of society, what does upcycling it into sculpture mean or do? Yeager posits that, as members of a consumerist society living in climate emergency, we cannot deny the roots of our contemporary condition in US intellectual and economic history, with its reliance on forced labor and resource exploitation at its core. Her sculptures are simultaneously an indictment of these conditions and an attempt to locate selfhood, and perhaps even dignity, within such a toxic environment, seeking a way to survive. They are a recuperative act. In queering the discarded, Yeager allows other stories to be told, in an attempt to make something out of what remains, unwanted, unnamed. These objects refuse to be taken to the landfill, to be unseen. The oscillations between recognition and illegibility within the works themselves form a portrait of an unstable society in danger. Like the landfill, Yeager's art implicates each visitor as complicit in the systems of power that have brought humanity to this edge of existence. They are here, sentinels looking back at us for interaction, recognition, in part or in whole, of what has been wrought—and of what might be salvaged.

Laura Raicovich

1 Mierle Laderman Ukeles, *Sanitation Manifesto!: Why Sanitation Can Be Used as a Model for Public Art*, 1984. All three quotes by Laderman Ukeles are excerpted from the full texts of Laderman Ukeles's writings as reprinted in Patricia C. Phillips, *Mierle Laderman Ukeles: Maintenance Art* (New York: Prestel, 2016), 217.

2 Sara Ahmed, *What's the Use*? (Durham, NC: Duke University Press, 2019), 37.

3 Ahmed, *What's the Use?*, 37.

4 Ahmed, *What's the Use?*, 34–35. Emphasis in original text.

5 Sara Ahmed, "Queer Use," *feministkilljoys* (blog), November 8, 2018, https://feministkilljoys.com/2018/11/08/queer-use.

6 Mierle Laderman Ukeles, "Leftovers/It's About Time for Fresh Kills" (2002), in Patricia C. Phillips, *Mierle Laderman Ukeles: Maintenance Art* (New York: Prestel, 2016), 221

7 Ahmed, "Queer Use."

8 These words are inscribed on a stainless steel plate mounted at the center of a large canvas painted yellow by Walter De Maria. It is from a series of works, *The Statement Series: Yellow Painting/The Color Men Choose When They Attack the Earth*, 1968, and is held by the Menil Collection, https://www.menil.org/collection/objects/8413-the-statement-series-yellow-painting-the-color-men-choose-when-they-attack-the-earth.

9 Ahmed, *What's the Use?*, 33–35.

10 Mierle Laderman Ukeles, "Précis, 1990," in Patricia C. Phillips, *Mierle Laderman Ukeles: Maintenance Art* (New York: Prestel, 2016), 218.

11 Here, I am thinking specifically of Christina Sharpe's foundational book *In the Wake*. I cannot overstate the importance of this text in confronting the afterlives of slavery, wherein Sharpe articulates "a method of encountering a past that is not past," wherein the United States's supposed-democracy "produces and requires Black death as normative." Christina Sharpe, *In the Wake:On Blackness and Being* (Durham, NC: Duke University Press, 2016),14 and 7.

12 Black historians, theorists, and storytellers, from Sharpe, Saidiya Hartman, and Hortense Spillers to Fred Moten, Ibram X. Kendi, and Frantz Fanon, have framed these relations in many important ways over many decades. I rely on their astute analyses and brilliance.

Externalities

Ang Li

Ang Li (Boston, MA; she/her) is an architect and assistant
professor at Northeastern University. She is the founder of
Ang Li Projects, an interdisciplinary design practice that
works at the intersection of architecture, experimental pre-
servation, and circular design practices to examine the
maintenance rituals and material afterlives behind architec-
tural production. Her work investigates the spatial ecologies
of the construction and demolition waste stream, exploring
how collective practices of repair and reuse could give rise
to new forms of architectural knowledge. Li's work has
been exhibited at Exhibit Columbus, the Chicago Architecture
Biennial, and the Lisbon Architecture Trienniale. She holds
a Master of Architecture from Princeton University.

Acknowledgments

Project Team:
Noelle Burke
Isabella Greco

Fabrication Support:
BOS | UA
Foam Factory
MS Fabrication
WireCrafters

Material Suppliers:
Nationwide Foam Recycling
Save That Stuff

Photography:
Jane Messinger
Science History Institute

Institutional Support:
Northeastern University,
School of Architecture

Exploring the relationship between mass and volume, Ang Li juxtaposes the properties of a seemingly weightless material with the densities of monumental form. Hidden layers of expanded polystyrene (EPS) foam form a universal membrane within our homes, landscapes, and supply chains. Here, EPS waste, diverted from landfills, is compressed into dense, discrete building blocks that can be read as both commodity and material catalog. Borrowing building techniques from the unit systems of waste processing industries, Li establishes an architecture of accumulation that prompts us to reflect on our systems of valuation, resource, and refuse.

Expanded polystyrene (EPS) foam is a synthetic, petroleum-based material that contains 98 percent air

ithin the EPS manufacturing process, individual beads of polystyrene are heated by steam and expanded

times their original size. The global EPS market was valued at 10.4 billion US dollars in 2022 and i

rojected to reach a value of 18.7 billion US dollars by 2030, at a compound annual growth rate of 8.8 p

ore than 14 million tons of EPS are produced each year globally, including 3 million tons in the United

States. Approximately 75 percent of the EPS produced in Europe is used in the building sector, the m

f it as insulation in the walls, floors, and roofing systems of residential and commercial construc-

minimum insulation requirement for commercial buildings at R-20. That means a minimum of 4.75 inches

of expanded polystyrene is required in any new commercial construction. The iconic 20-acre landscape i

Daley Park in downtown Chicago was constructed on top of approximately 65,000 cubic yards of EPS Geo

foam blocks. Around 22 million EPS fish boxes are used every year to transport the UK's wild-caught a

med fish to restaurants and supermarkets. A study of beach debris at 43 sites along the Orange County

coast in California found that EPS was the second most abundant form of beach debris. In 1977, the De

cal company evaluated the toxicity of burning polystyrene. Seven male Sprague-Dewey rats were exposed

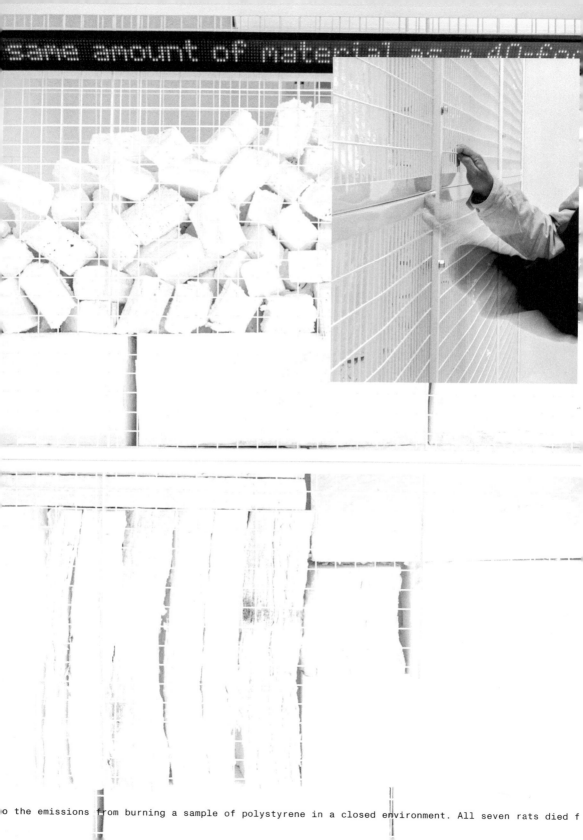

same amount of material as a 40-foot

o the emissions from burning a sample of polystyrene in a closed environment. All seven rats died f

Too Heavy: Finding the Places of Plastics, or How I Spent My Summer Vacation Not Going to the Venice Biennale[1]

Jessica Varner

Jessica Varner is a historian, environmental advocate, architect, and current ACLS/Getty Fellow in the History of Art (2023–2024). Her research focuses on design's environmental, material, and legal histories in the nineteenth and twentieth centuries. Her work has been supported by the Fulbright Foundation, National Science Foundation, Getty Research Institute, Science History Institute, Max Planck Institute for the History of Science, Martin Society of Fellows, and the Graham Foundation. Her recent research includes articles, chapters, and book projects on chromium, drywall, toxicity, the EPA's public history, synthetic chemicals in building materials, neurotoxins, and chemical modernity. In addition, she works collaboratively on toxic environmental advocacy with the Environmental Data and Governance Initiative and Coming Clean. She received her Bachelors of Science from the University of Nebraska (Lincoln), Master of Architecture and Master of Environmental Design from Yale University, and PhD in the History, Theory, and Criticism of Architecture and Art from the Massachusetts Institute of Technology.

1 The title references Philip Leider's critical piece "How I Spent My Summer Vacation" in the September 1970 issue of *Artforum*. In the piece, Leider, with Richard Serra and Joan Jonas, treks to Michael Heizer's newly completed *Double Negative* (1969) in Nevada. The article tours land art's physical places (Berkeley, CA, Nevada, etc.) during a moment of political upheaval. In response, artists attempted to address politics (literally) amidst the Vietnam War and attendant revolutionary movements. Leider's argument in and about *Double Negative* was that the visceral, unspoken, yet loud earthwork pushed the revolution's rhetoric to new heights. My title's conscious comparison marks a similar moment. As the climate crisis hits every being, art—and architecture—are responding in literal and figural ways, often asking art to "solve" the crisis. This essay narrates how Ang Li's work points in a different direction: toward awareness—a radically political act, far closer to art and architecture's real agency. See Philip Leider, "How I Spent My Summer Vacation or, Art and Politics in Nevada, Berkeley, San Francisco and Utah," *Artforum* 9, no. 1 (September 1970), https://www.artforum.com/features/how-i-spent-my-summer-vacation-201436.

2015 at Stanford University found that a species of plastic-eating mealworm can subsist on a sole die

In late summer of 2023, I embarked on a tour. Not to the Venice Architecture Biennale, but to its connected places—the US East Coast by Tacoma truck; the Avery Research Collections at Columbia University in New York City; the Science History Institute Archives in Philadelphia, PA; the Westbrook Public Library in Connecticut; and, via internet searches and email inquiries answered by artist Ang Li, while in my office on rural Connecticut brackish marshland. The tour's goal was to learn more about Li's contribution to the United States Pavilion's exhibition at the 2023 Venice Architecture Biennale, "Everlasting Plastics," without taking the intercontinental flight to Europe, saving the expense of atmospheric particles—hydrocarbons, sulfur oxides, black carbon, and emitted gases: carbon dioxide, water vapor, and nitrogen oxides. The result: a review as a tour through the places of plastic.

My journey touches on the exhibition's Midwestern connections; East Coast suppliers; Dow's laboratory and factory; the Texas oil well's supply route; and the Biennale's own industrial plastic roots, part of nearby Mestre's lagoons and marshes. In the architectural profession, "environmental" and "eco" are at once over-used and underexamined adjectives. The revelation of "Everlasting Plastics" challenges not just the environmental or eco-ness of humanmade polymers but also what constitutes the architectural canon, a tenet locked in formal notions of singular buildings and individual authorship. The issue remains that most of the architectural profession disregards the very presence of synthetic chemicals (and, by extension, plastics' durability) in historical and contemporary building practices— a phenomenon that connects every building and practitioner. Only recently have material explorations, such as the US Pavilion, placed architecture within its commodity-driven and capital-related petrochemical veracity. "Everlasting Plastics" pushes against the profession's routinely theoretical smugness (or at least lack of engagement) and eco-historical naivete, materially casting twenty-first-century architecture in doubt through the exhibition's explorations of plastic: formal majesty and grand visions no longer hold the timber, bricks, and concrete together; buildings are instead bound in building codes, logistics, supply chains, and plastics. Forged in expanded polystyrene (essentially, puffed plastic), Ang Li's contribution lays bare the architecture that we know today.

From the photographs of the 2023 Venice Architecture Biennale, I imagine ascending the US Pavilion's small marble half steps that separate the exterior courtyard from a glaring bright white interior—one, two, three. Artist Ang Li's thought-provoking contribution, *Externalities*, rests heavily inside— part visionary artwork, part capitalist ruin: a contradiction constructed in plastics—materially lightweight, heavy in environmental costs. Five white metal feet bridge the two sides of a centrally constructed wall, simultaneously buttressing and pooling around the partition, a nave in reverse. Compressed, white expanded polystyrene, or EPS, comprises this wall. It is layered with distinct strata, ranging from sizeable white EPS blocks in stacked synthetic rows at the bottom to crumbling petro-waste scree at the top—a geomorphology of chemical lamina. White mesh cages, reminiscent of logistic center containment systems or indoor bicycle storage units in apartment garages, hold everything loosely in place. A ticker screen

foam over a period of one month. After being ingested, the EPS fragments were broken down in the larva

hangs on the wall to the left, scrolling through plastic facts: *EPS is non-biodegradable and resistant to photolysis... It requires at least 500 years to decompose and is quickly becoming a permanent part of our geological record... Styrene residue is found in 100 percent of all samples of human fat tissue... Uncompressed, this material would fill the entire volume of this gallery.* Milled EPS cornices and ornaments purchased online from the "Foam Factory" in Pompano Beach, FL, hang on the wall like spoliated antiquities displayed at the Metropolitan Museum of Art. The pavilion's white walls appear color-matched to Benjamin Moore shade Genesis White 2134-70, the exact tone of freshly extruded EPS. That is, until you look closer at the displayed waste partition. Leaning in, multi-colored flecks appear, a tell-tale sign of foam recycling.

Two large-format images by photographer Jane Messinger displayed nearby capture the recycling plant where Li's plastic foam originated, offering a singular chromatic moment in the gallery space. The glossy framed prints show workers and machines in blues and grays, sorting and moving EPS shreds in Boston, MA, where Li acquired the compressed foam block innards. The bright hues in the photographs—a welcome reprieve from the stark white plastics—ground the installation in place, in a plastics recycling factory 3,000 miles from Venice, Italy.

August 1, 2023
Venice, Italy [visited via photographs]

On the phone, Li, one of the US pavilion's five "Everlasting Plastics" artists, responds to my questions as our conversation shifts from community, ethics, inspiration, curiosity, and hesitation to the importance of place. Li's career is rooted in field-based materials research. I spoke to her during her artist residency at the John Michael Kohler Art Center—near Sheboygan, WI—between her metal casting experiments, where she deployed large-scale resin-bonded sand molds to explore the material limits of cast iron and brass. She describes her path as "half accidental, half intentional."[2] Li's family moved from Luoyang, China, to Stockholm, Sweden, where the artist grew up. She completed her undergraduate studies in Architecture at Cambridge University in the United Kingdom before moving to the United States for graduate school at Princeton University. As a sole practitioner and a non-US citizen, Li found the intersection between art and architecture to be a liberating and productive space for exploring alternatives to commercial practice centered around research and making.

"The [EPS] project started long before the Biennale." Li's thinking about complex material supply chains and the enduring lives and afterlives of materials remains a facet of her practice. In 2019, she was awarded a six-week residency at Recycled Artists in Residence (RAIR), located in a construction and demolition waste recycling facility outside Philadelphia. At the waste-focused art residency, artists observe the sorting process, seeing how construction waste moves through a site, and make art from discards. While there, Li began thinking about the environmental footprint of plastic. "My interest in EPS came from that [experience]," she said. "It's a building product with a large footprint in the construction industry, but one

that we never see—it's often used as liners or fillers or as a lightweight substitute for mass." The RAIR residency informed an installation at Space p11 in Chicago, IL, for the 2019 Chicago Architectural Biennial, wherein Li explored how waste foam was re-assigned value in heavy components—"bales," as Li referred to them. This term leads me to think of hay, marking these components' aesthetics within political economy's terms, in a haybale—a common Midwestern currency unit.

August 8, 2023
Phone Conversation Between Westbrook, CT, and Sheboygan, WI

I travel nearly an hour to a small industrial EPS recycling shop on a clear, sticky, East Coast August day. A white, generic sign out front reads in raised block letters, "INSULATION TECHNOLOGY INC." The building is quiet, but I imagine a voice inside say, "TOO HEAVY." I imagine a worker's guttural response, low in the throat, lifting the white synthetic rock-like material, shoulder muscles tense with strained effort. I picture a foreman calling out the mistake. My mind flickers through possible scenarios with the compressed blocks as I peer through the EPS recycling manufacturer's open door, behind which forklifts lay still, waiting to grasp and move the hefty cubes.

Li told me that the compressed EPS scrap blocks used in her installation require at least two people to carry when intact. EPS is undervalued in the waste stream, considering its ecological cost—heavy with known carcinogens, but cheap on the market. Motionless, monolithic, white blocks line the recycling center's back wall, awaiting loading and shipment to the next supply line destination.

In Bridgewater, MA, the small, ivory metal-recycling depot is offset from the paved road. Out of sight but hardly out of sound, the depot's acoustic patterns commingle with those of its nearby industrial neighbors— the Redi-mix cement plant churns, a new cellular tower hums, Osterman Propane hisses, and the Diesel Truck Repair shop sporadically clangs. The manufacturers do not appear to complain about the crushing, cracking noise from the partially open foam-recycling center's garage door. Each facility takes advantage of the trucking corridor's common road and industrially zoned codes, a shared spine not only built to accommodate the width of a crate chassis but also free of decibel requirements or neighbors complaining about the smell of off-gassing plastics.

Across the main access road from the recycling center, Lake Nippenicket, an over 350-acre natural pond known colloquially as "The Nip," witnesses the changes in the land brought on by the small industrial park. The lake is bordered by the Hockomock Swamp, with woody growth and thick cattails, split and cut. The recent development of logistics warehouses and storage centers does not deter the marsh's growth. Adjacent wetlands and floodplains share land with the small factories and industries on muddy, industrially zoned plots, located a truck-ride's commute from the nearest metropolis, Boston. Small-scale industrial zones and wetlands are hydrologically connected underground through medium- and high-yield aquifer networks and above-ground aqueous bodies—Nunkets Pond, Titicut

decompose and is quickly becoming a permanent part of our geological record. Styrene residue is found

Swamp, and Coweesset Brook—their names signaling the ancestral lands of the Wampanoag and Nauset peoples, who call these places home. Water finds a way here, seeping underground via small streams and wide channels, undiscerningly connecting natural and industrial places. Curving landscapes turn abruptly into straight paved roads, gesturing toward the fundamental suburban development struggle of modern single-use zoning. The industrial corridor is a place for canoe paddling and petroleum substances—contemporaneously found in land-use maps and recent studies evidencing the abundance of PFAS—a common toxic used in plastic production—in nearby waterways.[3]

EPS plastic is hard to recycle. For the Biennale, Li focused on EPS's scale and movement: "I'm interested in the inventory systems through which this material is packed, sorted, and transported." Li's blocks were taken out of the supply chain from Save That Stuff in the Charlestown neighborhood of Boston. Built on an infill marsh, the Save That Stuff facility is a plant twin of the facility I visited in July. Both are integral to the plastic recycling network in New England, accommodating materials not accepted at your typical curbside weekly pick-up.

Consumer recycling markets do not easily accommodate EPS. Financially, it's too light. EPS takes up too much space to make it economically feasible to ship—standard EPS is roughly 100 times lighter than a similar volume of soil. To recycle EPS, recycling shops, such as Save That Stuff or Insulation Technology, Inc., use industrial machines and electrically driven pressure to crush and condense EPS. Cold compression, for example, is used to compact EPS waste to roughly 3 percent of its original volume. This size reduction reduces other costs, like transport and storage. White EPS, like Li's, is sorted manually in the recycling center. Workers inspect stockpiles of EPS scrap by hand for contaminants before they are moved into a multi-step shredding process. First, the parts are broken into palm-sized pieces. Then, the material is ground and sifted to create a post-substance called "shred." Shred is then cold-compacted for transport to another location, where it is melted down into other chemical components and cast into molds to form new consumer products. This is where Li's installation intervened. Her installation diverted this ready-made yet transitional unit of value out of the waste stream and placed it within the space of the gallery. In this gesture, Li gave plastics a place. "We don't often think of waste as site-specific, but it is." The Venice installation ultimately comprises "5,700 pounds of EPS waste intentionally shipped from the United States." A series of steel footings beneath the installation helped spread Li's heavy plastic load, culled from Massachusetts, onto the US Pavilion's antique brick foundation walls—modern North American waste piled on top of Venetian debris forged to make land on an unlivable marsh.

Li's white blocks hold a telltale sign of their journey and recycling past of coming through a second-use plant—flecks of black, crimson red, and vibrant blue shimmer stand out amidst the bright white foam. The minuscule multi-colored pieces are an EPS recycling after-effect, known as commingled waste. Errant missed package labels, tiny bits of other plastics, or adhered composite pieces from a sandwiched wall assembly create the microscopic, chromatic shimmer.

August 11, 2023
Bridgewater, MA

The Science History Institute in Philadelphia acquired the Dow Chemical Historical Collection in 2008. First culled and organized by a former Dow public relations employee (and then director), E. N. Brandt, the assorted archive ranges from disparate formula records to memos about the corporation's chemical start in bleach from the company's founder, Herbert H. Dow. Digging deeper, the repository reveals that Dow's synthetic chemicals are not generic or placeless.[4] The molecules and mixtures are from Dow-owned complexes concentrated in Michigan, Texas, Louisiana—localities journalist Ida Tarbell deemed "Oil Regions" in the early twentieth century and spots historian Rob Nixon named harbingers of "slow violence."[5] Extraction zones and production factories merge on Dow estates and in their products—like expanded polystyrene. EPS comes from Midland, MI, a situated plot of land heavy with the invention's success and its ecological catastrophe—land home to Dow's midcentury chemical wealth and haunted by an over 21-mile-long toxic US Superfund site spanning from the Tittabawassee River to the Saginaw Bay.[6] Environmental concerns cascade through the Midwest, a portent of the auto industry's polluting ways on the Cuyahoga River, the Flint water crisis, and more—the environmental historical opposite of a flyover region: a place where ecological problems come to stay. Industry provides jobs to the area, but along with economic gains comes environmental sacrifice.

Expanded polystyrene finds its start embedded in a combination common to synthetic chemical production's reach—oil extraction and the military-industrial complex. From 1931 to 1933, at Dow's Midland headquarters, a third of the Dow Chemical Physics Lab (a team of fifteen) dedicated its research time to improving styrene plastic production in order to find new uses for the material—a compound substance primarily made from ethylene and benzene after Dow oil and gas prospecting found new abundant sources of the chemical feedstocks.[7] Dr. Sylvia Stoesser, the chief scientist on the project, attempted to make the new styrene compound more commercially viable—eventually discovering that ethylene and benzene could form ethylbenzene. Ethylbenzene could then be easily hydrogenated to make a styrene monomer, which could be linked to form a styrene polymer—plastic. As World War II took hold, Dow's excess ethylene proved advantageous. Dow found ways to implement styrene into wartime products, blowing air into it to make it easy to move and float. The company made it into buoys, flotation devices, synthetic rubber, and other equipment needs. During the war, from 1937 to 1945, Dow produced and sold over 200,000,000 pounds of styrene.[8]

After World War II, Dow projected (or manifested) a postwar plastics boom. Ray Boundy, Dow's plastics department chief in Midland, visited Germany to survey the plastics operations at IG Farbenindustrie. At the same time, Bill Dixon, assistant director of Dow Plastics, met with the Dow Board of Directors in a meeting that led Dow to invest heavily in plastics expansion. To improve their chances, Dow Chemical purchased a wartime government-built styrene plant in Velasco, TX, and initiated an "aggressive" marketing campaign to make Dow Styron (the brand name for Dow styrene plastic) a household name. Ted Doan (later president of Dow) would recall

the moment as a turning point in Dow's history. Dixon was "a marketing genius, perhaps the first inventor of advertising to create demand back through the chain of supply."[9]

In nearby Detroit, MI, I can imagine the burgeoning industrial plastics empire that volleyed to outshine Ford Motors in the 1950s. I picture the small-scale plastic factories buying feedstock chemical supplies from Dow Chemical in nearby Midland. Expanded polystyrene remained out of the building materials market until the 1950s and 1960s, but, prior, it was a decorator's delight, centrally located and produced in Detroit. In 1948, Schwab & Frank Inc. in Detroit consumed the most expanded polystyrene in the US—5,000,000 lightweight ornaments and 30,000 bushels of "snow," used to manufacture miniature snowmen, holiday ornaments, and fake white precipitation for Hollywood sets.[10] Fred Schwab and Jack Frank came up with a new business idea for the surplus white material. After a test market study showed the appeal of the material that was "Christmasy in appearance, unbreakable, and didn't weigh down the branches of the Christmas tree," the company purchased the styrene logs from Dow. Machines sawed the logs into desired lengths and turned out over 1,000 ornaments an hour. Small-scale production plants like Schwab & Frank Inc. helped create a demand diversity for EPS plastics.

Dow and EPS also connect places like Texas and Michigan— through oil and gas. The substances, when cracked, form the recipe for plastics—heat and pressure, applied to extract oil and gas, break the matter into their constituent chemical molecules. The Eagle Ford Shale near the Brazos River in Texas and the Antrim Shale near the Saginaw Formation are underground resources with Dow-owned plants on top. The strategic placement is no coincidence. "There were no plants on the West Coast to make these products—vinyl chloride, and the petrochemical line that Dow makes in Texas, styrene, ethylene, propylene, acetone. The question was whether you could get through the environmental laws and restrictions on the Coast."[11] Texas and Michigan relied upon chemical expansion, like Dow's, for economic gains, jobs, etc.—and, in turn, developed a regulatory environment friendly to polluters.

Styrene research propelled Dow from fifteenth in size in the plastics industry to second place behind Union Carbide in 1957.[12] From Fischer-Price toys and Dow insulation boards in the 1950s, they went to the *Plastic as Plastic* exhibition (sponsored by the Hooker Chemical Co., a subsidiary of Occidental Petroleum Corp.) at the New York Museum of Contemporary Crafts in 1969, where designer Douglas Deeds presented a room sprayed with polystyrene foam. Plastics historian Jeffrey L. Meikle revels in how rapidly polystyrene products were adapted into the design world and defined the North American twentieth century.[13] Styrene became Styrofoam, Styron, and Saran polymers before being sold as products for consumers' homes, including in paints, appliances, electrical wires, sealants, and insulation.

A memory floods back when I think through the polymer connections in Midland. In 2018, I spent a leisurely Saturday afternoon touring three Midland midcentury modern homes. Ticketed guests, part of a parade of homes, shuffled through bathrooms and closets designed by local architect

Alden B. Dow, son of Dow's founder, Herbert H. Dow. Amidst the glossy Formica countertops and living rooms featuring red plush-carpeted terraced conversation pits and mirrored storage doors built for entertaining, I spoke to one of the volunteers, Nancy, who guided us through each room, quietly keeping us within the areas we were supposed to see and not in the rooms blocked from our view. I asked Nancy about a remarkable, gold, transparent chandelier perched high in the home's raftered dining room. "Plastic!" she cried.

August 14, 2023
Midland, MI [via Science History Institute, Philadelphia, PA]

In the 1950s, plastics also hit Washington, DC, in the Russell Building. The Russell Building was a crucial place in government and policy decision-making. Bounded by Constitution and Delaware Avenues and First and C Streets, the Beaux Arts Senate Office Building—later known as the Russell Building—contains a third-floor conference and public hearing room, the Caucus Room. Twelve Corinthian columns along longitudinal walls ground a ceiling laced with gilded rosettes, acanthus leaves in rows, and a ribbon stretched in a Greek key pattern; below sit six mahogany benches and two high benches capped with carved eagles designed by the Francis Bacon Furniture Company in Boston. Holding some of the most famous Senate Investigation hearings, from the hearings on the Titanic's fate to Watergate, the room also housed another debate in the Congressional Record: a select committee on small business that heatedly argued about postwar material shortages in plastics.

On January 23, 1951, business people from Louisiana, Iowa, Minnesota, Kansas, Massachusetts, and New Jersey amassed in the magisterial Caucus Room. Chaired by John Sparkman from Alabama, the meeting convened to debate the material shortages following the war. Dr. Lowell B. Kilgore, from the National Production Authority, Chemical Division, avowed, "It is obvious from the foregoing discussion that the amount so allocated to individual customers is quite likely to be insufficient to meet their current desires." William Dixon, from the Dow Chemical Company, followed in response to the conditions of the 1950s, stating, "About 25,000,000 pounds went into a very ingenious use which did not exist in 1945, except in one man's mind, the idea you could make a satisfactory wall tile out of polystyrene. It started out from nothing in 1945 and soon consumed about 25,000,000 pounds in the last year. It is an accepted building material today."[14] In the Caucus Room, plastics became a priority for chemical lobbying and a known substitute for rarer materials—steel, wood, clay, etc. From Christmas ornaments to Congressional hearings, plastics found a secure place in building materials in the 1950s, bounded by cheap inventions and political will.

August 17, 2023
Library of Congress [Washington, DC]

Li mentioned that she was approached at the Biennale opening to expand on whether her work could be read as an architectural prototype. The question echoed much of the architectural world's fascination with product

development and use-value and could be put another way: If one could use EPS for an art wall, must it have a real-world application? "The blocks of compressed EPS scrap in the installation have few useful applications in the conventional sense. They crumble when you pick them up. They don't have any significant load-bearing capacities," replied Li, refuting the professional questioning of use. "Monumentality was the most important thing. Instead of looking at it as a useful building material, I was more interested in using the piece to illustrate the scale of EPS build-up in our immediate environments." In Li's work then, EPS, pulled from a lifecycle of use, reuse, and disposal, becomes a visual symbol for the monumentality of industrial plastic waste, not a poster child for why we should recycle it.

Li's installation is no loud protest against plastics; it does not wield a research-heavy charge against petrochemical maladies. Her practice is unlike art-meets-performance protest organizations such as Art Not Oil, BP or not BP?, Shell Out Sounds, Stop Fossil Fuel Subsidies, the Climate Emergency Fund, or Extinction Rebellion, wherein performance and art become conduits of direct action and environmental protest. These groups work with big gestures, disrupting a Van Gogh viewing with soup, projecting climate warnings on the London Houses of Parliament, and revealing a Board of Directors' ties to big oil. Li's practice also does not emulate research-heavy tendencies of recent art and architectural exhibitions, in what critic Claire Bishop has called the "information overload" complex, wherein exhibitions "convey a sense of being immersed—even lost—in data," or what critic Emily Watlington has recently pointed out as research-based art that appears too truthful with "fuzzy evidence."[15]

Li avoids these trends. Does it provide a remedy for our future peril swimming in plastics? No. Does the piece reveal the materials' secrets? No. Do Koolhaasian infographics and pseudo-research overwhelm you with the dos and don'ts of the Petro-sphere? No (and thank goodness). Attention, quiet reorientation, and understanding that plastics affect a long supply chain from Massachusetts to Venice, Italy, are enough. As she stated, "It's a material that is similar anywhere. It was about bringing a specific piece of the waste stream into the gallery." Instead, *Externalities* is an embodiment of plastics, a sculptural silence, with pauses, flashes of color, and minimal words, giving the viewer time to reflect and be both intimate and distant with plastics. The piece is deeply political, even if it doesn't shout it, bound quietly to the contemporary environmental crisis, climate change, and our polluting ways. Li's Biennale installation commands a quiet reconsideration of the place of plastics, humanity's role in the material's proliferation, and architecture's responsibility in the petrochemical moment.

My own perspective had changed by the time I got back to my Connecticut home. Looking out across my backyard industrial marsh, I think of the journey here, there, and back again during the hot August month—nearly 3,000 miles from Connecticut to Venice and back (making the tour mostly virtually) with only 789 extra miles on my Tacoma truck. Often presented as universal or placeless, I found that plastics have a place. In fact, places. From Cleveland and Boston to Michigan and Venice, EPS, or expanded polystyrene, is now a cornerstone of the modern building industry. Ang Li's

approximately 1,370 tons of EPS is buried in landfills every day, where it occupies more space than a▮

quiet white room gently prods for us to question more. Less agnotological, more begging for investigation, the stacked wall mirrors an industry bound together by whispers and opaque power—in patents, Congressional hearings, and production in off-the-map places. The artwork (and the industry it attends to) appears disconnected at first but, when woven together, piece by piece, aggregates into a plastics empire largely unseen.

In a review following the opening of the 2023 Venice Architecture Biennale, architecture critic Christopher Hawthorne asks questions about the architectural nature of the plastics-themed US Pavilion. "Compared with the most memorable pavilions this year, which are linked by a messy, raucous interest in communal experiments that draw visitors into their imagined worlds, this one feels inert, not nearly plastic enough. It also has relatively little to do with architecture."[16] I disagree. The revelation of plastics at the US Pavilion challenges not just the durability and composition of buildings but also the canon, a canon locked in formal notions of what a building looks like or the individual authorship and singular genius of who created it. The issue is that much of the architectural profession and architectural history disregards the very presence of synthetic chemicals (and, by extension, plastics) in historical and contemporary building practices. Only recently do material explorations, such as the US Pavilion's, place architecture within its commodity and capitalist reality.

"Everlasting Plastics" casts twenty-first-century architecture in doubt. Li's material critique embedded in *Externalities* hints at the profession's theoretical smugness (or at least its lack of engagement) and often eco-historical naivete. If formal majesty or grand visions no longer hold timber, bricks, and concrete together, these materials bound instead, monumentally yet perilously, in building codes, chemical compounds, logistics, supply chains, ecological heaviness, and environmental toxicities in plastics, then Li's work—acute, quiet, and raw—lays bare the architecture that we know today, allowing us to see the architecture of contemporary plastics—durable, yet fragile—and imagine its undoing.

many as 20 times while still retaining all its physical properties. The current market rate for EPS scrap is 30 cents per pound. The recycling cost for EPS foam is approximately 1.5 dollars per pound, making it a loss-making proposition for many recyclers. During the recycling process, discarded EPS fragments are shredded and compacted into dense blocks through a 40 to 1 compression ratio to make them easier to transport and store. One pallet of densified EPS scrap contains roughly the same amount of material as a 40-foot shipping container full of uncompressed EPS foam. This installation contains approximately 250 cubic feet of densified EPS scrap blocks. Uncompressed, this material would fill the entire volume of this gallery.

2 All quotes from Ang Li are taken from a phone interview with the artist on August 8, 2023.

3 Barbara Moran, "Toxic 'Forever Chemicals' Force Mass. Towns to Face 'True Cost of Water,'" *WBUR*, February 14, 2023, https://www.wbur.org/news/2023/02/14/pfas-pfoa-massachusetts-drinking-water-clean-up.

4 Patrick H. Shea, chief curator of archives and manuscripts at the Science History Institute, in discussion with the author, July 2022.

5 Ida B. Tarbell, *The History of the Standard Oil Company,* ed. David M. Chalmers. (New York: W. W. Norton, 1966), 34–45; and Rob Nixon, *Slow Violence and the Environmentalism of the Poor* (Cambridge, MA: Harvard University Press, 2011).

6 For more on the Tittabawassee River and Saginaw River and Bay, see the EPA's Superfund profile, https://cumulis.epa.gov/supercpad/SiteProfiles/index.cfm?fuseaction=second.cleanup&id=0503250#bkground.

7 The Physics Lab excelled in the United States Depression era and hired for scientific research jobs when dire conditions existed throughout the rest of the country. Sales continued, and no major cutbacks occurred. Ray H. Boundy and J. Lawrence Amos, *A History of the Dow Chemical Physics Lab: The Freedom to Be Creative* (New York: M. Dekker, 1990), 5–11, 92.

8 Boundy and Amos, *History of the Dow Chemical Physics Lab,* 103.

9 E. N. Brandt, *Growth Company: Dow Chemical's First Century* (East Lansing, MI: Michigan State University Press, 1997), 583.

10 A. J. Cutting, "Snowballs all Year 'Round," *Nation's Business*, December 1948, 60.

11 A.T. Look, interview by E. N. Brandt, quoted in Brandt, *Growth Company*, 170.

12 Don Whitehead, *The Dow Story; the History of the Dow Chemical Company* (New York: McGraw-Hill, 1968), 236.

13 Jeffrey L. Meikle, *American Plastic: A Cultural History* (Middlesex County, NJ: Rutgers University Press, 1995), 185 and 189.

14 *Material Shortages, Plastics: Hearings before the Select Committee on Small Business*, 82nd Cong., 1st Sess., January 23, 1951.

15 Claire Bishop, "Information Overload," *Artforum* 61, no. 8 (April 2023), https://www.artforum.com/features/claire-bishop-on-the-superabundance-of-research-based-art-252571; and Emily Watlington, "When Does Artistic Research Become Fake News? Forensic Architecture Keeps Dodging the Question," *Art in America,* March 15, 2023, https://artnews.com/art-in-america/features/forensic-architecture-fake-news-1234661013.

16 Christopher Hawthorne, "Radical Rethinking at Biennale: Africa and the Future Share Pride of Place," *New York Times*, May 22, 2023, https://www.nytimes.com/2023/05/22/arts/design/venice-architecture-biennale-review.html.

PROOFING:
Resistant and Ready

Xavi L. Aguirre

Xavi L. Aguirre (Cambridge, MA; they/them) is an architectural designer, founder, and director of the architectural design practice stock-a-studio and assistant professor of Architecture at the Massachusetts Institute of Technology. They develop material tactics and assemble architectures that reconsider our relationship to material circulation and aesthetics by making visible how architectural commodities pass through our built environments, both physically and digitally. Aguirre's built and exhibition work has been commissioned by MOCA Geffen, Dartmouth College, Superblue Miami, Berghain Club, Materials & Applications, Queer Pile Up, and Design Core Detroit. Aguirre received a Master of Architecture from California State Polytechnic Pomona.

Acknowledgments

Design:
stock-a-studio

Sound:
Ash Fure

Commentary:
Deborah Garcia

Fabrication:
Agnes Parker
Cheng Qin
Samantha Ratanarat
Zachary Schumacher

Video:
Boneless Pizza - Studio
Ian Erickson
Jayson Kim
Zachary Slonsky

Website Design:
Ian Erickson
Zachary Slonsky

Installation Support:
Parasite 2.0

Audio Visual Support:
Chris Wood

Institutional Support:
Massachusetts Institute of
Technology School of
Architecture and Planning
Center for Art, Science
& Technology at Massachusetts
Institute of Technology

Surrounding us in a site-specific installation, Xavi L. Aguirre complicates our relationships with plastic proofing materials. These materials attempt to hermetically seal us from moisture, heat, and other threatening elements—to preserve us in time. Appropriating theatrical scenographies and club cultures, Aguirre creates a space of material entanglements that exemplify how repellant architectural tactics can attract and envelop us, suggesting a collapse between protection and endangerment. Aguirre invokes tactile relationships with the built environment through physical intimacies echoed in the immersive environments. Straddling two galleries, this multimedia installation probes future-proofing through scales of consumption.

A Suite on Architectural Disobedience

madison moore

madison moore is an artist-scholar, DJ, and assistant pro-
fessor of Modern Culture and Media at Brown University.
His first book, *Fabulous: The Rise of the Beautiful Eccentric*
(Yale University Press, 2018), offers a cultural analysis
of fabulousness as a practice of refusal. moore has performed
internationally at a broad range of art institutions and
nightclubs, including The Kitchen, Performance Space Sydney,
San Francisco Museum of Modern Art, and the Bemis Center
for Contemporary Arts. In February 2023, he guest co-edited
a special issue of *e-flux* on BLACK RAVE with McKenzie Wark.
moore is currently writing a book about queer nightlife.

It's hot in here. Dark, moist. Show your ID. Inside. Drop your coat at the coat check. Your eyes slowly adjust to the opacity of the space. Say hi to your friends. Feel the cascade of techno beats as they wrap around you. T gives you a drink ticket. Then: swerve through the crowd. Someone hot walks by: cruise them.

Techno is music that generates a symphony of sweaty, damp bodies moving, undulating, swaying, stomping through the groove, their screams and cheers adding even more steam to the room. The walls: *resistant and ready,* and dripping with perspiration. The floor and industrial-strength dancing platforms are caked in an ooze of sweat and spilled beer and vodka sodas, what I have called elsewhere "residues of sleaze," or the residual husks of queer pleasure.[1]

Through this moist steam of bodies moving, pulsing, colliding, I am reminded of *PROOFING: Resistant and Ready*, the architectural designer Xavi L. Aguirre's two-part contribution to the exhibition "Everlasting Plastics" at the United States Pavilion at the 2023 Venice Architecture Biennale, an installation that, in Aguirre's voicing, might propose a modular architecture of queer pleasure. I'm drawn to the brilliant way Aguirre describes architecture as "nothing but liquid management: drainage, plumbing, roofing, gutters, rubber polymers, barrels," adding that they "like the exercise of reducing buildings to an assembly of materials that manage moisture or control erosion."[2] Taking this emphasis on moisture as a cue, I'm thinking about spaces that manage and facilitate sweaty bodies working in pursuit of pleasure—spaces like dance floors, clubs, gyms, and sex clubs. When we go to the gym or the rave or the club, we don't often consider how these spaces are made or what they look like, probably because we are plunged into darkness, so we can't see anything, anyway. The point is that these kinds of venues must be made of materials that can manage a lot of sweaty traffic while also being able to withstand whatever you are going to do to/on/with/in the space.

The strongest memory I have from my first underground techno rave is how much I sweat the moment I got there. "Blade Moth," a 2014 minimal techno workout by Xhin, played in the background, and I was really feeling it. I didn't know it was possible to sweat so much. Within minutes of getting inside the venue, an undisclosed location far away from the urban center, I was coated in my own mist, and everybody else's mist, drenched and dripping, all before I even started dancing.

Even though my body temperature eventually adjusted to the space, I knew this sweat was part of my initiation into this other collective experience. It was a threshold I had to cross to fully transition into this room, this symphony of bodies—a residue that marked this time and space as different from wherever I was before.

Sweat might be normalized here, but, outside of the club, the gym, the rave, and the sex club, sweat is embarrassing, a "moisture excreted in the form of drops through the pores of the skin, usually as a result of excessive heat or exertion."[3] We use antiperspirants to help protect us—and others—from our sweat, to proof the body from sweat. You can take showers at the gym after a vigorous workout to re-enter the world fresh and clean. It turns out that buildings aren't the only structures that require moisture management. The body doubles as its own architecture in the

madison moore

pharmacopornographic era Paul B. Preciado describes so lyrically, as we rely on medical and over-the-counter treatments and modifications to control odor, hair, and skin—in other words, to manage, proof, and make the body resistant and ready for any kind of gaze or scrutiny.[4]

But not all sweat is created equal. A fever, a morning jog, the gym, the club: these are situations where sweat is the expected ephemeral residue of illness, exercise, or play. Drenched armpits outside these spaces often lead to feelings of shame and embarrassment—there is an appropriate time and place to sweat. Part of the allure of dancing and sweating at the club or the rave is the choreography of moisture: your moisture becomes my moisture, damp bodies moving, undulating, swaying, stomping through the groove, a symphony of sweaty bodies blending, blurring, and dissolving into one, all in service of "smearing the edges of subjectivity," as McKenzie Wark eloquently puts it.[5]

Aguirre's immersive work *PROOFING: Resistant and Ready* underscores the notion of architecture as nothing more than a system of liquid management, just as the installation suggests that there might be an architecture of sweat: locations, situations, and scenarios where sweat is not just the moisture in the room, wet beads on bodies, but is also actually facilitated and encouraged in the space. How might these architectures of sweat—and the hardness or softness of their materials, their tactility and responsiveness—facilitate an architecture of queer pleasure?

> *Proofing:* "To make proof against or impervious to something; to render resistant to some force or element; (originally and esp.) to render (a fabric, an article of clothing) impervious to water. Frequently with a modifying word specifying the object of resistance."[6]

> *Resistant:* "That makes or offers resistance or opposition; tending to resist someone or something; unyielding; not susceptible. Frequently with to."[7]

> *Ready:* "In a state of preparedness, so as to be capable of immediately performing or undergoing what is implied or expressed in the context."[8]

I lay out these three definitions—*proofing, resistant, ready*—to unstrap how architecture might facilitate a poetics of pleasure, a raw, sweaty, disobedient pleasure. In the simplest terms, *PROOFING: Resistant and Ready*—a rhizomatic extension of Aguirre's *someparts* project—is a modular, light scaffolding system made of screws, foam, rubbers, gaskets, bent aluminum, silicone, nuts and bolts, straps, soft pads, and pieces of WonderBoard Lite, a type of cement board that is not waterproof but which has "a significant ability to remain unaffected by prolonged exposure to moisture."[9]

This scaffolding and WonderBoard system is positioned throughout the room in five different configurations, scenarios, or situations, with each set-up flirting with another kind of use, proposing a new situation or way to engage.

WonderBoard Lite: "... a significant ability to remain unaffected by prolonged exposure to moisture."

When I showed K, a close friend of mine, images of *PROOFING* and mentioned I was writing a piece about it, the first thing he said to me was that it looked like some kind of techno sex dungeon. Not quite the response I was expecting! When I told him it was actually an installation in an art gallery that was part of a world-famous architecture biennale, he said, "Well, if you turned off the lights, you could easily imagine a pup in a sling."

Pushing this thread a little further, I asked what about this work made him think so specifically about a techno sex dungeon—particularly as he is not really interested in these kinds of spaces on a personal level. He immediately pointed to the materials and severity of the aesthetics: the metals, the suggestive situational positioning in the work, the industrial PVC curtains, the concrete floors. I would add to this the sense that *PROOFING* is not particularly precious: it is there, an obedient sub, ready to absorb and endure all kinds of impact and whatever else you plan to do to it. *Resistant:* that which "makes or offers resistance or opposition; tending to resist someone or something; unyielding; not susceptible. Frequently with to."

Within contemporary techno culture, and particularly within queer techno rave worlds, there is often a punk embrace of the aesthetics of severity through hard sounds, concrete, and the ruins of industrial spaces and industrial materials. The fashion, too, is often hard and uncompromising: severe haircuts, hard edges, and metal surfaces, usually in the form of jewelry: piercings, bracelets, harnesses, locks and chains around the neck, all of these doubling as symbols of BDSM subculture. Metal, PVC, concrete: indeed, these are all materials you might find in sex clubs and other spaces of vigorous aerobic activity, not least because they last a while, don't need to be changed much, and can absorb impact, but also because you can sweat anywhere and on anything, the space easily cleaned, wiped down, hosed off, sterilized, and, most importantly, available for the next use. *Resistant and ready.*

K's comment sticks with me, not because I think it offers some kind of definitive close reading of Aguirre's work, but because of the way their comment—*à la Dick Hebdige*—draws on a precise set of queer subcultural knowledge practices and reading strategies. For Hebdige, the heft of subcultural formations lies in a particular kind of semiotics, whereby ordinary objects that mean one thing in one quotidian context are hacked into to create whole new meanings right now and in subculture. The reality and tea, however, is that not everyone has the tools to understand these new, often secret meanings. In *PROOFING*, some will see a modular set up of building materials, some will think about a gym or a playground, and some will see a techno sex dungeon.

Cultural critic Gayle Rubin's notion of "scary sex" comes to mind as an urgent reminder of the types of sexual practices, geographies, and locations that are seen as socially acceptable.[10] In Rubin's telling, our "culture always treats sex with suspicion. It construes and judges almost any sexual practice in terms of its worst possible expression. Sex is presumed guilty until proven innocent," adding that "virtually all erotic behavior is considered bad unless a specific reason to exempt it has been established."[11] For

Rubin, the most acceptable reasons to have sex include three things: marriage, reproduction, and love.[12] This architecture of control and skepticism around sex leads to a sexual value system of "good" and "bad" sex, wherein "good" is straight, monogamous, "normal," and "natural," and "bad" might include promiscuous sex, commercial sex, or sex in public, the bushes, or the baths.[13]

Given these value systems of "good" and "bad" sex, more often than not, entering a gay bar or club can feel like walking into a police state, with strict warnings of what *not* to do. Isn't it interesting that bars and clubs are quick to tell us what we *cannot* do, but rarely what we *can* do? Indeed, some of the most policed sites and sexual geographies include bars, clubs, raves, and, certainly, cruising grounds, which can include bathrooms, wooded areas, parks, and industrial zones. In Pat Califia's telling, the legal difference between public and private sex is not quite as simple as making a choice between your room or the bushes. "There are many zones in between—a motel room, a bathhouse, a bar, an adult bookstore, a car, a public toilet, a dark and deserted alley—that are contested territory where police battle with perverts for control."[14] These spaces are policed in the most immediate sense—officers patrolling the area actively looking for disobedience—but they are also policed through more sinister and diffuse strategies like hostile architecture and changes to zoning laws to limit or prohibit where these spaces are located, whether they have doors, how high the doors are, when you can use them, and rules dictating what kinds of activities you can't do there.

This is all to say that architecture has not been kind to practices of cruising, and for many scholars, architecture has inadequately addressed the centrality of sex to everyday life. "It's odd how little architects have had to say on the subject of sex," cultural critic Richard J. Williams says. "If they're routinely designing the buildings in which sex happens, then you might expect them to spend more time thinking about it." He adds, "Buildings frame and house our sexual lives. They tell us where and when we can, and cannot, have sex, and with whom. To escape buildings for sex—to use a park, a beach, or the back seat of a car—is a transgression of one kind or another. Most of us keep sex indoors and out of sight."[15]

Building on the methods architecture uses to facilitate or discourage sex, the geographer Johan Andersson describes how the "historic restoration" of London's Bloomsbury neighborhood in the 2000s was actually a front to clean up the area from gay men cruising.[16] And in the 2018 Venice Architecture Biennale, the *Cruising Pavilion*—curated by Pierre-Alexander Mateos, Rasmus Myrup, Octave Perrault, and Charles Teyssou—aimed to draw attention to the dynamic interplay between architecture, cruising, and sex in public. "In the bathrooms built for cleanliness and the parks made for peacefulness," the curators write, "the modern city is cruised, dismantled and made into a drag of itself. The dungeon becomes playful, the labyrinth protective, and the baths erotic... Architecture is a sexual practice and cruising is one of the most crucial acts of disobedience."[17]

Instead of crackdowns on zones and locations of pleasure, dancing and sex, what if we could imagine a modular, temporary architecture that facilitated and encouraged pleasure? *Hose it down. Wipe it clean.* What

if you could attach speakers to it, and what if you could dance on it? What if it had a DJ booth and a bar? What about a modular chillout space with ambient music, and what about a modular dark room that could pop up at the edge of parking lots or in city centers, not unlike the urinals in Amsterdam that emerge out of the ground on the weekend? Indeed, in a moment when the increased financialization of urban space has led to the rapid closure of gay bars and other sites of disobedience—when it is often not feasible to open and sustain a gay bar, meaning we are losing gay venues left and right—what if the gay club was a modular form that could pop up anytime, anywhere?

Aguirre's work gives us the tools—literally the tools—to imagine and bring to life the capaciousness of this kind of architecture "on the run"— on the run from surveillance, on the run from cooptation, on the run from all sorts and kinds of enforcements, sometimes before they can even catch up, which is not possible in a more static architecture. This architecture "on the run" is dynamic, because it relies on the endless configurability of modularity, hacking, and plasticity, wherein spaces and materials can become whatever they need to be whenever the moment arises, a gesture toward the relationship between modularity and plasticity, or the expectation in the plastic regime that, as the curators of "Everlasting Plastics" write, "plasticity has created expectations for the behaviors of other materials."[18]

In *Queer Forms*, a study of the ways that form has shaped queer worldmaking practices and cultural production, critic Ramzi Fawaz refuses the idea that "fluidity is the most radical quality of divergent genders and sexualities," preferring to understand queerness as a method of shapeshifting.[19] Building on this notion of queer form and the impulse to shapeshift, *PROOFING* reflects Aguirre's broader interest in "an architecture that anticipates its own disassembly" through temporary use, reconfiguration, and reuse in ways that resist both the green rhetoric of recycling and the grand narrative of architecture as tied to singular authorship.[20] In this way, *PROOFING* also responds to the philosopher Paul B. Preciado's call to imagine a trans feminist and queer theory of architecture, one centered on "dematerialized critical practices."[21] In "Architecture as a Practice of Biopolitical Discourse," Preciado draws on a close reading of Foucault's theories of biopower to point out how architecture functions "as a normalizing, genderizing, and racializing force"—a site of control meant to uphold bourgeois values—as well as ways architecture has been used to discipline the body.[22] But, for Preciado, the key to breaking architecture's normalizing force might be to embrace a kind of "architectural disobedience," the kinds of practices of disruption, disassembly, and disobedience that *PROOFING* embraces. [23]

For example, *PROOFING* stems out of stock-a-studio, Aguirre's modular architectural design practice focused on small architectures and furnishings, like plant stands, clothing racks, kiosks, and fruit stands, and to which we can now imagine adding gyms, clubs, rave spaces. The critical gesture and invitation of stock-a-studio is not to use new materials to make something new, but instead to pop up, using and reusing building proofing materials; hacking into materials, spaces, and geographies; hacking into anything anywhere; becoming everything anytime; recirculating,

rearticulating, reusing. This malleable approach to assembly—its own kind of shapeshifting—rhymes with Heather Davis's generative thinking on plasticity. In other words, not only is there nowhere to go to escape plastic, but also our Plastic Age exists "because of the pliable, flexible manner of life in late capitalism."[24] Anything can become anything. *stock-a-studio*: "a rig for life; a perpetually reusable kit of parts for future-minded small architectures; a response to fast furniture and the damaging material life cycles of cheap single use furniture, one of the largest contributors to landfill accumulations."[25]

 An important extension of *PROOFING: Resistant and Ready,* as installed at the 2023 Venice Architecture Biennale, is a three-minute video that further brings the piece to life by drawing on moving image, 3D renderings of Aguirre's modular architecture, and a blistering soundscape by the sound artist Ash Fure, who often collaborates with Aguirre's stock-a-studio to build industrial instruments that are themselves resistant and ready to manipulate sound. The video begins with a grayed-out foggy screen—picture a fresh burst of haze right out of the fog machine—and we are pulled forward into and through the fog. Tension rises sonically with a rhythmic buzz that scratches through the scene and increases in intensity as we are pulled through. Within seconds, the fog breaks, and we finally get a glimpse of the scene: a gray, dystopian mountain top, high in the clouds, with shattered pieces of rock scattered about.

 We're flying now, heading toward a rectangular structure, which seems like it might be the last physical structure left on this particular planet, which might not be Earth. Night falls, and the buzz intensifies. As it does, we are zapped through a tiny peephole into a bright orange space where the ceiling, floor, and walls are made up of triangular-shaped sound-absorbing acoustic pads, a visual cue that rhymes with how soft the room sounds now—muffled. An orange, modular gogo platform/catwalk/dancefloor lines the right side of the room. The range of materials here indicates Aguirre's interest in a multitude of surfaces and their interactions.

 But we're still flying, going through another peephole, entering a new space, this one armed with an intimidating wall of orange Funktion-One speakers—perhaps the most recognizable speaker tower on the international techno dance floor and the soundsystem of choice at Berghain, Berlin's cathedral of techno. Funktion-One speaker towers are celebrated for both their intensity and clarity of sound, important elements for a raving, sweaty dance floor.

 Still flying: another portal, another peephole, another space where the plumbing, infrastructure, and guts of the building become visible, the music growing even more intense before softening again in another space. Here, soft pads are strapped to base structures—resistant and ready for action or relaxation. We move through PVC curtains and into another padded, brightly lit space before being led out onto the roof. The sun is coming out now, and, as we get to the edge of the building, we move past an imposing metal den of pipes that carry and manage the building's moisture and liquids to an atrium layered with mounds of silky fabric, the music quiet, but only briefly, before we are deposited back outside into the rocky, grisaille, foggy dystopia. There are no people: the only thing left is the material.

 `A Suite on Architectural Disobedience`

The most powerful effect of this video is the way it connects the proposed usage of this modular architecture to what these spaces might sound like—at turns soft and muffled, ambient and relaxing, measured and intense. It positions architecture as a sonic practice by highlighting the aural experience of the materials—that is, demonstrating what these materials do to our experience of sound when they are in the room. Each time we go through a peephole, each time we move through a new space—*actually* on the run—we are in flight.

What would it mean to think about queerness as a kind of flying? Where are we going, and will it be fun when we get there? If queerness is a kind of moving through the peepholes of capitalism, what is waiting on the other side?

As a final thought, I'd like to gesture toward what might be the queer stakes of flight and impermanence. Following Heather Davis, if we are in a plastic world and there's no getting away from the stuff now, what might truly evaporating, ephemeral traces teach us, allow us to feel, allow us to do? Might queer worldmaking be a practice of impermanence? When I think about impermanence, I'm not thinking so much about a short life span, notions of the temporary, or "the end," and I'm certainly not thinking about queer erasure. But I am interested in teasing out and embracing the creative spirit of *popping up*. A queer pop-up does just that: it pops up. Though not a permanent structure or situation, a pop-up can often get away with a lot more, taking certain risks because it's not a permanent structure. A pop-up offers a flash, a doing, a taste, a portal, a peephole, a moment or string of moments, an event that, before it has run its course (*or gets subsumed by capital*), evaporates to then make way for a new intervention—one that, this time, might be even more dynamic or fulfilling or interesting. In a culture that values—if not fetishizes—permanence, stability, legibility, location, and binary fixity, and wherein forces of capital often make building and maintaining collective experiences prohibitive and expensive, the flying, itinerant pop-up might offer a more dynamic, disobedient method of creating space, leading us to new pleasures and community.

madison moore

1 madison moore, "Dark Room: Sleaze and the Queer Archive,"
Contemporary Theatre Review 31 (2021): 191.
2 Serpentine Gallery, "Xavi L. Aguirre and P. Staff, Acid
Plumbing at Queer Earth and Liquid Matters | Serpentine," May
22, 2023, *YouTube,* 30:27, https://www.youtube.com/watch?v=ZbJkCJWNrRw.
3 Oxford English Dictionary, s.v. "sweat, n., sense II.2.a,"
accessed September 2023, https://doi.org/10.1093/OED/2738761443.
4 Paul B. Preciado, *Testo Junkie: Sex, Drugs, and
Biopolitics in the Pharmacopornographic Era*, trans. Bruce Benderson
(New York: Feminist Press, 2013).
5 Lychee, "EX.679: McKenzie Wark," September 21, 2023, in *RA
Exchange*, produced by Resident Advisor, podcast,1:03:20, https://
soundcloud.com/ra-exchange/ex679-mckenzie-wark.
6 Oxford English Dictionary, s.v. "proof, v., sense 2,"
accessed July 2023, https://doi.org/10.1093/OED/6963053740.
7 Oxford English Dictionary, s.v. "resistant, adj., sense
1.a," accessed September 2023, https://doi.org/10.1093/OED
/3487455587.
8 Oxford English Dictionary, s.v. "ready, adj., sense II.6.b,"
accessed September 2023, https://doi.org/10.1093/OED/2044180527.
9 Custom Building Projects, *1/2" WonderBoard ®Cement
Backerboard* (n.d.), https://sweets.construction.com/swts_content
_files/2170/E219914.pdf.
10 Gayle Rubin, "Thinking Sex: Notes for a Radical Theory
of the Politics of Sexuality," in *Culture, Society and Sexuality*, ed.
Richard Parker and Peter Aggleton (New York: Routledge, 2006), 152.
11 Rubin, "Thinking Sex," 150.
12 Rubin, "Thinking Sex," 150.
13 Rubin, "Thinking Sex," 152.
14 Pat Califia, *Public Sex: The Culture of Radical Sex*
(San Francisco: Cleis Press, 1994), 73.
15 Richard J. Williams, "Room for Sex," *Aeon*, June 27, 2013,
https://aeon.co/essays/can-architecture-improve-our-sex-lives.
16 For more, see Johan Andersson, "Heritage Discourse and
the Dessexualixation of Public Space: The 'Historical Restoration'
of Bloomsbury's Squares," *Antipode* 44, no. 4 (September 2012):
1081–1098.
17 Pierre-Alexandre Mateos, Rasmus Myrup, Octave Perrault,
and Charles Teyssou, curators, "Cruising Pavilion," 16th
Venice Architecture Biennale, Spazio Punch, Giudecca, Italy, May
24–July 1, 2018, https://www.cruisingpavilion.com.
18 Tizziana Baldenebro and Lauren Leving, curatorial statement
for "Everlasting Plastics," 18th Venice Architecture Biennale, US
Pavilion, May 20–November 26, 2023, everlastingplastics.org.
19 Ramzi Fawaz, *Queer Forms* (New York: NYU Press, 2022),
6; 10–11.
20 Serpentine Gallery, "Xavi L. Aguirre and P. Staff."
21 Paul B. Preciado, "Architecture as a Practice of Biopolitical
Discourse," *Log*, no. 25 (Summer 2012): 134.
22 Preciado, "Architecture as a Practice of Biopolitical
Discourse," 121–22.
23 Preciado, "Architecture as a Practice of Biopolitical
Discourse," 134.
24 Heather Davis, *Plastic Matter* (Durham, NC: Duke University
Press, 2022), 24.
25 Serpentine Gallery, "Xavi L. Aguirre and P. Staff."

Re+Prise

Norman Teague

Norman Teague (Chicago, IL; he/him) is a designer, founder
and lead designer of Norman Teague Design Studios, and
assistant professor of Industrial Design at the University
of Illinois Chicago. His practice focuses on the sys-
tematic complexity of urbanism and the culture of
communities. Working with common, locally sourced building
materials, Teague collaborates with local fabricators
to create culturally-rooted objects and spaces that explore
simplicity, honesty, and cleverness. His work utilizes
design in an effort to uplift Black and Brown communities
through unified listening and thinking with a hint of
joint labor and care. In 2017, Teague was named creative
collaborator on the exhibitions team for the Barack
Obama Presidential Center and has works inside numerous
museums across the United States. Teague holds a Master of
Fine Arts in Designed Objects from the School of the
Art Institute of Chicago.

Acknowledgments

Norman Teague Design
Studios:
Leslie Cain
Max Davis
Daniel Overbey
Jacob Polhill

Design Consultants:
Tom Burtonwood
Ken Dunn
Cody Norman Studios

Advisors:
alt_Chicago (Jordan
Campbell and Jon Veal)
Dee Clements
Theaster Gates
Juan De La Mora Monsivais
Adedayo Laoye
Patric McCoy
Benjamin Pardo
Paul Preissner
Antonio Torres
McKinley Wells
Amanda Williams

Institutional Support:
University of Illinois
Chicago, School of Design
(Marcia Lausen; Jonathan
Mekinda; and Rebecca Rugg)
Fondazione Prada
Rebuild Foundation

Working within a new material framework for his practice, Norman Teague embraces experimentation through the (re)use of extruded plastics. Within this body of work, he performs cultural memory, drawing from Bolga and Agaseke basket-weaving techniques, and reinterpreting traditional vessels through recycled materials. His work bridges the Global South and the Global North through a diasporic lens. Tracing waste and production streams, Teague's vessels critique Western extractivist practices in the Global South which return previously mined ore as refuse. The colors of these objects reflect prismatic commercial waste, while at times also melting together, creating bodily, earthy tones.

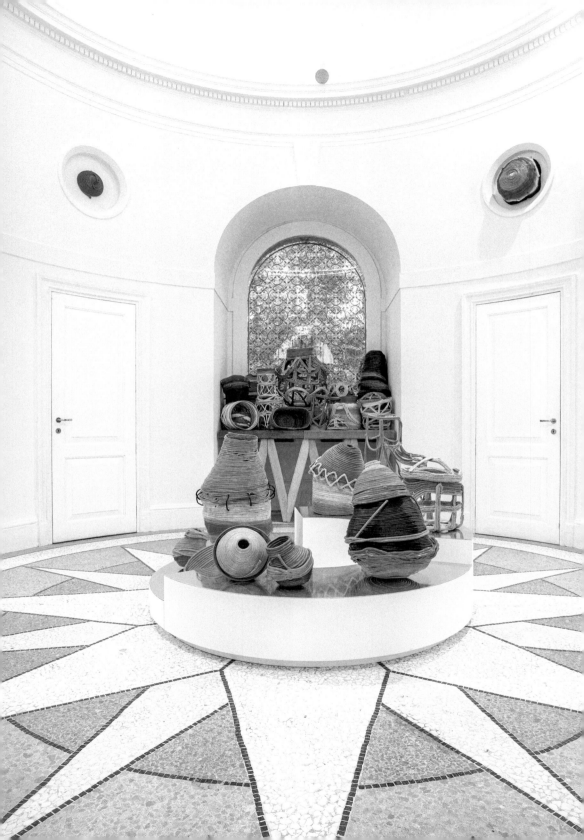

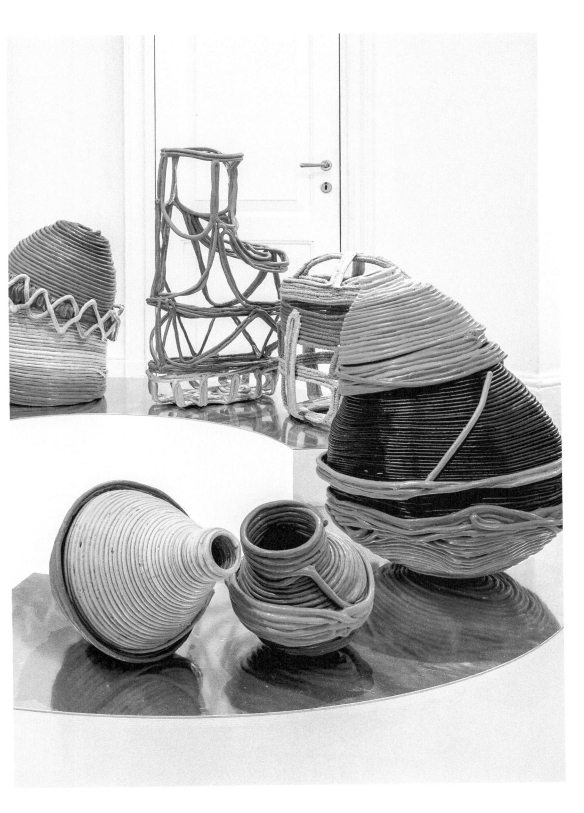

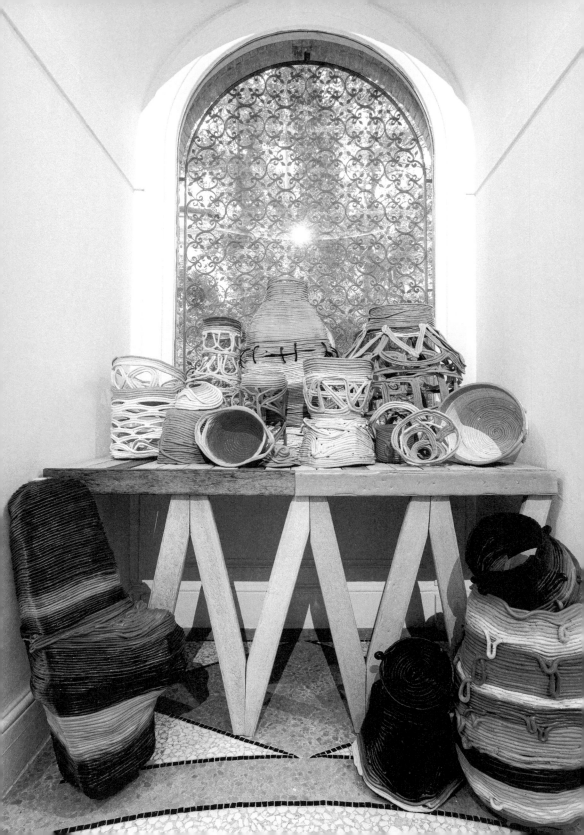

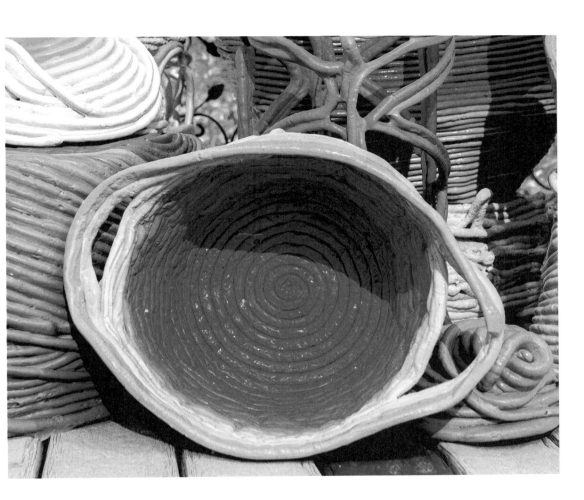

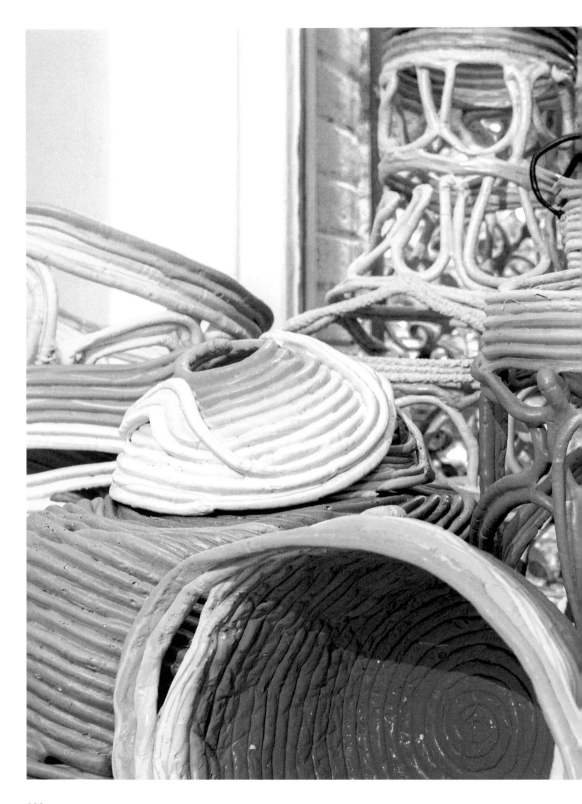

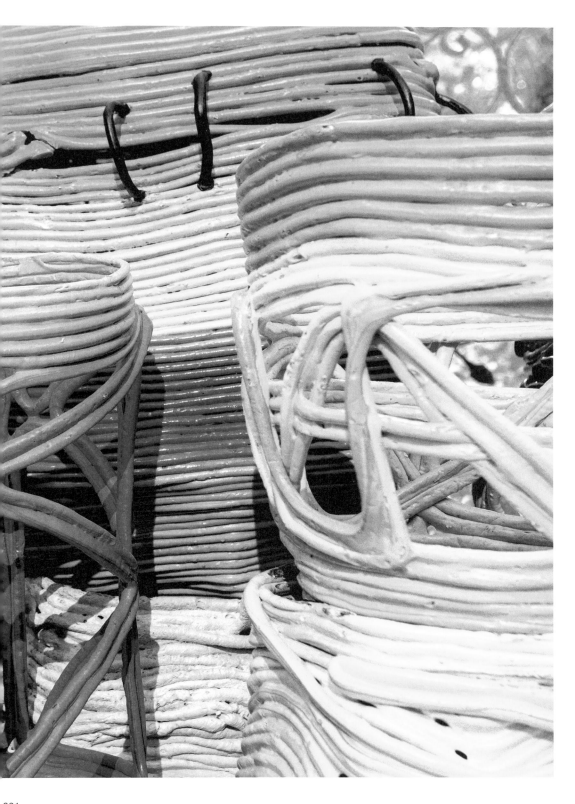

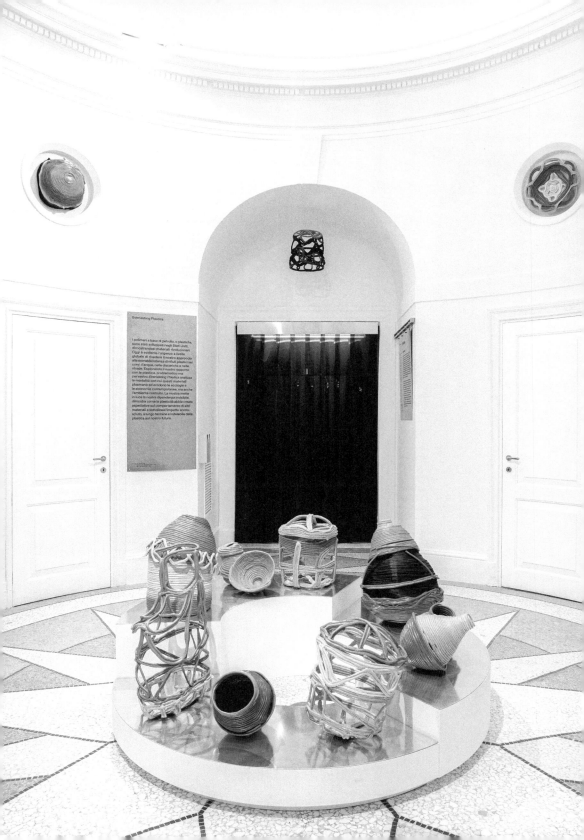

Everlasting Plastics

I polimeri a base di petrolio, o plastiche, sono stati sviluppati negli Stati Uniti, dimostrandosi materiali rivoluzionari. Oggi è evidente l'urgenza a livello globale di rivedere il nostro approccio alla sovrabbondanza di rifiuti plastici nei corsi d'acqua, nelle discariche e nelle strade. Esplorando il nostro rapporto con le plastica, problematico ma pervasivo, Everlasting Plastics analizza le modalità con cui questi materiali plasmano ed erodono le ecologie e le economie contemporanee, ma anche l'ambiente costruito. La mostra mette in luce la nostra dipendenza invisibile, dimostra come la plasticità abbia creato aspettative sul comportamento di altri materiali e sottolinea l'impatto sconosciuto, a lungo termine e indelebile della plastica sul nostro futuro.

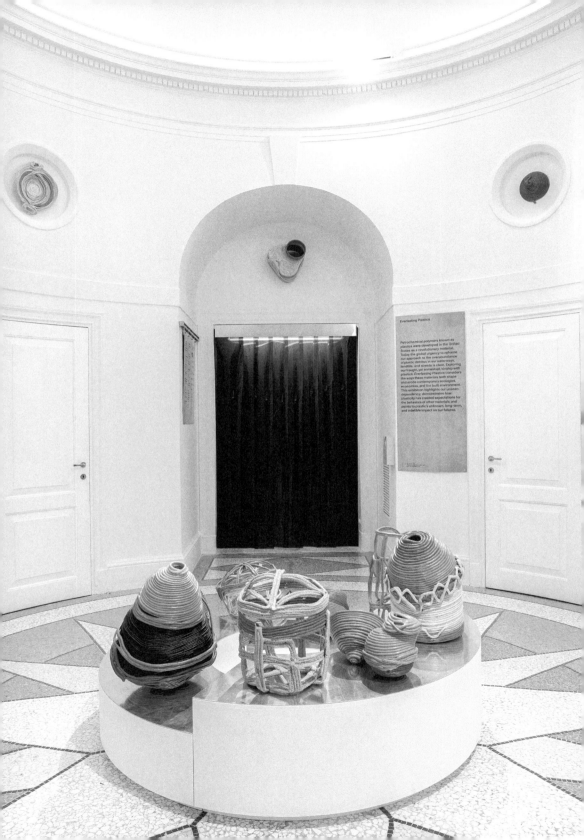

Everlasting Plastics

Petrochemical polymers known as plastics were developed in the United States as a revolutionary material. Today the global urgency to reframe our approach to the overabundance of plastic debris in our waterways, landfills, and streets is clear. Exploring our fraught, yet somewhat, kinship with plastics, *Everlasting Plastics* considers the ways these materials both shape and erode contemporary ecologies, economies, and the built environment. This exhibition highlights our uneven dependency; demonstrates how plasticity has created expectations for the behaviors of other materials; and points to plastic's unknown, long-term, and indelible impact on our futures.

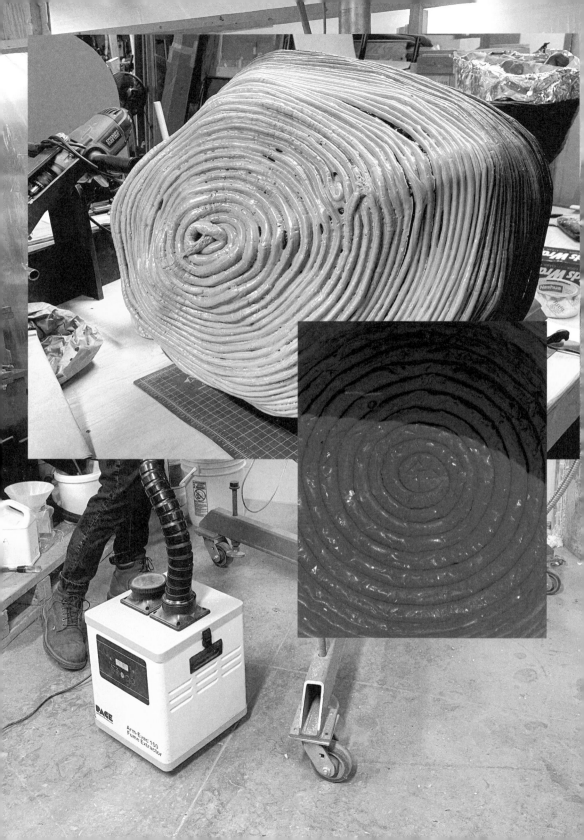

Evoking Objects of Change

Michele Y. Washington

Michele Y. Washington is a designer, strategist, and design critic. Her writings have been featured in publications such as *The Black Experience in Design: Identity, Expression & Reflection* (Allworth Press, 2022), *InQue Magazine*, *Architectural Record*, and *Wonderful City of the World: New York City Travel Posters* (Poster House, 2024). She is also a contributor to the *Eco Collective* blog and the founder and host of the *Curious Story Lab* podcast. See more of Washington's work at www.culturalboundaries.com.

... in the decorative display of *what-goes-without-saying*...
Roland Barthes[1]

Writing in 1957, prominent French philosopher and theorist Roland Barthes meditated on plastic's cultural significance: "So, more than a substance, plastic is the very idea of its infinite transformation... it is less a thing than the trace of a movement."[2] It was, for him, a material *process*, one that profoundly changed the relationship between consumers, modernity, convenience, and disposability, shifting the meaning and expectations around matter and its relationship to place. He continues:

> And as the movement here is almost infinite, transforming original crystals in a multitude of more and more startling objects, plastic is, all told, a spectacle to be deciphered: the very spectacle of its end-products. At the sight of each terminal form (suitcases, brush, car-body, toy, fabric, tube, basin or paper), the mind does not cease from considering the original matter as an enigma. This is because the quick-change artistry of plastic is absolute: it can become buckets as well as jewels.[3]

Barthes examined plastics through the theoretical lens of "floating signifiers," understood simply as signs or symbols with shifting meanings, and his book *Mythologies* attempted to trace and decipher the "falsely obvious" stuff of his world, from plastic and detergent to "good French wine" and the new Citroën DS car. In the preface to *Mythologies*, Barthes admits the starting point for this exercise: "a feeling of impatience at the sight of the 'naturalness' with which newspapers, art, and common sense constantly dress up a reality which, even though it is the one we live in, is undoubtedly determined by history."[4]

Norman Teague thought it was a joke when he was first invited to participate in the US Pavilion's exhibition "Everlasting Plastics" at the 2023 Venice Architecture Biennale because his practice had, until that point, primarily dealt with wood. Ultimately accepting the invitation, Teague titled his project *Re+Prise*, playing on the word "reprise," evoking a recurrence, repetition, and resumption "of an action." The *Re+Prise* project offered Teague and his team, collectively Norman Teague Design Studios (NTDS), an opportunity to broaden the breadth of their material knowledge, expanding from wood to plastics. This inclusion in "Everlasting Plastics" opened up experimental possibilities for Teague and his team to pursue a rapid-fire, speculative project and to think more expansively about their approach to design. In a similar spirit to Barthes's own plastic meditations in *Mythologies*, Teague's studio was compelled to work and think through notions of recurrence and repetition. *Re+Prise* highlights the ways in which Teague learns and orients an incredibly ubiquitous material anew, in a process that might, in and of itself, be called "plastic." By substituting plastic for the methods, materials, and functions that typically guide his practice, Teague renders plastic waste unfamiliar. In a beautiful and provocative repetition of plastic as the ultimate material imitator, Teague not only reframes our relationship to plastic, but, by asking it to mirror traditional forms of craft, also locates other material cultural legacies in the process.

Michele Y. Washington

Re-expressing and interpreting the functionality of plastics and thinking of their adaptive evolutionary changes—particularly with digital technology and intelligence—allowed Teague and his team to consider ways of reimagining plastic reuse through exploratory artistic objects. Teague's studio-based furniture and objects, largely crafted from either recycled or reclaimed wood, are often designed for the utilitarian function of human comfort. Though *Re+Prise* necessitated a switch from working with organic to synthetic materials, NTDS retained the same high level of craftsmanship in executing this project, ultimately returning to an interrogation of recycled materials—in this instance, plastic.

Shifting to inorganic materials pushed Teague and his team to consider how designers might begin reimagining ways of working with recycled plastics to create objects that re-enter our daily lives. These kinds of speculative projects, wherein designers are able to step beyond the marketing, viability, and use of their objects in order to build potential for materials, are necessary for rethinking responses to global recycling crises of plastic and trash. Bringing experimentation to the forefront opens up possibilities for visionary ideas that can lead to new knowledge production.

In this way, the studio became a laboratory to cultivate new material dialogues; for assistant designers Daniel Overby, an industrial design graduate from Columbia College in Chicago, and Jacob Polhill, an instructional lab specialist in the industrial design department at the University of Illinois Chicago, the worksite became a testing ground, or perhaps like a return to graduate school. Teague's mind, in constant motion, pushed, pulled, propelled the team through each phase of the project. In dialogue with US Pavilion curators Tizziana Baldenebro and Lauren Leving, the designer cycled through different potential concept iterations and forms, from inflatables to injection molding—all material processes in tension with the years of skill acquired from working with wood. Alongside Teague, Overby and Polhill worked feverishly, researching, brainstorming, sketching, and prototyping, eventually embracing *Re+Prise* as an experiment in and of itself, based not on organic development but on insistence and repetition.

> ... two unreconciled strivings...
> W.E.B Du Bois[5]

Curator Lesley Lokko's "Laboratory of the Future," the theme of the 2023 Venice Architecture Biennale, invited participants to look to Africa as the new vanguard of change within the architectural discipline, as a new vantage from which to tell architectural stories. While initially surprised by the invitation to participate in the "Everlasting Plastics" exhibition, Teague was intrigued by Lokko's overarching agenda and how it might overlap with contemporary conversations on waste and plastics. In a statement on the show, Lokko invoked W.E.B. Du Bois and Frantz Fanon's use of the phrase "double consciousness" alongside questions of technology, identification, and vision—connections which became instrumental in shaping Teague's initial sketches and concepts for "Everlasting Plastics." "New technologies continuously appear and disappear," stated Lokko:

Giving us unfiltered glimpses of life in parts of the globe we will likely never visit... But to see both near and far simultaneously is also... a form of "double consciousness," the internal conflict of all subordinated or colonized groups, which describes the majority of the world, not only "there," in the so-called Developing-, Third-, and Arab Worlds, but "here" too, in the metropolis, and landscapes of the global North. In Europe, we speak of minorities and diversity, but the truth is that the West's minorities are the global majority; diversity is our norm.[6]

The term "double consciousness," coined by Du Bois, one of the foremost Black intellectuals of the twentieth century as well as an activist, historian, author, and sociologist, clearly resonates in the twenty-first century. Through extensive research and writings on the plight of the Black American experience, from social and educational to economic and political conditions, Du Bois articulated "double consciousness" in his seminal 1903 book *The Souls of Black Folk*, writing:

One ever feels his twoness—an American, a Negro; two souls, two thoughts, two unreconciled strivings; two warring ideals in one dark body, whose dogged strength alone keeps it from being torn asunder. He simply wishes to make it possible for a man to be both a Negro and an American without being cursed and spit upon by his fellows, without having the doors of Opportunity closed roughly in his face.[7]

Lokko's statement implicitly highlights the "twoness" that Du Bois describes permeating the Black American experience: the challenge of conforming to American ideals and norms in order to survive, while simultaneously embodying and preserving the complex and diverse heritage of the Global South and the African Diaspora—the capacity of holding multiple selves together, of code switching as a method of survival but also of opportunity. Lokko contends predominantly with the oft-singular narrative and experience that defines much of the design world, which is dominated by white creative spaces and perspectives. With a creative practice and teaching pedagogy that continually embraces the complexity of race and identity, Teague took up these concerns with *Re+Prise*, aiming to work with Lokko's framing of "double consciousness" and its relation to the design field—positioning Africa as a "laboratory of the future."

NTDS itself operates on the South Side of Chicago, employing a new generation of Black designers, and rethinking what sustainability might mean for communities experiencing disinvestment. Teague's Africana Chair, for instance, is chiseled with techniques that both appropriate and excoriate Western fabrication standards. The Sinmai Stool eschews punitive modernist seating interventions, favoring a distinctly relaxed lean. Already reflexively operating in this "twoness" within their woodworking practice, NTDS applied these ideas to plastics. Looking to Africa, while working with American waste, Teague began to think of how the two might intersect.

In many ways, Teague's research methodology was anthropological. After experimenting with various material processes and technologies, he refocused on the question of the object. The idea of a vessel—the barest

Michele Y. Washington

and simplest type of container and, by extension, the simplest architectural form became the focus of their research. Teague traveled throughout Africa, visiting Burkina Faso; Cairo, Egypt; Lagos, Nigeria, each place enriching his sensibility of cultural geographies, from the people to the makers, food, and markets. Teague's vessels hold these multiple encounters: they carry Teague's own mobility, summoning, once again, Barthes's oft-repeated statement about plastic—"less a thing than a trace of movement."[8] It was Teague's travels that likely directed his team to explore the Agaseke and Bolga baskets to develop the prototyping framework for Re+Prise. These baskets, with their colorful patterns and bold silhouettes, are traditional African heritage artifacts that blend function and form. Teague has a keen eye for functionality, which has led him to design small-scale colorful clay vessels such as vases, small serving vessels, and wooden objects.

Agaseke—the word for "peace basket" in Kinyarwanda—are handwoven vessels from Rwanda. Usually made by women, these baskets are woven from a range of strong and durable natural materials, from papyrus reed to sisal fibers. Working with natural dyes, the women create vibrant color palettes, intricate designs, and colorful patterns that make the Agaseke baskets distinctive. Apart from serving the daily purposes of storing food and decorating homes, they are also used for gift giving on occasions like weddings, funerals, and coming-of-age ceremonies. Much like the Agaseke basket, Bolga baskets, sometimes referred to as Bolga market baskets or Ghanaian Bolgatanga baskets, are steeped in the heritage of African culture. Woven by artisans from Bolgatanga, in the Upper East Region of Ghana, who are highly regarded for their craftsmanship, the baskets are constructed out of elephant grass (Veta Vera) that has been softened with water and dyed by natural plant dyes. Bolga baskets have patterns woven throughout in a broad range of colors, including bright greens, oranges, yellows, and blues. Both the Agaseke and Bolga baskets are sold in outdoor markets and collected for their artisanship and cultural relevance. As cultural artifacts, these baskets are valued in part because of the way they hold and preserve craftsmanship amidst mass-market globalization; they possess a never-ending cultural currency—a perpetuity that guarantees their longstanding future.

Attracted by the colors and shapes, NTDS looked to these baskets as a way of understanding forms of containment. Reducing baskets to their essential architectures, tight coils stitched or woven into one another, the team realized that, similar to clay, extruded plastics might allow the same coiling without additional stitching or weaving. Even better than clay, the coil instantly clings to its neighboring coils. They developed a technique that was part mold, part air coil, playing with the extrusions in ways they hadn't been able to do with wood and more rigid materials. This experimentation and exuberance allowed for a deeper exploration that is evident in the loops and colors of the vessels. Throughout Re+Prise, it is possible to trace how NTDS's skills evolved over the short production timeline—of how, with each basket, they achieved a greater command of color, of texture, of coiling.

In building up these new forms of material and cultural knowledge, Teague and his team also forged new networks with practitioners exploring the

regeneration of "single-use" materials. Ken Dunn, dubbed "Chicago's King of Recycling," runs the city's resource center. Over multiple site visits and conversations with Dunn, Teague came to better understand waste and waste systems in Chicago as a microcosm of broader global issues. The South Side of Chicago, where NTDS is located, holds many parallels to global conditions of waste and waste relocation: waste and recycling centers with lax oversight dot the bottom half of the city, and the region's most toxic waste seemingly migrates to the area.[9] Global waste patterns also have southward-moving tendencies. A 2018 report by the United Nations Environment Programme reports:

> Developed countries typically have very strict standards with regards to the collection, treatment, and disposal of municipal and industrial hazardous wastes. The differences between developed and developing countries in the management of hazardous waste, including legislation, often lead to the "export of waste to countries where environmental laws, occupational safety and health regulations, governance and monitoring are looser..." This has also resulted in illegal trafficking of hazardous waste from developed countries to countries in Africa for cheap disposal, often without any treatment.[10]

These conversations about the political, economic, and cultural forces and places responsible for the world's waste—about the extraction and provision of resources—are entangled in Teague's material exploration.

Nzambi Matee, a Kenyan engineer, environmentalist, and founder of Gjenge Makers in Nairobi, practices an ideology rooted in social change, and has developed new ways of transforming waste into sustainable building materials. Working with non-virgin plastics, she uses high heat to mix plastics with sand and presses these compounds into bricks for streets and highways. Thinking both practically and functionally, Matee inspired Teague's process for *Re+Prise* as he approached this new material, playing a crucial role in informing the team's choice of materials, methods, and designs. However, unlike Matee's pragmatic approach, Teague's process operated in a more playful way, inverting value and reducing functionalism. And yet these divergent infusions into more circular economies both subvert linear solutionism and celebrate rethinking through process and experimentation. By hacking materials, Matee and Teague both aim to minimize waste and add value to their communities; at the same time, they are eager to exploit the value of waste by creating new, alternative forms of use, knowledge, and products.

In exploring these alternatives, one of the biggest challenges for NTDS was the shift from wood to recycled plastics. Dunn, while happy to meet and connect over plastic waste, is retired, and so he introduced the studio to Cody Norman, a Chicago-based artist, designer, and educator who works primarily in plastic extrusion. They bonded quickly as NTDS outlined the aims of the "Everlasting Plastics" project and their hopes for a collaborative exchange. Cody Norman generously turned over his studio space, along with full access to his plastic extruder, to Teague's team. He graciously shared his own experience and knowledge of the process as the NTDS experiment unfurled.

Michele Y. Washington

Knowing very little about plastic extruders, Teague's team was in uncharted territory. Plastic scraps are shredded and then converted to pellets, to be poured into hot extruders. Then, the extruder spews a sinewy cord of about ¼ or ⅜ inches. Carefully hand-guided, the molten material slowly wraps around a cyclical form to maintain its shape as it is gradually coiled. In reimagining the traditional baskets through renewable sources, NTDS also located and iterated upon the history and evolution of manufacturing methods, such as those used in confectionery. Controlling the flow, twirling, and winding of the sinewy plastics somewhat replicates the process of making saltwater taffy candy: taffy flows out of a similar extruder machine before it is cut and hand-wrapped. Twirling colored plastic is also similar to making cotton candy. Plastics and other malleable forms maintain the trace of their production, as Barthes (again) reminds us: "Plastic remains impregnated throughout with this wonder: it is less a thing than the trace of a movement." Craftsmanship sets the stage for learning anew through trial and error.

The team experimented with making various vessel shapes, determining colors as they moved through the process. In another form of borrowing, NTDS adapted their knowledge from the wood-turning process, maintaining high craftsmanship and material knowledge. Woodworkers use a lathe for "turning" wood with tools to chisel out the form; Teague's team employed a similar method of turning a coiling plastic cord around a form to shape it. They made many vessels while learning how to use the extruder. Hot, colorful cords spewed out of the extruder, burning fingertips as the team coiled and shaped each vessel.

During the creative process, NTDS compiled images of Agaseke and Bolga baskets, capturing their essence as they relate to their use, their sense of place. These photographs shaped the final narrative of the *Re+Prise* installation. Further, the playful shapes and a vibrant cacophony of colors feel connected to our broader disposable consumer culture. The color palette of *Re+Prise* correspondingly is imbued with a playfulness around our many associations and relations to plasticity—the baskets evoke the pastels of cotton candy or saltwater taffy, while, in reality, they are drawn from Tide and Cascade PET bottles. Like fast fashion, plastics elicit newness and disposability, prizing cheapness and quickness over quality.

The coloring of plastic bottles and other containers is based on branding or corporate identity, as brands develop signature looks using colors, typography, and visual imagery. Emotionally, consumers are connected through color to the products they love. Walking down supermarkets or big-box store aisles, consumers can quickly identify colors before acknowledging names. Disambiguated from the aisles, the colors catch our eye, familiar and yet totally unrecognizable to us in their new form. Downy blue bleeds into Arm & Hammer orange, which turns into Gain green. We are all implicated in waste, regardless of our brand loyalties.

> ... an incubator of expanded meanings, conceptual dislocations, and perceptual disorientations...
> Leonard Koren[11]

Some of the plastic vessels possess a smooth surface with a slight sheen. And yet, they still manage to emulate the raw material sensibility of Agaseke and Bolga baskets. This clash of materials and medium allows for a productively irreverent approach to cultural memory. Within diasporas, the absence of certainty can be inhibiting. Here, Teague imagines a world of triumphant diasporic collaboration.

The staging of the vessels in the exhibition space further pushes this collision of cultural and material geographies. Arranging the Re+Prise vessels or objects based on their form, scale, size, and colors evokes an alternative way of identifying the individuality of each object. In Arranging Things: A Rhetoric of Object Placement, Leonard Koren notes how the placement and composition of objects are a form of communication, which, "like natural languages, grow[s] and develop[s] through perpetual use and experimentation. In the process, the communication possibilities are extended."[12] What, then, is communicated in Teague's installation? The arrangements encourage Biennale visitors to leisurely browse the baskets, as if consumers, casually strolling through the outdoor markets where Agaseke and Bolga baskets are traditionally sold, stopping at stalls or small shops with goods spilling onto the sidewalks. People's sense of smell may be engaged as materials silently and invisibly seep scents into the body and the air—both noxious and familiar. Perhaps they can hear chattering sounds of people busily interacting with each other while browsing the various vessel offerings. Is there haggling over the price of each object, or are the prices fixed? The multisensorial outdoor market cacophony is reinterpreted in Venice for a very different audience, a challenge, in its own way, to Western consumption.

The arrangement of baskets in clusters, in juxtaposition with the colors of each vessel's structure or shape, also creates a conversation between them—composition and arrangement, lyrical and fluid placement adjacent to each other. Here, they meld together, embracing a massing and an accumulation. Arranged so closely together, the juxtaposition of these objects offers a narrative dialogue amongst them; drawing upon the vibrant burst of colors from nature and dyed fibers but realized in plastic technicolor, these vessels reach tonalities previously unimaginable (or unthinkable) to basket weavers.

Teague's experiences from participating in the Venice Architecture Biennale have opened up new avenues for further exploration. In particular, an opportunity arose for residency with M4-Factory in Woodstock, IL, following "Everlasting Plastics." Teague is now examining alternative ways of working between wood and plastics, similar to Eames and Saarinen designing home furnishing from meshing, wood, metal, and plastic materials. In this regard, he has the potential to effect change through his experiences of creating Re+Prise for "Everlasting Plastics" to produce new, experimental, sustainable objects that might live with us forever.

As I reflect on NTDS's body of work, I am struck by how Teague continually pushes boundaries, as evidenced by how he met the challenge of navigating Africa as a laboratory of the future at the Venice Architecture Biennale. Teague possesses a deeply rooted intuitive spirituality that embraces ways of empowering Black and Brown communities, which is carefully, yet playfully reflected here, through immersing Western waste material and

Michele Y. Washington

production technology with Ghanaian craft and coiling techniques. Embracing cultural African and Black traditions of making something out of nothing—or hacking materials—Teague reinterprets and reroutes the toxic flows of globalized waste streams.

1 Roland Barthes, preface to *Mythologies*, trans. Annette Levers (New York: Noonday Press, 1972), 10.
2 Roland Barthes, "Plastic," in *Mythologies*, trans. Annette Levers (New York: Noonday Press, 1972), 97.
3 Barthes, "Plastic," 97.
4 Barthes, preface to *Mythologies*, 10.
5 W.E.B Du Bois, "Of Our Spiritual Strivings," in *The Souls of Black Folk* (Oxford: Oxford University Press, 2007), 8.
6 Statement by Lesley Lokko from "Biennale Architettura 2023: The Laboratory of the Future," La Biennale Di Venezia, May 31, 2022, https://www.labiennale.org/en/news/biennale-architettura-2023-laboratory-future.
7 Du Bois, "Of Our Spiritual Strivings," 8-9.
8 Barthes, "Plastic," 97.
9 Martha Irvine and Samantha Moilanen, "'I Don't Think [We] Deserve to Live like This': For South Side Residents, the Fight for Environmental Justice Is Far from Over," *DePaulia*, January 23, 2023, www.depauliaonlinee.com/61943/news/i-dont-think-we-deserve-to-live-like-this-for-south-side-residents-the-fight-for-environmental-justice-is-far-from-over.
10 United Nations Environment Programme, *Africa Waste Management Outlook* (Nairobi: United Nations Environment Programme, 2018), www.unep.org/ietc/resources/publication/africa-waste-management-outlook. Accessed 21 Jan. 2024.
11 Leonard Koren, *In Arranging Things: A Rhetoric of Object Placement* (Berkeley: Stone Bridge Press, 2003), 21.
12 Koren, *In Arranging Things*, 14.

This Will K̶i̶l̶l̶ _____ That

Simon Anton

Simon Anton (Detroit, MI; he/him) is a multi-disciplinary
artist, designer, and educator that collaborates across the
fields of architecture, interior design, furniture, art,
and jewelry. He is the co-founder of Thing Thing, a design
collective that experiments in the transformation of
post-consumer, hand-recycled polyethylene plastic sourced
from surrounding communities and from industrial man-
ufacturing. He also runs "Transforming Trash," where he
works with youth in Detroit to transform community plastic
waste into art. His work has been presented at the Hong
Kong Shenzhen Biennale, Expo Chicago, and Museum of
Contemporary Art Detroit. Anton received a Master of Fine
Arts in 3D Design from Cranbrook Academy of Art.

Acknowledgments

Patrick Anton
Aaron Bonnell-Kangas
Craig Hejka
Armelle Taylor
Eiji Jimbo
Georgia Michalopoulou
Thom Moran
Rachel Mulder

Through a process of grafting plastic waste onto armatures, Simon Anton reinscribes modern functional and political objects into ornamental critiques. He combines designs of the past with the material present to suggest invented and reimagined archeological reconstructions, resituating ornamental detail to recall moments across architectural history within the context of our current plastic proliferation. Drawing from individual and industrial waste streams, Anton creates a material technique that examines circular histories and reimagines possible futures for a world in which waste plastics are increasingly inseparable from the built environment.

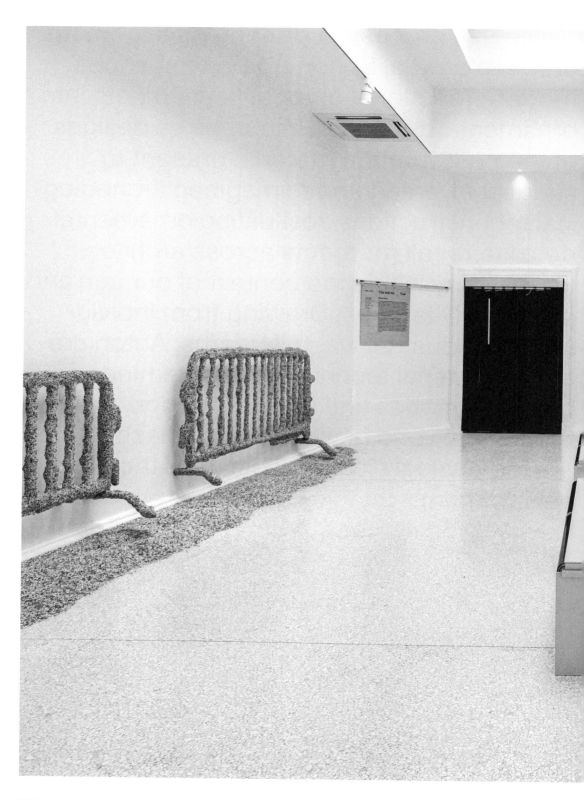

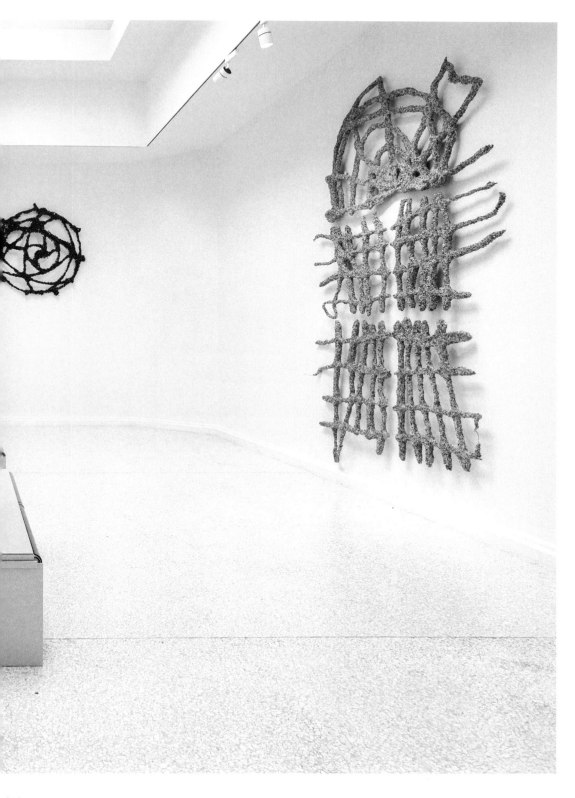

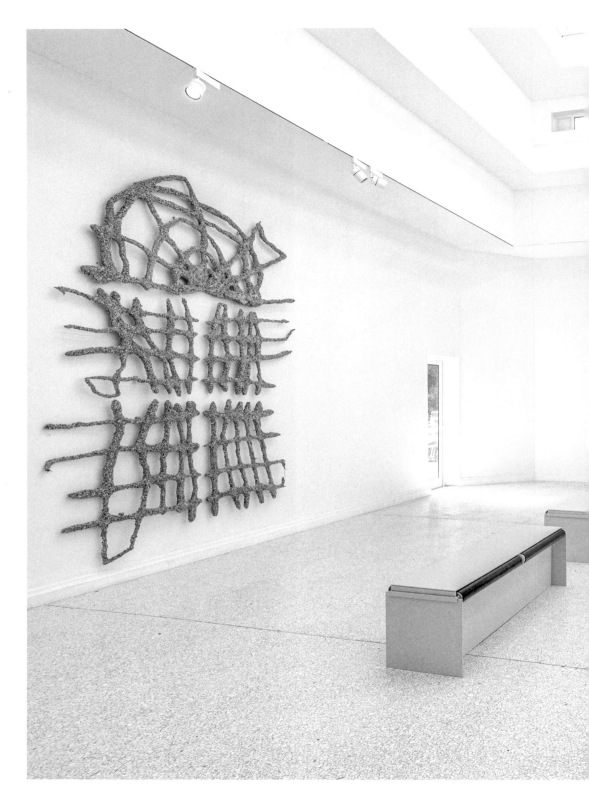

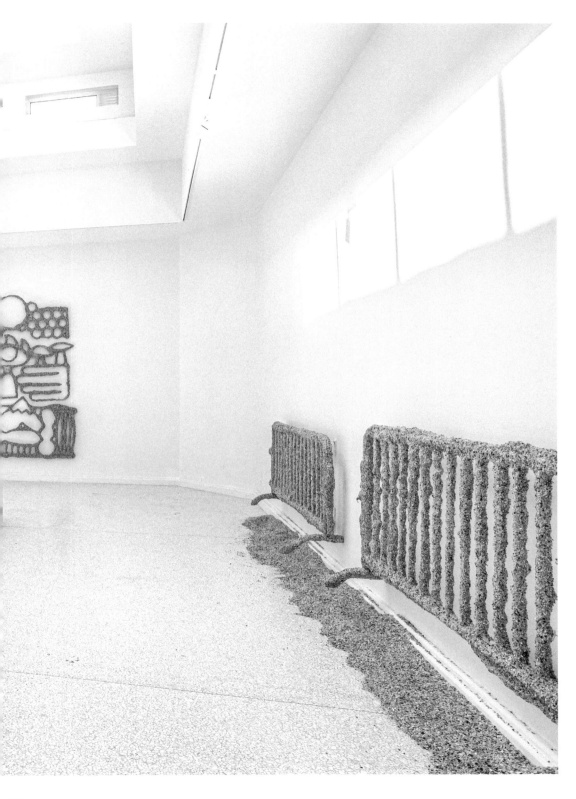

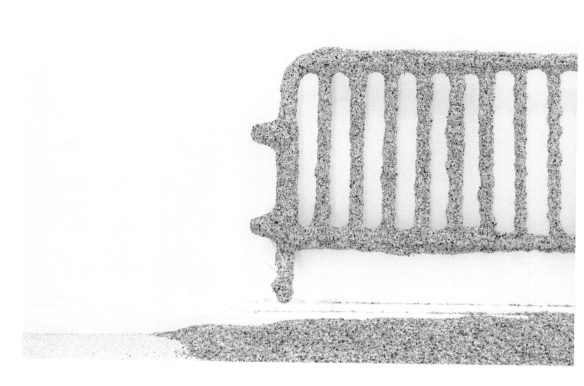

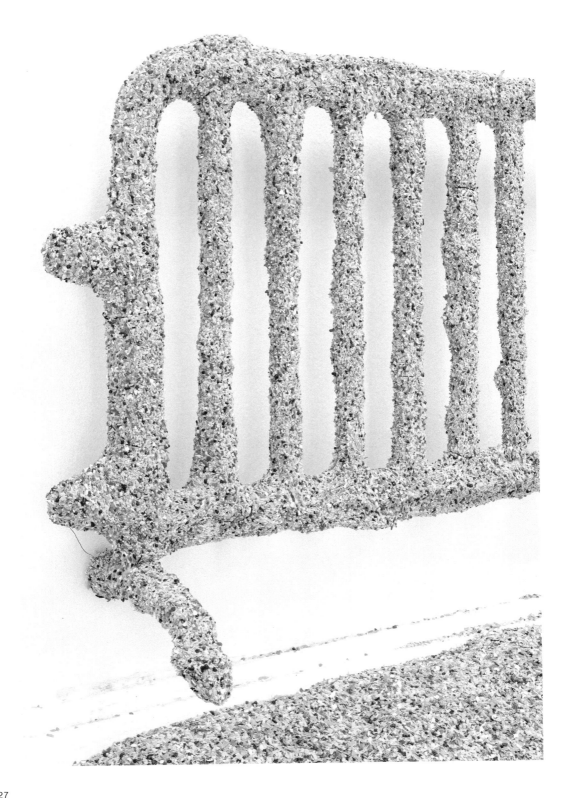

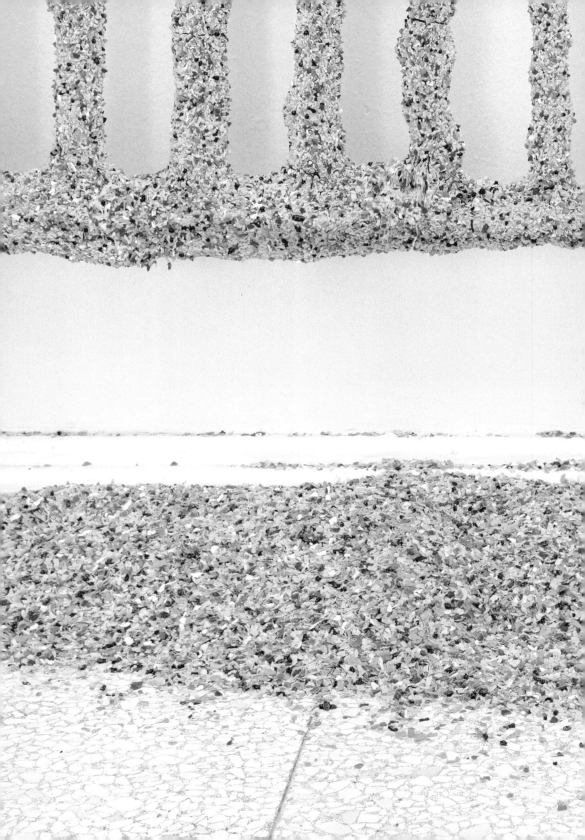

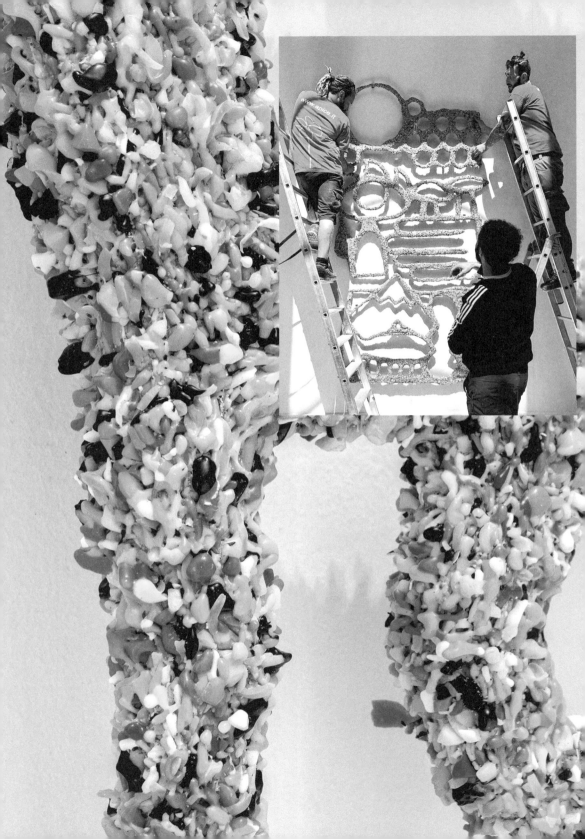

Being is nothing but our own mutability: A meditation on sorrow in 4-parts

Shannon Rae Stratton

Shannon Rae Stratton has worked in the visual arts for over
twenty years as a curator, writer, artist, and arts admin-
istrator. She cofounded the Chicago nonprofit Threewalls in
2003, where she was Executive Director until 2015. From
2015 to 2019 she was chief curator at the Museum of Arts and
Design in New York. She is currently executive director
at Ox-Bow School of Art and Artists' Residency in Saugatuck,
Michigan, splitting her time between campus and her home
in Chicago.

Being is nothing but our own mutability

Chewing on it

When I am faced with a problem, it is almost as though I see it hanging in the space between me and the other, as though it is a material that is possible to work with. I manifest the problem with language and then continually rework it with new words, both in conversation and on the page. I pull it apart and push it back together, discovering its malleability and plasticity through shaping and reshaping it with language. I test the problem to see what bounces off or sticks to it. I put it out in the world, pinging for an interlocutor, for a return signal. As I go through this exercise—sometimes, for only a few minutes or hours alone in a car or the shower; at other times, for weeks or months through conversations with friends, writing, and reading books—I change my relationship to the problem, and, with that, something in me changes as well. I am unlikely to have "solved" the problem, so much as to have transformed my relationship to it, and, largely, my relationship in and to the world because of it.

The concept of "processing" usually describes a person, alone or in conversation, talking or thinking through an incident of some kind along with the attendant emotions. *I am processing the argument we had last night* when I go over our words, reactions, and the context that led to it; *she is still processing her grief* as she talks about her loss with friends over and over; *they are processing the major changes that have occurred in their life over the past year* when they write about it in their journal, sometimes repeating the same feelings until they transform into new ones; *he is processing an incident at work and the tone of an email that he received* as he compares that email to those he has received before from the same person or similar incidents he had experienced in the past. These operations orient us toward change or preservation—they transform or protect things that are integral to our sense of self.

While my examples conjure up typical emotional or dialogical processing, we also process the world physically. Some may turn to exercise to work out big feelings, moving and metabolizing them through the body. The idea that the body acts as both a storehouse and a filter for trauma (as written about by Bessel van der Kolk in *The Body Keeps Score* or by Gabor Maté in *When the Body Says No: The Cost of Hidden Stress*)[1] points to the fact that metabolizing is not strictly the work of digesting food, but the work of digesting experience as well. It's a process that occurs "in order to maintain life."

I have come to refer to the work of the artist as that of metabolization for the larger cultural body. Their work with matter, images, words, sounds, and movement is a kind of physical processing on society's behalf, as they mentally ingest a social or political moment and release it back into the world as art. Whether they practice this alchemy with words or clay or paint, they transmute the matters of the world into a new substance. Do the big generational ideas, big community feelings, big political moments get effectively processed, recovered, reintegrated with each subsequent generation of artists who do this work of metabolizing on society's behalf? Does the larger social organism experience change with each wave of artistic zeitgeist?

Shannon Rae Stratton

Both processing and artmaking imply a kind of plasticity—of mind and of matter: the "plastic arts" entail a physical manipulation of material, but there's also the plastic mind, or "neural plasticity," wherein the brain has the capacity to adapt and change through experience. The French philosopher Catherine Malabou writes extensively on the plasticity of the brain. She says, "Being is none other than changing forms; being is nothing but its own mutability."[2] In the inverse, destructive plasticity, often the result of serious injury or illness, can form identity through the annihilation of the known or original "self."

Unlike *elasticity,* whereby an object returns to its original shape, *plasticity* is the capacity to be deformed and reformed, but *not* recover its original shape. Actual plastic matter is helpful in imaging this: plastic can be remolded with the force of heat, but, as it cools, it hardens into a new form. It doesn't spring back to its former shape after being released from the pressure of heat. But other materials are considered "plastic" in this way— anything that is cured in a kiln (clay, glass, wood) loses its capability to return to its original form. It can be "recycled" into a new object but cannot recover its "original" shape, so to speak. Elasticity (flexibility, even), on the other hand, is a property that an object might have that has no relationship to transformation—unless, of course, you take these metaphors to great lengths and contemplate that repeated stress on an object's flexibility may eventually wear this property out.

When we apply the concept of recovery to humans, we might think about how we can be resilient in the face of repeated stress, recovering our equilibrium after a hard day at work. We are the same person at the end of the day thanks to our flexibility. Plasticity comes into play when we transform, unbeknownst to our conscious self, due to a particularly impactful experience or repeated practicing of a process. The transformation is not necessarily internally recognizable, and, once complete, we have no ability to return to "before." A simple example might be how the brain builds strong connections with the practice of repetitive movements until they become ingrained (muscle memory), but we cannot return to the brain that we had prior to the building of this muscle memory no matter how hard we try. A brain injury might impair a skill, but it still doesn't return us to the state we were in before we learned it.

Malabou's philosophy is about the human capacity for transformation and is rooted in neuroscience and the discovery that the brain could reorganize synaptic connections in response to learning or after injury. Malabou's distinguishing between *flexibility* and *plasticity* is based on flexibility's lack of transformation; she notes that "by bending in every direction we don't learn to be resilient or loyal to ourselves." Plasticity on the other hand, requires much more heat so to speak, and thus, as she goes onto say in an interview in the *Philonomist*, "allows you to resist external demands, and choose not to obey immediately. It's a principle of inner disobedience."[3] Whether that inner disobedience is conscious or not, however, might be up for debate:

The Philonomist ... You tell us to "sculpt our own brain," which is a nice idea... But how can we always differentiate between the

Being is nothing but our own mutability

changes we desire and those that we endure? When neuronal capitalism and its screens command our full attention in the street, how can we resist?

Malabou I belong to a materialist tradition that goes all the way back to Spinoza, and even Hegel, for whom desire, which is at the root of human willpower, has a biological origin. If our brain is well sculpted, it goes to a place which is good for it. Our brain wants to create more connections, it wants to "increase its power of action," as Spinoza puts it.

The Philonomist If the brain is like dough or marble, doesn't it need a hand to shape it?

Malabou It does, and that hand is desire.[4]

Plasticity and Disobedience

I understand Malabou's "hand of desire" that shapes and reshapes our brain to be, in psychoanalytic terms, the libido. As an instinct that drives all of our behavior, the libido manages our survival, and it may choose "disobedience" as a means to do so. Friction occurs when we try to manipulate another's libido, whether subtle or overt, interrupting or curtailing one's natural drives.

An armature is an invisible structure—the skeleton hidden beneath the skin—that, I would argue, can be deployed to manipulate or control and, in doing so, frequently creates sites of friction, particularly when met with disobedience. Armature and armor, one inside the body and the other outside, grow from the same root, *arma*—the tools or implements of war. The bones of the thing, the skin of the thing—etymologically—are tools for conflict.

Simon Anton's installation for "Everlasting Plastics," *This Will Kill* ____*That* is a series of steel armatures—barricades, a distorted grate/gate, an interlocking line drawing of simple, pictographic images—armored in a colorful skin of ground-up and shredded plastics. Which is the "this" and which is the "that" is unclear, and the answers to "Whose tools?" and "For what conflict?" remain ambiguous. As implements of control, do they curb conflict or heighten tensions? Are they the weapons of the autocrat, or are they commonly held and deployed, circulated and used naively?

Social and political armatures like language, legal relationships, economic systems, and religion with a central text might define a nation, communities, or networks of people. These armatures give some structure to a group of people and may work to alleviate the ambiguity that can otherwise infuse life—both relationships and our internal world—at the same time that they create a rigidity that, while not totally impervious to change, can, at best, curtail the libido and, at worst, be totally oppressive.

Anton uses a range of shapes and forms to suggest the diversity of armatures that shape our world. Here the material and poetic rub up against one another as Anton is actually making the framework that lies at the core of a sculpture while nodding to the conceptual armatures that construct (and control) social and political life. In the context of the Biennale,

Shannon Rae Stratton

they also summon the concept of the state as armature and the components that comprise it—from its laws to its governing bodies and its nationalist agenda.

Capitalism might be conceived of as a hyper-armature, one that has been erected across most of the globe, stretching between and connecting nations. Capitalism has proliferated, in part because it has subjugated other armatures in its path—from education to spirituality to healthcare—to its logics, turning nearly all cultural and political frameworks into one dependent on extractive and transactional practices. At this point, nearly every need or experience is dependent on capitalism's armature. Health, art, food, friendship, leisure, family, even love have caked so thickly onto this framework of exchange that it is often concealed or, perhaps, willfully disregarded. How many young people who abhor capitalism in theory still use dating sites that they pay for to find love, choosing potential partners like they choose any other product on the marketplace and offering themselves up to be objectified just the same?

Perhaps this is the meaning behind Anton's *FACE: Modern Tales of Plastic Proliferation*. Anton's objects are playful, seductive even, thanks to the slick, vivid nature of plastic—revealing how the design of control mechanisms can be attractive and even tap into desire. *FACE*, which is an amalgam of emojis and pictograms, might be the most unsettling of Anton's plastic covered armatures, given that it is the most seemingly benign. A world reduced to cute, clever images and symbols is digestible, simple, and quick, but is it indicative of a loss of a more robust experience?

Under the influence of contemporary digital technologies, our retrieval of memories has been altered, and valuing of knowledge has lessened. We live in an era of reductive language, an outcome of rapid digital communication that has us scrolling and swiping to the detriment of our attentional capacities. Smart phones spread social contagion and screens mediate and blunt the power of mirror neurons to build empathy. Brains are in the process of being changed before we even consider the new technologies that are on the cusp.

Those expeditious emojis, text messages, and social media missives that we deploy mediate our relationship to the complexity of life. This mediation then acts as a control mechanism, slowly reshaping our communication so as to lose all tolerance for nuance. We are left speaking to one another as if writing headlines or ad copy, everything a sales pitch about our identity, our feelings and our opinions, and, presumably, in its use, it slowly alters both our inner worlds and our expectations (and acceptance) of others'.

The superficial feeling of simple and rapid digital missives matches a kind of decorative veneer that Anton invokes in his use of shredded plastic as a coating for his armatures. These tiny fragments evoke color and fun, and maybe even pixels, alluding to the different ways space is shaped or molded by features that are frequently mistaken (perhaps because they are intentionally disguised) as decorative, playful, or benign. Ironwork fences, gates, bars, and barriers, even when beautiful, are things meant to define boundaries between what or who is on the inside, and what or who is kept out. Light and air might pass around and through these objects, but they are

still barriers to entry and subtle reminders of private property, crowd control, and other forms of behavioral modification that humans subject one another to in the ongoing battle to manage our environment and one another.

While the police barricade, which Anton references in *Crowd Control*, might be more recognizable as a tool for dominance, the high iron fences and gates that protect private property can at first read as genteel. *After the Federal Reserve* recalls the ironwork used to secure windows and doors, with flourishes that unfurl like tentacles. Not unlike *FACE*, at first, this little bit of beauty might seem mild, until we imagine who might get entangled in these projections and why. As the regulatory body for banking in the United States, the "Fed" has control over the larger economic success of American citizens, whether through setting interest rates or controlling inflation. Many critique its effectiveness and lack of transparency.

Orologio (Plastic Time) stands apart in its suggestion, but not depiction, of a clock. Encrusted in black plastic waste, it summons images of seabirds tragically coated in oil, destroying their natural capacity to repel water and conserve heat. Installed at a height that hovers over the gallery and viewer, it becomes celestial, a nod to the passage of time as read in planetary movement, even as it grounds in the earth itself, where:

> The millions of years that go into the creation of a plastic item, and the indefinitely long time it will take for that plastic item to decompose, are seemingly obliterated by the fact that we often use plastic packaging for, at most, a few months, compressing deep time into what seems like an eternal, and eternally replicating present.[5]

All four sculptures are a composite of two things that hide in plain sight—the decorative barrier and ubiquitous plastic. In her book *Plastic Matter*, Heather Davis writes, "The terms of materiality within the post-Enlightenment Western project are impressed into plastic, where matter is subservient and dichotomous to the wills and whim of the human mind."[6] Yet, plastic refuses to submit.

Scattered at the foot of *Crowd Control* are flakes of colored plastic. It's an interesting juxtaposition, since these tiny plastic particles certainly cannot be regulated by this porous barrier. Thus, Anton's sculptures fuse the two sides of dis/obedience. The barrier, the commanding object, is suffocated by plastic, the defiant one. The resulting surface is a playful, dimensional pointillism that is both alluring and misleading, perhaps not unlike "plastic" itself.

Plastic, in fact, is so insistent, so pervasive, that it is inside of us, and not just as invaluable prosthetic hips or knees, but on a microlevel: it has infiltrated the very fiber of our being through ingested microplastics that make their way into our food and water. Or, perhaps, prioritized differently, plastic is so pervasive that it is inside of us, and not just through contaminates like microplastics, but through invaluable prostheses like pacemakers, whose lead components are insulated by polyurethane. Plastic's ambiguity is part of its disobedience, and is perhaps why it makes such a compelling material to address the complexity of capitalism and control. Like many things that have the power to fundamentally change us, it is as desirable as it is disruptive.

Shannon Rae Stratton

The Desiring Hand

> Malabou's question "What should we do with our brain?" is a real
> question, but the choices before us are not under our control.
> They are leaps and bounds, and where we land erases the point
> from which we leapt. This problem of a disappearing measure
> of change is a limit to plasticity not as a process but as a thinkable
> question. So the investigation of one's own plasticity is always
> a kind of thought experiment. When the process actually takes
> place, whether subtle or dramatic, it is often imperceptible.
>
> Jairus Grove[7]

Can't we all recall a moment in our lives when a change was suddenly,
harshly apparent? A moment when something that had been lurking in the
shadows, transforming under invisible hands, materializes, forever alter-
ing what had been (up until its emergence) understood? Who hasn't faced
a bleak, stark moment when nothing will ever be as it was?

It took me twenty minutes to write those three sentences, because
it is nearly impossible to describe the feeling of an invisible transforma-
tion. One reality has seamlessly dissolved into another—isn't it that simple?
But yet, any attempt to truly trace the transition and understand its origins,
which levers were pulled and in what order, will only lead a person back
through and along a path that doubles back, dead-ends, and, in some parts,
simply crumbles away. Depending on the change, you might be running
around in panic, with tears streaking your face, or you may simply stare at
the end of the path—toeing where it became overgrown with weeds—
completely lost.

One of the horrors of the concept of brain plasticity is the idea that
a cohesive "I" does not exist. That the "aleatory world of the brain puts
the 'I' in the potent grip of forces well beyond our control"[8] means that there
is an "I" that can live on as someone that "I" do not currently "know."

> Unlike elasticity, plasticity has no promise of return. Both concepts
> suggest a limit point at which the system breaks. However, the
> change in each is different, as something elastic returns or can re-
> turn to form after its change. Plasticity names an unredeemable
> metamorphosis.[9]

That our being could be contingent on change beyond our control, beyond
"changing our minds" or "personal development," brings into focus the pos-
sibility of an outside force that can design or steer subjects, not so much
against their will as without the subject even having "any index of who they
were before."[10]

Anton's barricades allude to the possibility of invisible control. By
putting the obvious barriers of *Crowd Control* and *After the Federal Reserve*
in conversation with the less-than-tangible barriers of *Orologio* and *FACE*,
we start to see how the material and immaterial condition our existence.
The former might seek to illustrate the impact of state control and capital-
ism, while the latter prompts the age-old question of how technology
might reshape the human mind (not that all four—state, capitalism, time,
and technology—are not intertwined).

Being is nothing but our own mutability

To be plastic is to be moldable, but plastic polymers are very resistant to outside forces—as per Malabou's use of the word, plastic itself is quite resistant to external demands. In fact, plastic resists the earth's forces. Plastic bags biodegrade in ten to twenty years, but other plastic items are estimated to decompose anywhere from 200 years to 10,000. Plastic is clogging up the planet's body, and the planet's bodies. In *Plastic Matter*, Davis recounts the scale of plastic's impact, noting that it is "produced in astronomical amounts—about 380 million tonnes globally," with 91 percent going to landfills, incinerated, or reused in durable goods. "If rates of plastic production continue," she writes, "it is predicted that by 2050 twelve billion tonnes of plastic will be in landfills and throughout the wider environment, where it circulates in the currents of water and air."[11]

Scientists are still not certain what the extent of the damage of ingested microplastics is, but the residue of capitalism, of "progress" and "improvement," of human desire, coursing through the water and hovering in the air, is remolding bodies. Perhaps humans are more plastic, more malleable than polymers themselves. At this moment, we may not know who we have become or how we have arrived here. (The IV bag I see every six weeks for an infusion is meant to control a disease no one understands. Did plastic give me this illness, and, if so, how could plastic take it away?)

Whether it is the effect of DEHP from vinyl IV bags on the endocrine system or inhaled microplastics that may result in respiratory and cardiovascular diseases, plastics are quietly and invisibly at work. The duality in Anton's work—the armature and the residue of capitalism—is a forceful metaphor: the waste of capitalism is conditioning and *controlling* our bodies, invisibly and mysteriously. Our bodies don't metabolize plastic—*we* don't translate it into energy. Plastic processes, and mutates, us.

Epilogue: Do We Remember Who We Are

On September 13, 2023, the *Guardian* published a story with the headline:

> Earth "well outside safe operating space for humanity," scientists find.[12]

"Hello from inside
the albatross
with a windproof lighter
and Japanese police tape."[13]

I should like to be this landscape which I am contemplating[14]
I eat this moment whole
No in parts
I keep taking bites, chaotically

> Six out of nine planetary boundaries, exceeded.
> The limits of the Earth's health, breached.

"Hello from can-opened
Delta gators,
Taxidermied
With twenty-five grocery sacks
And a Halloween Hulk mask."[15]

I eat this moment and I don't chew it
No I chew it for days
I chew it at night in my dreams I am chewing

> Two more boundaries are dangerously close to being broken.
> Only one, the atmospheric ozone,
> (The environmental crisis of my childhood)
> Is not threatened.

"Hello from bacteria
Making their germinal way
To the poles in the pockets
Of packing foam"[16]

My teeth fall out
And they fill my mouth
There are more teeth in my mouth than I had
I am spitting them out, I swallow

> These breached boundaries are turning points
> For the Earth's life support systems.
> The Earth is like a patient
> with dangerously high blood-pressure,
> the *Guardian* says.[17]

"Hello from low-density
polyethylene dropstones
glacially tilled
by desiccated,
bowel obstructed camels."[18]

I thought there was chemistry
Between us
A mutual mutability
But maybe this moment just sat inside waiting
Hiding in the folds of my gut
It contracts and shivers and tries to move me

> This is what has been changing in our shadows,
> The invisible hands of our desire remaking the world,
> The collective body transmogrified.
> Except it is not magical.

Being is nothing but our own mutability

"Hello from six-pack rings
And chokeholds,
From breast milk
And cord blood,
From microfibres
Rinsed through yoga pants
And polyester fleece"[19]

I am trying I am trying I am trying
To write
To paint
I make an object and name it "Misery"
I make an object and name it "Hope"
I try throwing up
I try shitting out
I try making up
And nothing really comes out

> We are headed into uncharted acidic waters,
> Bodies clogged with plastics, invited and uninvited,
> Our faces streaked with tears or

I am trying to maintain a toehold
I am trying to grasp ghosts
I am trying to stay in focus

"Hello from washed up
Fishnet thigh-highs
And frog suits
And egg cups
And sperm.
Hello."[20]

> Perhaps, dead-eyed and lost.

Hello.

1 Bessel van der Kolk M.D., *The Body Keeps the Score: Brain, Mind, and Body in the Healing of Trauma* (New York: Penguin Books, 2015); Gabor Maté, *When the Body Says No: The Cost of Hidden Stress* (Brunswick, Australia: Scribe, 2019).

2 Catherine Malabou, *Plasticity at the Dusk of Writing: Dialectic, Destruction, Deconstruction*, trans. Carolyn Shread (New York: Columbia University Press, 2010), 43.

3 Catherine Malabou, "No to Flexibility, Yes to Plasticity! Interview with Catherine Malabou," *Philonomist*, last updated January 15, 2020, https://www.philonomist.com/en/entretien/no-flexibility-yes-plasticity.

4 Malabou, "No to Flexibility, Yes to Plasticity!"

5 Heather Davis, *Plastic Matter* (Durham, NC: Duke University Press, 2022), 11.

6 Davis, *Plastic Matter*, 9.

7 Jairus Grove, *Savage Ecology: War and Geopolitics at the End of the World* (Durham, NC: Duke University Press, 2019), 160.

8 Jairus Grove, "Something Darkly This Way Comes: The Horror of Plasticity in an Age of Control," in *Plastic Materialities: Politics, Legality, and Metamorphosis in the Work of Catherine Malabou*, ed. Brenna Bhandar and Jonathan Goldberg-Hiller (Durham, NC: Duke University Press, 2015), 238.

9 Grove, "Something Darkly This Way Comes," 238.

10 Grove, "Something Darkly This Way Comes," 239.

11 Davis, *Plastic Matter*, 8.

12 Damian Carrington, "Earth 'Well Outside Safe Operating Space for Humanity,' Scientists Find," *Guardian*, September 13, 2023, https://www.theguardian.com/environment/2023/sep/13/earth-well-outside-safe-operating-space-for-humanity-scientists-find.

13 Adam Dickinson, "The Polymers," in *Energy Humanities: An Anthology*, ed. Imre Szeman and Dominic Boyer (Baltimore: Johns Hopkins University Press, 2017), 512.

14 Simone de Beauvoir, *The Ethics of Ambiguity* (Paris: Editions Gallimard, 1947), 11.

15 Dickinson, "The Polymers," 513.

16 Dickinson, "The Polymers," 513.

17 Carrington, "Earth 'Well Outside Safe Operating Space for Humanity.'"

18 Carrington, "Earth 'Well Outside Safe Operating Space For Humanity.'"

19 Carrington, "Earth 'Well Outside Safe Operating Space For Humanity.'"

20 Carrington, "Earth 'Well Outside Safe Operating Space For Humanity.'"

ARTH 392/492[1]
Issues in 20th/21st Century Art: Plastocene Era:
Art, Plastics, and the Future of the Planet
Thursdays, 2:30–5:00pm, at SPACES
Spring 2023

Andrea Wolk Rager, Associate Professor, Case Western
Reserve University
Portia Silver, Graduate Teaching Assistant

Community Partners:
Tizziana Baldenebro, Executive Director, SPACES
Lauren Leving, Curator, moCa Cleveland

Cleveland's SPACES gallery has been selected as the com-
missioning institution for the US Pavilion at the 2023
Venice Architecture Biennale. Titled "Everlasting Plastics,"
this group exhibition is co-curated by Lauren Leving,
curator at the Museum of Contemporary Art Cleveland,
and Tizziana Baldenebro, executive director of SPACES,
and will be open May 20, 2023–November 26, 2023.
Featured artists include Xavi L. Aguirre, Simon Anton, Ang
Li, Norman Teague, and the Cleveland-based sculptor
Lauren Yeager. This course presents a unique opportunity
for a community-engaged learning partnership with
SPACES centered around "Everlasting Plastics." The course
will consider the central themes of the exhibition, includ-
ing the history and emergence of plastics as an industrial
product, the rising global environmental crisis of plastic
pollution, and how artists have engaged with plastic as a
medium for critiquing and raising awareness of its pervasive
impact. We will explore the local and global networks
of plastic consumption, plastic waste, and plastic futures,
connecting Lake Erie to the Venice Lagoon, as a vital

Plastiglomerates (2013)
resulted from an art/science
research investigation by
artist Kelly Jazvac, geologist
Patricia Corcoran, and
oceanographer Charles Moore.
Photograph by Jeff Elstone.
Courtesy of the artist.

component of social and environmental justice. A significant portion of the class will take place at the SPACES gallery on Cleveland's West Side, where students will have the opportunity to contribute to the implementation of the exhibition, as well as related programming, by working closely with co-curators Baldenebro and Leving. Students will write regular journal entries, which will include responses to class discussions and synopses of tasks completed to support the exhibition, as well as a final reflective paper.

Required Readings
There is one required text for this class: Mateo Kries, Jochen Eisenbrand, Mea Hoffmann et al., eds., *Plastic: Remaking Our World* (Weil am Rhein: Vitra Design Museum, 2022). Additional required readings and resources will be available on Canvas, the class Google Drive Folder, or on reserve at Ingalls Library.

Course Schedule and Recommended Readings
Please note: Due to the organic nature of this unique, collaborative community partnered class, the reading list will be updated throughout the semester. This schedule will serve as an initial organizing document, but will also be flexible in order to take advantage of opportunities like artist studio visits or guest lectures and will respond to student input and interests. Updates will be posted to Canvas and to our class Google Drive Folder.

Thursday, Jan. 19: Introduction to "Everlasting Plastics" and SPACES[2]

- Tim Dickinson, "Planet Plastic: How Big Oil and Big Soda Kept a Global Environmental Calamity a Secret for Decades," *Rolling Stone*, March 3, 2020, https://www.rollingstone.com/culture/culture-features/plastic-problem-recycling-myth-big-oil-950957.
- Sharon Lerner, "Waste Only: How the Plastics Industry Is Fighting to Keep Polluting the World," *The Intercept*, July 20, 2019, https://theintercept.com/2019/07/20/plastics-industry-plastic-recycling.

2 Katelyn Jones
At our first meeting, Tizziana Baldenebro shared the challenges of building an architecture exhibition in the US Pavilion, which, because of its weak foundations, cannot support significant weight. This talk about layers, foundations, and erosion made me think about the layer of plastics that now exists in the Earth's crust. These oil-based polymers alter the foundations of many eco-systems around the globe; how will they affect the literal foundation of the US Pavilion in the future?

3 Rebekah Utian
Within a week, I couldn't help but notice plastic everywhere. I became acutely aware of my own mindless consumption of it. I started to feel the paradox of plastic: we cannot live without it, but the Earth will become inhospitable if we continue to produce new plastic and plastic waste.

4 Rebekah Utian
In class we talked about plastic's historical romanticism in contrast to the contemporary moment, where we barely notice our consumption of it. Plastic was created out of scarcity; out of the growing shortages and prices of certain natural products. When understood historically, it is apparent that the development of plastic was never about finding a more ecological, moral, or collaborative solution but about creating a market. Demand, disposability, and profit—this is the recipe that corporations continue to feast on.

5 Katelyn Jones
Conservator Jessica Walthew of the Cooper Hewitt Design Museum shared with us that plastics have become the single most challenging material for conservators today; that the "design lifetime" of plastic objects and the "museum lifetime" expected of museum objects are often incompatible. While "design lifetime" often predicts an object's eventual presence in the trash, the museum, as Walthew emphasized, is seen as "the opposite of the trash can."

Thursday, Jan. 26: Discussion of the exhibition *Plastic: Remaking Our World* (Vitra Design Museum, 2022)[3]
- Kries et al., eds., *Plastic: Remaking Our World* (Weil am Rhein: Vitra Design Museum, 2022).[4]

Friday, Jan. 27: Symposium, "Synthetic Histories: Plastics, Climate, and Colonialism," hosted by V&A Dundee and the Paul Mellon Centre for Studies in British Art (Virtual), 5:00am–12:30pm EST
Students are required to attend at least two hours of the virtual symposium (this counts in lieu of an in-person class session on March 23, 2023). Registration and Program: https://www.paul-mellon-centre.ac.uk/whats-on /forthcoming/synthetic-histories-conference.

Wednesday, Feb. 1, 7:30pm: Event, Happy Dog Takes On "Everlasting Plastics," hosted by The City Club of Cleveland

Thursday, Feb. 2: *Plastic Matter*
- Heather Davis, *Plastic Matter* (Durham, NC: Duke University Press, 2022), available as an ebook through KSL.
- Recommended Reading: Amanda Boetzkes, *Plastic Capitalism: Contemporary Art and the Drive to Waste* (Cambridge, MA: MIT Press, 2019), available as an ebook through KSL.

Thursday, Feb. 9: Plastics and Art Conservation; Guest lecture by art conservators Jessica Walthew and Beth Edelstein[5]
- Browse: https://www.getty.edu/conservation/our _projects/science/plastics.
- Recommended Lecture: "Icons in Plastic," https:// www.youtube.com/watch?v=0z1L5TsR64g.
- Recommended Program: "Semi-synthetic and Synthetic Textile Materials in Fashion, Design and Art," ICOM-CC Modern Materials and Contemporary Art & Textiles Working Groups, Virtual Joint Interim Meeting February 21–23, 2023.
- Recommended Podcast: *Trace Material*, Season 2: "Plastics," 2021, produced by the Healthy Materials Lab at Parsons School of Design.

Thursday, Feb. 16: Artistic Antecedents: Robert Smithson & Mierle Laderman Ukeles; Students encouraged to attend Norman Teague lecture at Oberlin, 5:30–7:00pm

Group A: Robert Smithson
- Robert Smithson, "A Sedimentation of the Mind: Earth Projects," in *Art in Theory: 1900–2000*, ed. Charles Harrison (Oxford: Blackwell, 2002), 877–881.
- Robert Smithson, "Frederick Law Olmstead and the Dialectical Landscape," (1973) rpt. in *Robert Smithson: Collected Writings*, ed. Jack Flam (Berkeley, CA: University of California Press, 1996), 157–171.
- Jennifer L. Roberts, "Spiral Jetty/Golden Spike," *Mirror Travels: Robert Smithson and History* (New Haven, CT: Yale University Press, 2004), 114–139.

Group B: Mierle Laderman Ukeles[6]
- Jo Anna Isaak, "Trash: Public Art by the Garbage Girls," *Gendering Landscape Art* (New Brunswick, NJ: Rutgers University Press, 2001), 173–185.
- Toby Perl Freilich, "Blazing Epiphany: Maintenance Art Manifesto 1969!: An Interview with Mierle Laderman Ukeles," *Cultural Politics* 16, no. 1 (2020): 14–23.
- Amanda Boetzkes, "Landfill Archaeology for a New Demos," *Plastic Capitalism: Contemporary Art and the Drive to Waste* (Cambridge, MA: MIT Press, 2019), 77–125.
- Ronald Feldman Gallery, https://feldmangallery.com/artist-home/mierle-laderman-ukeles.
- Holland Cotter, "An Artist Redefines Power. With Sanitation Equipment.," *New York Times*, September 15, 2016.
- Recommended Reading: Patricia C. Phillips, "Making Necessity Art: Collisions of Maintenance and Freedom," *Mierle Laderman Ukeles: Maintenance Art*, ed. Patricia C. Philips (New York: Queens Museum and DelMonico Books, 2016), 23–193.

Topic Discussions I, II, & III

ARTH 492 students will work in pairs to present on three topics (one each week) related to the core themes of the exhibition. Topics will be generated collectively. Graduate student teams will assign relevant readings, in consultation with Professor Rager, which will be posted on the Google Drive Folder and shared to Canvas no later than one week before the discussion.

6 Portia Silver
While many of the contemporary artists we've encountered in this class engage with questions of reclaimed materials, Ukeles powerfully engages with waste *systems*. Her project *The Social Mirror*, which embellished a garbage truck with mirrors as it made its rounds in New York City, tackles both individual and systemic waste and responsibility—implicating and connecting New Yorkers and municipal workers alike in the production and management of trash.

7 Portia Silver
Max Liboiron characterizes waste, specifically plastic, as modern colonialism in which the pattern of use of Indigenous land is continued through the disposal of waste and extraction of resources. As the exhibition attempts to grapple with the effect of plastic consumption on human lives in the context of colonialism, we discussed to what extent working within existing institutions can create meaningful and systemic change.

8 Ruth Bryant
Considering plastic in relation to the history of the Biennale, its influences and its connections to (the problems of) nationalism and globalism, poses incredibly urgent questions about borders. Plastic disregards all borders. It travels. It is made in one place, used in another, and disposed of somewhere else. This mobility is a privilege; the harm associated with it is not equally distributed. Borders too are plastic, as is plastic often used to border. Plastic wrapping around food, around cars, around property.

9 Rebekah Utian
Tizziana Baldenebro brought in samples of the plastic curtains or thresholds that would be installed throughout the US Pavilion. The amber-colored plastic was incredibly aesthetically appealing. It was fascinating how we all gravitated toward these large plastic sheets; the aesthetic capacity of plastic—its compelling nature—is powerful.

Thursday, Feb. 23: Topic Discussion I: Disposability, Waste, Colonialism[7] (Graduate Student Team Leaders: Jess Long and Grace Hanselman)

- Edwin Jurriens, "Art, Image, and Environment: Revisualizing Bali in the Plastiliticum," *Continuum: Journal of Media & Cultural Studies* 33, no. 1 (2018): 119–136.
- Max Liboiron, "Waste Colonialism," *Discard Studies*, November 1, 2018, https://discardstudies.com /2018/11/01/waste-colonialism.

Thursday, March 2: Topic Discussion II: Venice Biennale—Past, Present, Future[8] (Graduate Student Team Leaders: Katelyn Jones and Portia Silver)

- Léa-Catherine Szacka, introduction to *Biennials/ Triennials: Conversations on the Geography of Itinerant Display* (New York: Columbia Books on Architecture and the City, 2019), 15–43.
- Claudette Lauzon, "Reluctant Nomads: Biennial Culture and Its Discontents," *RACAR: Revue d'art Canadienne/ Canadian Art Review* 36, no. 2 (2011): 15–30.
- Recommended Reading: Dermis P. León, "Havana, Biennial, Tourism: The Spectacle of Utopia," *Art Journal* 60, no. 4 (2001): 68–73.

Thursday, March 9: Topic Discussion III: Ecocriticism and Recent Exhibitions[9] (Graduate Student Team Leaders: Zoe Appleby and Rebekah Utian)

- Andrew Patrizio, "The Ecological Eye: Assembling an Ecocritical Art History," in *The Ecological Eye: Assembling an Ecocritical Art History* (Manchester: Manchester University Press, 2018), 24–41.
- Alan C. Braddock and Karl Kussero, introduction to *Nature's Nation: American Art and Environment*, (Princeton, NJ: Princeton University Art Museum, 2018), 12–39.
- Cochester + Ipswich Museums, "Landscape and Environmental Emergency – 'Nature's Nation,' Ecocritical Art History," *YouTube*, September 2, 2021, https:// www.youtube.com/watch?v=XxM0CiGOBLM.

Thursday, March 15: No Class

Thursday, March 23: Individual Conferences
Students should sign up for individual and/or small group meetings with Professor Rager to discuss their contributions to "Everlasting Plastics" and SPACES, and the expectations for the remainder of the semester. Students will be expected to continue independent work during this time.

Thursday, March 30: Contemporary Artist Presentations
Each student will select a contemporary artist whose work intersects with the exhibitors in "Everlasting Plastics" and prepare a presentation to be shared with the class.

Thursday, April 6-20: Collaborative and Independent Work for "Everlasting Plastics"

Thursday, April 27: Concluding Discussion, Reflection, and Next Steps

Friday, April 28: Macro Sustainability Day, Kent Hale Smith Building, unveiling of Lauren Yeager's new sculpture installations in the Putnam Collection[10]

Saturday, May 6: "From Lake to Lagoon: Exploring Sustainability in Cleveland & Venice," Town Hall Event at CWRU Health Education Campus[11]

Tuesday, May 9: Final Reflective Paper and Journal Entry Due

Saturday, May 20: Opening of 2023 Venice Architecture Biennale and "Everlasting Plastics"

Friday and Saturday, Oct. 6–7: Symposium, "Canal to Cuyahoga: 'Everlasting Plastics' in Context," Cleveland Museum of Art, co-hosted by SPACES and the Department of Art History & Art at CWRU[12]

10 Katelyn Jones
A begrudged—though well-meaning—staff member installed fluorescent (plastic) caution tape to block access to Lauren Yeager's sculpture as it was being touched by viewers. How are we to interact with discarded vintage coolers now that they have been so purposefully, monumentally stacked and declared as art?

11 Katelyn Jones
We organized a town hall-style event for members of the community to meet and start crucial conversations with local leaders in sustainability. We often discussed the importance of not recreating a "single-use" mentality in "Everlasting Plastics" so the ideas and conversations prompted by the exhibition would not be disposed of but rather resonate through many communities and venues. The curators and artists shared their experience with the attendees of the town hall event, live from a broom closet in the US Pavilion.

12 Ruth Bryant
In her keynote address on plastic performativity, writer/artist/theorist Katie Schaag walked center stage and breathed deeply into a plastic bag. Schaag was emulating the 2015 perfomance art piece by Claudia Borgna, *When I breathe you breathe, when you breathe I breathe*. With each breath, the plastic bag inflates and deflates, mimicking the action of the lungs—literally and metaphorically connecting the human body with plastic in ways that are devastating and life-giving.

Acknowledgments

This project, spanning exhibitions, dialogs, texts, and beyond, explores our troubled connection to material culture through the lens of plastic. Through the works of five architects, designers, and artists, we examine this relationship's durability and complications. As plastic permeates every part of our lives, we mimic its ubiquity through expansive networks and kinships. *Everlasting Plastics* is indebted to many people, ideas, and precedents. It has been a collaborative and generative experience that has influenced our own curatorial work, inasmuch as it has opened our eyes to the unsustainable models of creative practice.

We extend our heartfelt gratitude to all those who have contributed to the realization of this book, without whom this endeavor would not have been possible.

First and foremost, we express our deepest appreciation to Paula Volpato, our assistant curator, whose dedication and tireless efforts have been invaluable throughout the entire process. She has been a true thought partner and collaborator in every sense of the word.

We are immensely grateful to our exhibitors whose remarkable talents have brought life and vibrancy to our texts and ideas: Xavi L. Aguirre, Simon Anton, Ang Li, Norman Teague, and Lauren Yeager. Their innovative perspectives and creative visions have enriched our project immeasurably.

We extend our sincere thanks to our funding partners for their generous support and commitment to the arts and architecture: US Department of State, Bureau of Education and Cultural Affairs; Ford Foundation; the Cleveland Foundation; Alphawood Foundation; The George Gund Foundation; the Nord Family Foundation; the Ohio Arts Council; the Graham Foundation for Advanced Studies in the Fine Arts; the Beyer Family Foundation; Margaret Cohen and Kevin Rahilly; The Andy Warhol Foundation for the Visual Arts; the Joyce Foundation; Agnes Gund; Ulmer & Berne LLP; University of Illinois Chicago; School of the Art Institute of Chicago; FRONT International: Cleveland Triennial for Contemporary Art; Glen-Gery; John Williams; AIA; Howard Freedman and Rita Montlack; Biagio and Lorraine Gagliano; Dennis and Kathy Barrie; David Novgorodsky; Neil and Amy Viny; Ian Muir; and Becky Dunn.

We extend our deepest gratitude to Columbia Books on Architecture and the City and our dedicated editors, Isabelle Kirkham-Lewitt, Joanna Joseph, Meriam Soltan, and copyeditor Grace Sparapani for their invaluable contributions and guidance.

Special thanks to our graphic design team Normal, in particular Renata Graw and Lucas Reif, for their exceptional creativity and attention to detail.

We are deeply grateful to our exhibition designers, Chloe Munkenbeck and Adnan Faysal Altunbozar, for their outstanding work in bringing our vision to life.

To our team in Venice, especially our host at the Peggy Guggenheim Collection, Chiara Barbieri, we are immensely grateful for the hospitality and support. Jill Weinreich's on-the-ground assistance has been invaluable, and we extend our thanks to Giacomo di Thiene at Th&Ma Architettura,

Ott Art, Minto, and Gallo for their contributions. And thanks to Resnicow + Associates for their clear communications of our project.

A special mention goes to the art preparators in Venice, Apice, with extra special thanks to Nicolò Muffato, Thomas Bonotto, Davide Ducceschi, Tommaso Miglio, Davide Timis, and Costanza VitaFinzi for their meticulous attention to detail and professionalism.

Our sincere appreciation goes to our hosts and collaborators at the Carnegie Museum of Art, especially curators Theodossis Issaias and Alyssa Velazquez, and to our partners at Wrightwood 659 and at FRONT International: Cleveland Triennial for Contemporary Art for their support and collaboration.

We extend our gratitude to Dr. Andrea Wolk Rager and her students in art history at Case Western Reserve University for their thoughtful partnership and collaborative work, as well as to our hosts for the symposium, including Sears think[box] and the Cleveland Museum of Art. We also thank all of the scholars and thinkers, especially the contributors to *Sketches on Everlasting Plastics* and the essayists featured in this publication, whose works on plastic intersected with our own research.

We are indebted to our partners in life, Nathan Florsheim and David Novgorodsky, for their unwavering support and for providing us with the space to realize this project. We extend our heartfelt gratitude to our families for their endless love and encouragement.

To the staff and board at SPACES, we express our appreciation for their vital role in fostering creativity and experimentation, allowing us the freedom to boldly showcase our best work.

Thank you to everyone who has contributed to this endeavor. Your support has been instrumental in making this exhibition and book a reality.

—Tizziana Baldenebro and Lauren Leving, April 2024

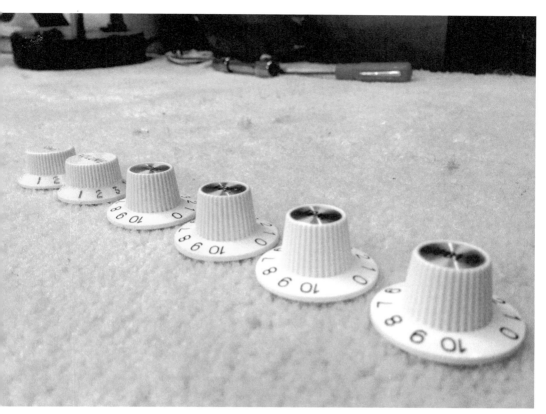

Image from "Aging plastic," *Project: Jazzmaster* (blog), June 6, 2013, https://
projectjazzmaster.wordpress.com/2013/06/06/aging-knobs.

ISBN: 9781941332818
Library of Congress Control
Number: 2024935923

Graphic Design: Normal
(Renata Graw and Lucas Reif)
Copyeditor: Grace Sparapani
Printer: Grafiche Veneziane
Lithographer: Marjeta Morinc
Paper: Munken Polar 120gsm,
Recytal Offset White 70gsm,
and Munken Polar 300gsm
Type: Monument Grotesk

Columbia Books on Architecture
and the City
An imprint of the Graduate
School of Architecture,
Planning, and Preservation

Columbia University
415 Avery Hall
1172 Amsterdam Ave
New York, NY 10027

arch.columbia.edu/books
Distributed by Columbia
University Press
cup.columbia.edu

Everlasting Plastics
Edited by Tizziana
Baldenebro, Joanna Joseph,
Isabelle Kirkham-Lewitt,
and Lauren Leving.
With contributions from Xavi L.
Aguirre, Simon Anton, Kristen
Bos, K. Jake Chakasim, Sky
Cubacub, Heather Davis,
Jennifer Gabrys, Rania Ghosn,
Stephanie Ginese, Aurelia
Guo, Adam Hanieh, Ilana Harris-
Babou, Theodossis Issaias,
Zakiyyah Iman Jackson, Carolyn
L. Kane, Laleh Khalili, Anjuli
Fatima Raza Kolb, Naa Oyo
A. Kwate, Esther Leslie, Ang
Li, Ani Liu, Adie Mitchell,
Timothy Mitchell, madison moore,
Gabrielle Printz, Andrea Wolk
Rager, Laura Raicovich, Kyla
Schuller, Terry Schwarz,
Pallavi Sen, Ayesha A. Siddiqi,
Marisa Solomon, Meriam
Soltan, Shannon Rae Stratton,
Ala Tannir, Norman Teague,
Jessica Varner, Paula Volpato,
Michele Y. Washington, RA
Washington, and Lauren Yeager.

"Everlasting Plastics" was
commissioned by SPACES in
Cleveland, OH.
All exhibition photography for
"Everlasting Plastics" © 2024
ReportArch/Andrea Ferro
Photography except inset images
on pages 103, 120, 148, 232,
245, 252, 257, and background
images on page 204.

This book has been produced
through the Office of the
Dean, Andrés Jaque, and the Office
of Publications at Columbia
University GSAPP.

Director of Publications:
Isabelle Kirkham-Lewitt
Assistant Director: Joanna Joseph
Editor: Meriam Soltan

Process 1: Plastic vessel being extruded by Daniel Overbey and Jacob Polhill at Cody Norman Studio.

Shredded material separated by color.

Cody Norman in the studio with the shredder (left)
and the extruder (right).

Jacob Polhill with early extrusion results after coiling
the plastic.

Daniel Overbey extruding and coiling blue plastics.

Norman Teague with fork extrusion coiling over an object.

Process 2: Plastic vessel being extruded by Daniel Overbey
and Jacob Polhill at Cody Norman Studio.

Daniel Overbey releasing cooled and coiled plastic
form from form.

Notes on Waste Collection
Lauren Yeager

Having access to city waste collection schedules is integral to my practice. Disposal guidelines, especially related to bulk trash, vary across cities. In Cleveland and its surrounding communities, bulk items may be placed separately on residential curbs (not bagged or stuffed into bins) and are picked up on regular weekly collection days or based on special collection schedules.

These guidelines are ideal for people who scrap or salvage: they create opportunities to intercept items to repair, repurpose, or sell, which not only reduces the amount of waste that workers have to collect and haul to landfills each month but also creates potential, alternative sources of income. My neighbor collects lawnmowers, snow blowers, and bicycles that he repairs and resells. Metal scrappers provide an independent recycling service to the city, collecting and transporting items that cannot be recycled in household bins to facilities that purchase them. These salvage practices divert many truckloads of garbage from the waste stream each week. I may see a pile of five or six items on my neighbor's curb in the evening, and the pile will be gone by the next morning, before the city collection trucks have even begun their rounds.

Over the years, I've noticed that some cities have removed these schedules from their websites. A couple of months ago, I downloaded Cleveland's waste collection map to share for this project, and now, at the time of writing, it appears that the administration has updated the website and removed the link to this map. I can no longer find it easily online. Other municipalities have ways of obscuring this information, often requiring that residents ask about the schedule for their individual addresses by telephone. These strategies, I believe, are a form of deterrence (maybe even a result of local complaints) intended to discourage scrappers from coming into a community—they are an effort to "keep out the riff-raff." By reproducing the following map and calendar from the City of Cleveland, Sanitation Department, I am attempting to archive and preserve access to this information so that people can continue to utilize their waste stream as a community resource.

Waste Collection Pickup

Monday
Tuesday
Wednesday
Thursday
Friday
------- Municipal Boundary

Waste Collection Pickup
Division of Waste Collection & Recycling
Department of Public Service
City of Cleveland

2023

CITY OF CLEVELAND OHIO

CITY OF CLEVELAND
Mayor Justin M. Bibb

Department of Public Works
Division of Waste Collection

B Bulk Week **H** One Day Delay

JANUARY

	S	M	T	W	T	F	S
B	1	H	3	4	5	6	7
	8	9	10	11	12	13	14
	15	H	17	18	19	20	21
	22	23	24	25	26	27	28
	29	30	31				

Jan. 2nd - New Year's Day
Jan. 16th - MLK Day
Waste Collection; 1 day delay all week

FEBRUARY

	S	M	T	W	T	F	S
				1	2	3	
B	5	6	7	8	9	10	
	12	13	14	15	16	17	
	19	H	21	22	23	24	
	26	27	28				

Feb. 20th - President's Day
No delay in collection

MAY

	S	M	T	W	T	F	S
		1	2	3	4	5	6
B	7	8	9	10	11	12	13
	14	15	16	17	18	19	20
	21	22	23	24	25	26	27
	28	H	30	31			

May 29th - Memorial Day
1 day delay all week

JUNE

	S	M	T	W	T	F	S
					1	2	
B	4	5	6	7	8	9	
	11	12	13	14	15	16	
	18	H	20	21	22	23	
	25	26	27	28	29	30	

Jun 19th - Juneteenth Nat'l
Independence Day
No delay in collection

SEPTEMBER

	S	M	T	W	T	F	S
						1	2
B	3	4	5	6	7	8	9
	10	11	12	13	14	15	16
	17	18	19	20	21	22	23
	24	25	26	27	28	29	30

Sept. 4th - Labor Day

OCTOBER

	S	M	T	W	T	F	S
B	1	2	3	4	5	6	
	8	9	10	11	12	13	
	15	16	17	18	19	20	
	22	23	24	25	26	27	
	29	30	31				

ion **H** **Holiday with Regular Pickup**

MARCH

S	M	T	W	T	F	S
			1	2	3	4
5	6	7	8	9	10	11
12	13	14	15	16	17	18
19	20	21	22	23	24	25
26	27	28	29	30	31	

APRIL

	S	M	T	W	T	F	S
							1
B	2	3	4	5	6	**H**	8
	9	10	11	12	13	14	15
	16	17	18	19	20	21	22
	23	24	25	26	27	28	29
	30						

Apr. 7th - Good Friday
No delay in collection

JULY

S	M	T	W	T	F	S
						1
2	3	**H**	5	6	7	8
9	10	11	12	13	14	15
16	17	18	19	20	21	22
23	24	25	26	27	28	29
30	31					

July 4th - Independence Day
1 day delay all week

AUGUST

	S	M	T	W	T	F	S
			1	2	3	4	5
B	6	7	8	9	10	11	12
	13	14	15	16	17	18	19
	20	21	22	23	24	25	26
	27	28	29	30	31		

NOVEMBER

S	M	T	W	T	F	S
			1	2	3	4
5	6	7	8	9	10	11
12	13	14	15	16	17	18
19	20	21	22	**H**	24	25
26	27	28	29	30		

Nov. 23rd - Thanksgiving Day

DECEMBER

	S	M	T	W	T	F	S
						1	2
B	3	4	5	6	7	8	9
	10	11	12	13	14	15	16
	17	18	19	20	21	22	23
	24	**H**	26	27	28	29	30
	31						

Dec. 25th - Christmas Holiday

Proper Set Out*

- All waste/garbage in city issued carts
- Bulk items separated
- Yard waste bundled
- *As shown, 1st full week of month (tires/bulk)

Improper Set Out

- Excess waste outside of cart
- Use of improper waste containers

For more information on set out services

Hours That Count

Ang Li

May 3, 2023: Two weeks before the opening of the 2023 Venice Architecture Biennale, a pair of cargo boats pulled up along the Rio dei Giardini. Among other things, they held two shipping containers worth of plastic waste exported from the United States. Even though the contents shared the same petroleum origins, their physical expressions varied in size, weight, and appearance, from consumer objects to building components and raw materials in pelletized, extruded, and densified forms. Amidst the crates and containers being unloaded onto dry land were six pallets of expanded polystyrene (EPS) foam.

March 3, 2023: This material began its journey two months earlier in a waste-processing facility outside Boston, Massachusetts, where 5,700 pounds of EPS waste diverted from demolition sites, film productions, and packaging companies were compressed into dense blocks, palletized, and labeled for pick-up.[1] From there, the pallets were loaded onto a semi-truck and sent to a warehouse in Cleveland, Ohio, where they were individually weighed, photographed, wrapped in more layers of plastic, and placed inside one of two 40-foot containers bound for an international shipping terminal in Norfolk, Virginia.

March 3, 2023. Save That Stuff, Boston, MA. Twenty-two pallets of densified EPS scrap arrive at the facility from another plastic recycler in the Boston area. Photograph by the artist.

March 6, 2023. Ross Express, Auburn, MA. Bill of lading documenting the shipment of six pallets, or "skids" (5,700 pounds), of densified EPS scrap from Boston, MA to Cleveland, OH.

March 13, 2023. Berea Moving and Shipping, Cleveland, OH. Interior view of a 40-foot shipping container filled with pallets of EPS scrap and other exhibition materials. Photograph by Paula Volpato.

March 13, 2023. Berea Moving and Shipping, Cleveland, OH. A 40-foot shipping container filled with pallets of EPS scrap bound for an international terminal in Norfolk, VA. Photograph by Paula Volpato.

March 13, 2023. Berea Moving and Shipping, Cleveland, OH. Close-up of a container seal that ensures that the contents within the shipping container will not be tampered with along the journey. Photograph by Paula Volpato.

March 14, 2023. Berea Moving and Shipping, Cleveland, OH. Dock receipt documenting the transfer of a 40-foot shipping container from Cleveland, OH, to Norfolk, VA, by rail. Photograph by Paula Volpato.

March 27, 2023. Port of Virginia, Norfolk, VA. Seaway bill from Ocean Network Express documenting the transfer of two 40-foot shipping containers aboard the cargo ship Chicago Express, from Norfolk, VA, to Genoa, Italy. The contents of the containers are labeled as "exhibition materials." Their combined gross weight is listed as 82,296.00 pounds.

March 27, 2023: The containers were loaded onto a 1,100-foot cargo ship called the Chicago Express, with a carrying capacity of 8,749 TEU.[2] This seventeen-year-old freighter is owned and operated by Hapag-Lloyd, a German shipping and transportation company founded in 1970 that has often been referred to as one of the largest shippers of plastic waste in the world.[3] After spending a day at the Port of Virginia, this laden vessel embarked on a month-long voyage across the Atlantic Ocean, before making its way through the Strait of Gibraltar and over the Iberian Sea toward Italy.

March 27–April 26, 2023. In Transit. Historical AIS Data on vessel traffic collected by the US Coast Guard showing the itinerary of the Chicago Express. After picking up the containers in Norfolk, VA, on March 27, 2023, the ship traveled through Savannah, GA; Miami, FL; Algeciras, Spain; and Livorno, Italy, before docking at the Port of Genoa on April 26, 2023. Courtesy of ShipAtlas, Maritime Optima.

The Chicago Express. Photograph by Hans Rosenkranz, August 10, 2017, Rotterdam, Netherlands.

April 26, 2023: Following a three-day stop in Livorno, the Chicago Express docked at the Port of Genoa in northern Italy,[4] where two shipping containers labeled as "exhibition materials" from the United States were unloaded onto trucks and driven four hours east to an anonymous warehouse on the outskirts of Mestre, an industrial suburb located across the lagoon from Venice.

Moving between far-flung sites of supply and demand, this increasingly precious cargo passed through a series of liminal spaces largely hidden from public view: unassuming back-of-house areas of recycling centers and distribution warehouses; interiors of countless skips, trucks, and shipping materials. At each point along this journey, the containers exchanged hands and moved through shifting systems of evaluation, from the ruthless weight-to-volume calculations of waste collectors and warehouse attendants to the customs classification systems of shipping agents and insurance companies. The anthropologist Anna Lowenhaupt Tsing describes the suspended gaps of time in which materials remain in transit as "hours that count," a brief window in which inventories are created, deals are brokered, and commodities are brought in and out of capitalist systems of waste and value.[5]

As the petroleum byproducts within the containers made their way across international waters, they underwent a similar process of transformation. Even though the six pallets of EPS foam that began their journey in Boston remained physically intact, the varying practices of discernment they were subjected to at each step along their itinerary facilitated a gradual transfer in value: from waste to stock, to building product, to cultural export.

May 3, 2023. Giardini, Venice, Italy. Art handlers unloading exhibition materials for the US Pavilion from two cargo ships along the Rio dei Giardini. Photograph by the artist.

May 3, 2023. Giardini, Venice, Italy. A forklift operator
transports a single pallet of densified EPS scrap from the
canal to the US Pavilion. Photograph by the artist.

May 3, 2023. US Pavilion, Venice, Italy. Pallets of
densified EPS scrap arriving at the pavilion. Photograph
by the artist.

May 5, 2023: In the courtyard of the United States Pavilion,
a team of experienced art handlers unpacked this long-
anticipated shipment with a level of care and precision usu-
ally reserved for valuable works of art with a more distin-
guished provenance. Piece by piece, blocks of densified
EPS scrap were measured, brought inside the gallery and
placed on a protective layer of bubble wrap that some-
one had taken the trouble to lay down earlier that morning.
Arranged in rows by size, shape, and aesthetic attributes,
they recalled blocks of freshly hewn marble at a quarry
—an uncanny resemblance that reminds us of the enduring
footprints of our fossil-fueled entanglements.

 During the six-month period when the pavilion is
open to the public, the pallets of EPS scrap on display

remain in a kind of holding pattern. Diverted from their predestined travels and placed within the space of the gallery, these reconstituted rocks resist categorization. They exist in a state of limbo between waste and commodity—too pristine to dismiss as matter out of place and too elusive to behold as objects of human desire. Released momentarily from the unrelenting cycles of consumption and disposal that govern the circulation of plastics within our supply chains and waste streams, these future fossils serve as an open invitation for other ways of looking. If we resist the immediate urge to consume or to condemn them, what else can they reveal: as an inventory system, a monument to a bygone era, or a layer in formation within our shared geological record?

May 5, 2023. US Pavilion, Venice, Italy. Unpacking pallets of densified EPS scrap during the installation process. Photograph by the artist.

1 Erik Levy (owner of Save That Stuff, Boston, MA), in discussion with the author, Boston, March 3, 2023.

2 A TEU is a 20-foot equivalent unit, a measurement of capacity in the shipping industry based on the rough approximation of the modern steel shipping container. "Vessel Information," ShipAtlas, Maritime Optima, accessed October 25, 2023, https://app.maritimeoptima.com/?lat=36.855&lon=-76.318&vessel=9295268.

3 Wayne Grady, "Shipping Lines Urged to Stop All Plastic Waste Exports," *Lloyd's List*, February 23, 2022, https://lloydslist.com/LL1139949/Shipping-lines-urged-to-stop-all-plastic-waste-exports.

4 "Historical AIS Data," ShipAtlas, Maritime Optima, accessed October 25, 2023, https://app.maritimeoptima.com/?lat=36.855&lon=-76.318&vessel=9295268.

5 Anna Lowenhaupt Tsing, *The Mushroom at the End of the World* (Princeton: Princeton University Press, 2015), 128.

A conversation with Xavi L. Aguirre and Deborah Garcia

Xavi L. Aguirre and Deborah Garcia

Proofing: resistant and ready. Not a concept, but, rather, an attitude—and the title of Xavi L. Aguirre's project for the United States Pavilion at the 2023 Venice Architecture Biennale. *PROOFING* explores the materials that make our built environments defiant and indulgent: architectural tactics that turn things waterproof, soundproof, exposureproof, spillproof, tractionproof; bodily spaces, spaces of physical exertion and catharsis, spaces ready for sweat and fog and spit alike.

 The following writing is a read: a conversational exchange between Xavi L. Aguirre (XA) and Deborah Garcia (DG), framing the repellent and durable qualities of "proofing" as an embodiment of the prevalent attitude and burgeoning aesthetic of now-times. Proofing: "to imbue something with the ability to withstand damage"—a brutish vibe (counter-camp, counter-cute, counter-identity capitalism) that finds quiet in the loud and protection in the retreat. This text leads to an unfinished glossary of observations, unpacked and explored here in a stream of virtual chats and low-resolution screenshots.

XA/DG This may be the closest you'll ever get to our phones, with their ravaged batteries and dwindling storage. More a personal collection of memetic imagery than the staking of a conclusive disciplinary position, our exchange tries out a method for architectural reflection that revels in the scrap, the conjoined parts, the aggregated thread. The fragments below have little to do with tying up the loose ends of material, labor, and structural flows, and everything to do with surviving within them.

DG

JPG 457/Protective Isolation Environment Suit/self-proofing survival mood/catch me inside/unbothered and untouched. From Renfrew Group International.

Resistant and Ready

DG

TF124/300g Transparent Waterproof Adhesive Exterior Walls Leak Proof Coating Bathroom Floor Crack Sealing Mold Proof/LICK IT OFF ME, says the bathroom floor, laboratory floor, gym floor, etc. From AliExpress.

DG I am full of resistance—in fact, I cover myself in it. I slather it on and peel it off at the end of the day and slip on something slipperier. I imagine these materials of resistance say something like that.

XA They perform it.

DG I'm remembering an edit someone made of Britney's "Oops, I Did It Again" video, where they removed the music so all you hear is the latex squeaking. I think the goal was to produce a kind of cringe ASMR, but, instead, it's such a great moment where the material outperforms the performer. But, of course, it all depends who dons the latex.

DG

PD345/Repellent red latex suit/it's giving and not giving/it's delivering impervious/it's all in how sheslams the door at 00:00:05 and says "boy talk to myA double S"/Repellent ASMR. From CDS Bollywood Tweets,"Rakhi Sawant Looks Hot in Red at Grand Launch of Music Video Sharabi," *YouTube*, May 1, 2023.

DG Architecture is in a constant state of resistance. Destruction is routinely present on, within, against it, in such rapid and relentless ways that it has invaded the atomic structure of structures (like microplastics in blood), and it permeates all material, so that every part, bit, piece, limb requires protection to survive.

Ready resistance is different from resistant and ready.

Resistance at the ready is like a war machine—a tank or a gun or a spear or a rock.

Resistant and ready points toward readiness as a condition of openness, perhaps even eagerness—for fun, for play, for being challenged. It's a party mood. It's the vibe of polyurethane leather. It's...

XA ... a disposition, a kind of resting anticipation of physical wear. Proofing wants to draw a line between materials, between the body and an ecology beyond it while also inviting interaction... There is weather outside, but there is weather inside too.

DG Describe the weather.

XA Sweat, spills, friction, steam, heat, loudness: an interior storm, pretty much. We think of building exteriors being protected from weather, but I am thinking about interiors that are equally equipped to handle high impact. Clubs, gyms, bathrooms: these post-natural ecologies that are made robust, *butched-up* with a roster of protective layers and architectural techniques. I appreciate that the interior tends to have a direct protective relationship to people. These spaces take a beating night after night. They negotiate many uses and users, and, through these materials, their readiness is communicated. They're coded both ways: telling us what they are ready for and what they allow.

XA

SS767/Plastic as material coding/temporary construction dust-proofing/ grandma couch/ club lounge liner. From #black lagoon moodboard by fskip via Tumgik.

DG It's people-weather: bodies as a kind of eroding force.

XA People-weather... Damn, yeah! And the materials to withstand people-weather—coatings, rubbers, gaskets, foam, vapor barriers, moisture blockers, insulation, adhesives —each resists different damages, but they all anticipate many people-weathers. The materials on their own are not necessarily durable, but they all participate in making other elements more robust, reliable, and withstanding.

DG Butched-up with protection—again, an attitude, not just an architectural treatment. There are specific techniques, modalities, signals, rituals, and moves in the act of *butching-up*, in the process of *robusting* (lol). It is the business of dressing/cladding/slathering your space—hell, your self—in materials and modes of hostility that are also irresistibly and unarguably *for engaging*, irreducible because of their capacity to keep you out(side) but in(terested) nonetheless. They are materials that, when deployed and composed with a design attitude that is *resistant and ready*, produce conditions of ultimate rejection and attraction. It is an architectural position that negotiates an ongoing ontological riddle—simultane-ously resisting and inviting at each level of resolution, from the molecular to the semantic. The design knowledge required to understand and play with that material code is delivered not through the pragmatics of queering archi-tecture but rather of queering body—squaring up for the violence and tenderness of intimacy with the world.[1] Prepare and protect thyself to destroy thyself: liberation through anticipatory proofing.

DG abhorrenceabominationanathemaanimosityanimusantagonismantipathy
willirritantloathingmalevolencemalignitymislikenasty lookno love
lostnuisanceobjectionodiumpainrancorranklingrepellencyrepugnancerep
··· 7 days ago

DD099/Google search "repellence synonym"/thesaurus
.com splash page glitch/methodologies of resistance
/malignity-mis-like-nasty is really, really good.

Temporary and Durable

XA

HX999/Coin garage
flooring from
Tractor Supply in
gray/materials
to protect other
materials/car
oil is a pretty
intense thing to
protect against/
coin shape
for traction even
when slippery.
From ArmorPoxy.

XA In design, temporary can often mean built cheap-ly, with materials of lesser quality. While the permanent tends to be built with an inextricably bonded materiality (a mush of rebar, concrete, insulation, adhesives, nails), nei-ther bears the traits of future adaptability to new uses or users. What I actually consider durable and future-ready is nimbleness, is a robust transformability that delivers ma-terial resilience now and a programmatic adaptability later.

DG Permanence is a kind of sobering virus in architecture. It's the ultimate killer of the fantastically interesting. As soon as you throw in words like "lineage" or "responding to" (in the context of architecture history), things fall apart. A space that bypasses *that* is also a space that renounces those pre-established connections to history, to disciplinary decorum... to disciplinary allegiance. Fuck that. These are spaces for the now. And, maybe in that sense, they are more vulnerable and infinitely hotter.

XA There is definitely a hot vulnerability in the temporality of these spaces. These are spaces for temporary pleasures—objects to objects, people to people, objects to people, assembled together provisionally for one day, one night, one day into night. Impermanent encounters paired with materials intending permanence—this is very different than impermanent encounters paired with impermanent ma-terials: that's a gross music festival aftermath—abandoned tents and water bottles. That's the extreme end of the indulgent and selfish. No resistance there.

XA

MP333/Aftermath of the Reading Festival 2023
/temporary materiality of temporary event/repelled
by the durability of the aftermath. Photograph
by Chris Gorman, August 29, 2022. Courtesy of
Getty Images.

DG So you propose using durable materials at the service of the impermanent—is there something about their material qualities that feels more usable or tactile?

XA A lot of these materials have names like Dura-Grip, Dura-Coat, etc.

DG Yeah, their names sort of ask you, or tell you what to do...

DG They're inviting use?

XA They invite use while their durability ensures that use be calibrated to particular extremes.

DG Tiptoeing lines between invitational affordances while allowing for the other end of the spectrum of use: I no longer have use for this, so it must change or disappear. I don't think it's that much of a binary, but maybe it feels imperative, like a survival instinct: *I must change/move/transform, or I will disappear*—at once a freedom and a repeating condition.

XA Proofing is an embrace of that condition. It turns that condition into a material attitude by proposing not just materials but architectural formulas for enduring impermanence and sensible change, making each unit of the assembly more robust in two senses: more able to handle use/abuse and more modular—easier to assemble and disassemble. It's a design logic that uses eternally useful blocks, whole-size cuts, replaceable layers, orthogonal connections, nuts and bolts instead of nails... Proofing as a building technique attempts to design its future unmaking and perpetual transformation.

DG It is vital that all the parts, down to the nuts and bolts, communicate a readiness for rearrangement. In your material palette, I think it is super important that you don't codify elements. You don't color-code use; you don't give us a kit of parts that comes with a rule set for assembly. Instead, it seems that the reassembly of certain pieces in certain ways is more about the qualities of those objects and the ways in which those objects might encounter bodies.

XA It tries not to be prescriptive and instead points to options rather than singular solutions, to invite interpretation: *just read the room.* The palette communicates a lot without telling you: smooth bent aluminum surfaces, drainage grates, plastic handles with grip, rubber backsplash, coarse granulated rubber mat, cross-linked polyethylene foam, plastic washers, waterproof backer board, polyurethane sound-absorbing panels, cement board underlayment, silicone sheets... Developing intuitions of use and reuse alongside these materials then becomes the perennial tool, not one's ability to read instructions.

Soft/Tough

XA

BB099/Airbag pants/fallproof wear/air gap as
protection/distancing. From Mo'cycle.

XA What do you think about this?

DG Wearable distancing: an impact protection device
—a perfect outfit in a crowded club.

XA Yeah, exactly. It's in line with the general ethos of
anticipated physical intensity. Queer clubs are *containers
of potentially extreme experiences*, where you can be all
body and no body at the same time, hardcore in presentation
but liberating in adoption, where you can be alone but
together, part of the collective but anonymous, present but
dissociated. This outfit protects but invites contact.

DG I also think that these are spaces where historically,
or perhaps at a mainstream level, particular bodies feel
they have been given affordances to exist. And other bodies—
those that have been barred, rejected, policed in those same
spaces—need to find ways to do the same thing, but with
a particular kind of stealth. The spaces that you make seem to
employ that stealth, but also amplify it so that, in some ways,
we are invited to act like the architecture: all body for no body.

XA Yeah. But it is a qualified invitation. The entitled body
would definitely try to break this space; the entitled body
that does not read the room, the one that just wants to take...
can break it, if unchecked—because the material/textural
qualities of these spaces communicate the possibility of the
hardcore, because they allow for physical intensity. But
they only keep giving if one keeps tending to that collective
ethos—or, rather, they will give the most when you become
attuned to their coded dispositions and limits.

XA This materiality points to a conversation beyond
care or maintenance of a space. That is a conversation hap-
pening within the bounds of socially monitored behavior.

The materials here are anticipating behavior that challenges these social codes as well. We do certain things here that we are not allowed to do elsewhere. That does not mean they are spaces where anything goes... There are simply different social codes here, and there are different ways of asserting them. Bodily allowances might be foregrounded, but vibe checks are many. The vibe is cared for. Those that do not tend to it will be filtered out. This requires the space itself to be ready, to have its own attitude to combat the inertias of entitlement, of aggro/rowdy privilege.

XA

"Time To Penis" (or just "TTP" in the streetz) is defined as the amount of time it will take children to make something rude out of a set of tools they've been given -- typically, that object is a penis. Mar 24, 2009

> e Engadget
> https://www.engadget.com › 2009-03-24-overheard-gd... ⋮
> Overheard@GDC09: TTP = Time To Penis - Engadget

TTP012/Time To Penis (TTP) is a video game development metric/TTP can be measured down to the near-second. Kevin Kelly, "Overheard@GDC09: TTP = Time To Penis," *Engadget*, March 24, 2009.

Culprit and Protector

XA

AX234/Radio Anechoic Chamber/no sound, no radio waves, no satellites, no mobile networks/access-proofing of many kinds/ so quiet that you can hear your own heart pumping. Photograph by Alastair Philip Wiper, *Unintended Beauty* (2020).

XA When all these impermeable, hermetic, insulating, easy-to-clean materials we talk about are used for future-unaware architectures—single-use architectures with materials that have been bound together, glued, nailed, cut with no anticipation of future transformation—they tend to be the most ecologically damaging. They are at once culprit and protector, simultaneously supporting our worlds and undermining them.

DG I remember a moment at the "Everlasting Plastics" panel in Venice when you, alluding to plastics, said "The Master's Tools Will Kill the Master." In many ways as these materials are deployed to protect, they are also filled with an imperative to disrupt and even destroy biology— or, at least, transform it beyond our current understanding of biological life. In that sense, these materials are at odds with their own promises and aspirations.

DG Culprit is a great word. It's got some cartoon bandit energy, like a Pink Panther character. Culpability might be one of the strongest emotive qualities of plastic in our current situation of pollution and overproduction.

XA Beyond culprit and the ethics of culpability, queer thinking offers us other options, less righteous ones... to design in ways that anticipate change and transformation, which, in my case, means designing for disassembly and adaptability with heavy-duty materials that can withstand transition; it means developing an adaptable system of modular structures and whole size sheet materials. The ethics are there, built in, but it's mostly a design question for me. There is a *Trans logic* to these re-combinatory practices: parts disassembling and reconstituting into new selves, ever-ready to go under the radar, are over the radar in new forms.

DG

FH045/PVC transparent heels/ the moisture for looks exchange/wearing the Spectator-3045Cs or wearing all your weather inside. Jessica W. Leonard (@bourgeoisgurl), *Instagram*, September 30, 2016.

DG Definitely. There is something in this attitude—resistant and ready—that challenges other contemporary attempts at reconciling a future with plastics. At the heart of this conversation is an understanding that queer bodies have long held an awareness of this paradoxical state of resistance and vulnerability and that, from that constant state of negotiation, comes a deep knowledge of reading and playing with those qualities in the material world around us, as well as rendering from them new ways of existing that fundamentally ask for more conscious intimate liberatory blurry sensorial tender relationships to the built environment.

Allowances and Limits

XA Proofing is a brutish bravado: a calculated refusal and a coded allowance for the physical.

DG But it's not a playground. There is something more hardcore. The way you use the term "brutish" suggests that the sheer layering and proofing of materials is, at a molecular level, a rejection... of liquids, decay, destruction...

And because these materials reject certain bodily byproducts, they also invite the kind of use that produces these exact fluids and secretions: sweat, tears, piss, blood.

XA

GH077/Dust-proofing on construction site/ "This way to proofing." Courtesy of the artist.

XA Exactly. By serving as environmental buffers against moisture, heat, loudness, these materials create an instinctive inertia toward them. This risky tactility... that invites touch but refuses full access... becomes common in these sealed-in spaces of desire and body vibes. To achieve this dual spatial attitude, many architectural techniques are deployed: bullnose edges, sealed seams, bent continuous surfaces, handles, floor grip, affixed furniture, easy-wipe everything... for many distinct bodily pleasures.

XA Architecture loves to sanction use, to declare what can happen where. An architecture with a proofing attitude, however, provides a distributed opportunism that meanders around to read the room, materially and bodily. It spatially favors allowance over sanctioning but complicates the code... both for survival but also for fun.

XA

SA456/Special activity space/ a room within a room/what is allowed and what is invited? From Keling Purification Technology Co., Ltd.

DG But it also requires a queer approach to use—or maybe asks users to enter usage differently. Architecture loves to sanction use, but it also likes to limit use toward a surface-level behavioral exchange, one where the transaction is simple and controllable. *Resistant and Ready* seeks something else: an architecture that does not simply

concern itself with influencing maximums (and thus with limiting behavior) but rather asks you to recalibrate your understanding of where the limit is through use—perhaps even extreme use. It's a really introspective ask.

XA It asks you to use the space to find your own limits—sonic, bodily, emotional, collective limits. These are guts-out environments that affect you as much as you affect them, that fight you back as they give you coded permissions. Extreme-use environments flip the material conversation from an externalized one to an internalized one. Inner lives are linked to material lives.

DG The easy way out—where colonial mentality rears its fucking ugly head—is to waste one's time finding the limits of the built environment. How many kinds of ways can I break this shit? But not in a conscious rageful way: in a careless state.

XA Yeah, it's a state of mind. You have an entire room that you can use to explore and find your edges, and instead you're going to spend time delaminating this corner.

DG Once you've destroyed the space, you've ensured that you no longer have to engage with what it could do for your psyche and personhood.

DG I'm gonna be the asshole and quote some Foucault. He writes on the last domain of biopolitics: "[it] is that of the environment to the extent that it is not a natural environment, that it has been created by the population and therefore has effects on that population."[2]

Enter/Bouncer

XA It seems important to expand the definition of proofing to include material conditions that give us privacy or make us opaque—shutters, rubber curtains, doggie doors, imposing facades with no signage—conditions that allow for the proofing of one's selfhood from sight: from gaze, from identity tourism, from the lurk of all-access consumption.

XA … A filter like a bouncer, one that imposes a highly undemocratic criterion for deciding who gets in. This is actually the first step at ensuring a particular interior vibe. Tourists don't get in; you show a hungry thirsty influencer glint in your eye—boom, you don't get in. That might sound ethically untimely to many, but it's the first step in tending to the vibe that creates a focused and intense public. The bouncer/s had the last word, but… you self-selected well before then, when you decided what level of readiness you were wearing for the night.

XA

TR833/Spray some liquid rubber on/toe-shoe/proofing the body/plastic camo/hardcore vulnerability/fill the void. From Memes | Daily Memes | Funny (@memezz_1rt), *Instagram*, September 19, 2023.

DG I think it's important that we're also talking about a particular kind of club—not a bridal shower on the Strip. We're talking about gay culture—or, at least, spaces where queer existence and exploration are protected by those exact filters that you're talking about. The denial of access to all ensures a space for some, in particular those who often are denied space otherwise.

XA Yeah, the origin story of this project is Berghain. Very few and very specific clubs, in fact, manage to maintain these spaces for this otherness... this hardcore vulnerability.

XA There is often a short but explicit code of conduct listed upon entrance. "No photos" is usually right at the top of these lists, which immediately weeds out the tourist and takes a first pass at filtering out the experience shoppers. You pre-select yourself as someone that is here for an intensely collective and personal experience rather than a visual one. Stickers block phone cameras. The experience prevents you from consuming it visually, so you can engage it with other senses. Other venues also have sliding scales of entry/mini manifestos about how to treat others in the space with you, emphasizing the sense that you are now part of something with others—no perfume, for example.

XA

PV101/Says "No photos"/stickers to cover phone cameras in clubs/no photos allowed. Photograph by Paulus Ponizak via *Berliner Zeitung*.

DG The space ASKS—it has direct requests, and they're tough asks that lead to a particularly liberatory experience. Those who have been asked, all their lives, even tougher requests—more violent requests—by society, here can experience that kind of energy sent in the opposite direction to produce a safer condition. It's the opposite of entitlement.

DG To get in, you need to display a stealthy readiness or a vulnerable resistance.

XA It's an attitude. You can choose one and put it on.

DG It's not just behavioral codification.

XA No, but it's also not just an outfit. But it definitely can be sometimes too. Ja ja.

DG Absolutely—an outfit is also a cladding. You have to be in conversation with the architecture.

DG Building materials and layers have dispositions—so do yours.

XA A transformative substance with the power to shape, queerness has embraced plastics as part of an argument against an innate naturalism. This embrace, however, has often manifested through the materials of camp and maximalism, a kinship with shine, spandex, elastics, nylon... *PROOFING: Resistant and Ready*, however, looks in the shadows of that happy glitteriness for another kind of embrace of plastics, searching for a hose-down, defiant materiality that encourages bodily freedom, decadence, expressions of desire and transformation.

DG A queer approach that is explicitly resistant to camp —this is important. I think because, in some ways, camp is accessible. Or, at least, it has become so, co-opted and digested into a pop-cultural, mass-produced flow. A queer approach that both acknowledges and uses the survival methods of queerness (defiance, fronting, sunglasses during the day, hood up, a wall is put up)... methods of protection that also have a certain kind of... dare I say *style*?? Fuck yeah, style. Protective methods that are a fucking vibe. There is an aesthetic being defined that has not been historically identified as an aesthetic.

XA It might even be a denial-aesthetic.

DG Yeah, not relating to beauty or an appreciation of beauty.

XA It's also one that resists commerce, or maybe what I mean more is that the act of resisting being consumed is built into the aesthetic. Maybe that's its *butchness*? It can of course, be commodified like everything else, but there is a cleverness in its resistance.

DG In fact, it takes deep joy in avoiding consumability. It wants you to choke on it.

XA It wants you to leave it alone. Be gone friend.

XA

BF586/Bunker club in Beirut/no permit/only accessible via dirt road/butch-presenting/known for musical therapy nights. B018 nightclub designed by Bernard Khoury, Karantina, Beirut, Lebanon, 1998.

Fun and Cleaning

XA We don't want to think about tomorrow morning tonight, but the space does that for us already.

XA I'm hesitant to use the word "care."

DG Why?

XA Because care has been conflated with virtue, twice over: first, with the virtue of maintenance—"cleanliness next to godliness"—then, through the virtues of liberal feminist discourse. I think these spaces stand in contrast to that, as they do not presume a moral high ground. The bathrooms have seamless, bent metal toilets, so that they can easily be hosed down—not because they want to present us with a standard of cleanliness, but rather to present us with a tolerance for filth. It's a hose-down materiality that allows for filth, and that filth, in turn, is easier to clean, so that more filth can happen—not cleanliness as virtue.

XA It's building the maintenance into the materials to make the caring easier.

DG It's cleanliness not as a ritual to get closer to the building, not to turn labor into some kind of modernist exercise of loving architecture... "Once everything will have been cleansed, once an end will have been put to all viral processes and to all social and bacillary contamination, then only the virus of sadness will remain, in this universe of deadly cleanliness and sophistication."[3]

XA It's not maintaining cleanliness for the sake of cleanliness either, or for elevating it to a superior quality. It's the opposite—it's about maintaining the possibility of continuing to get messy: a hose-it-down-easy kind of cleanliness, not one that limits use but instead just provides a continuous detail with good drainage. Easy wipe.

XA

EE098/Pressure-washed Nissan interior/hose-it-down materiality/EZ clean. From Christopher Smith, "See This Nissan's Interior Get Pressure-Washed in the Name of Science," Motor1.com, September 27, 2019.

XA Even though we are allowing for more filth, the cleaning is actually easier when we equip it with that readiness. The hardest places to clean are those that never presume that filth will happen on them; in fact, they are often in denial of the impending unavoidable dirt that is ensured by the act of living and using.

DG Sweat rate is proportional to metabolic rate and can amount to 3 to 4 liters per hour or as much as 10 liters per day: indoor human weather. We have always wept and leaked and sweat our liquids inside and on architecture; these materials of resistance bring that fluid reality to their atomic surface through high performance repellence. *Resistant and Ready* is play time with repulsive forces —material, cultural, social: the slippery slope of a rubberized corner, a hard gaze, an unmarked door... All lead to the soft underbelly of intimacies that may occur in this space designed for hard-earned release.

1	Here I ponder (messily) on Judith Butler and Catherine Malabou's "You Be My Body for Me," in which the two explore questions of subjectivity, body, and their "outsideness," their "vexed relation, at once outside itself and not." Catherine Malabou's work on plasticity and Judith Butler's writing, in particular in *Psychic Life of Power*, come together in this exchange to move us away from the thinking of "having" a body to instead focus on the process of coming to "be" a body, "to produce one's body in such a way that the activity of its production—and its essential relation to [power]—is denied." Or, at least, this is my read in the context of your work and its importance in a language of architectural play that is actively emerging from a queer attitude to making in the world, that queerness being in resistance to historical structures of power, control, and destruction of the queer body. See Judith Butler and Catherine Malabou, "You Be My Body for Me: Body, Shape, and Plasticity in Hegel's *Phenomenology of Spirit*," in *A Companion to Hegel*, ed. Stephen Houlgate and Michael Baur (Malden, MA: Wiley-Blackwell, 2011), 611–640; Catherine Malabou, *Plasticity: The Promise of Explosion*, ed. Tyler M. Williams (Edinburgh: Edinburgh University Press, 2022); and Judith Butler, *Psychic Life of Power: Theories in Subjection* (Stanford: Stanford University Press, 1997).
2	Michel Foucault, *Society Must Be Defended: Lectures at the College de France, 1975–1976* (New York: Picador, 2003), 245.
3	Jean Baudrillard, *The Ecstasy of Communication*, trans. Bernard and Caroline Schutze, ed. Sylvère Lotringer (Los Angeles: Semiotext(e), 1988), 38.

Deborah Garcia is a designer, storyteller, and educator. She holds a Master of Architecture from Princeton University and a Bachelors of Architecture from the Southern California Institute of Architecture. She was a recipient of the Princeton University Butler Traveling Fellowship, which took her to the corporate agricultural complex of the United States heartland, where she was a resident at ARTFarm Nebraska, and was an invited participant for the 2019 Arctic Circle Expedition in the international territory of Svalbard, Norway. She was a co-curator of *The Drawing Show* at the A+D Architecture and Design Museum in 2017 and curator of *One-Night Stand for Art and Architecture – LA* in 2016. She was the Marion Mahoney Emerging Practitioner Fellow at the MIT Department of Architecture and teaches at the Yale School of Architecture. She is currently designing, wiring, soldering, testing, and experimenting with the integration of sound technologies into modes of architectural representation and space-making. She is an explorer chasing and discovering ways of making space in the world, actively looking to create new imaginaries and develop her ability to craft escape plans from colonial fantasy futures.

book, we have reinterpreted the condensed page width and typographic grid of *Sketches* for an interleaved sequence of subcontainers—one nested within each exhibitor's documentation—to house the process notes, dialogues, logistics, receipts, and other detritus of artistic and architectural production. In our conversations with CBAC, we have taken to calling these subcontainers *interludes*, though they operate with a familiar sketch-like logic.

If the stakes of the *Sketches* project largely revolved around a certain omission of closure, an operation counter to our usual expectations of book- and exhibition-making, the stakes of *Everlasting Plastics* might, in part, be conceived of as another experiment in the temporary fixing of a plastic discourse, knowing that it will necessarily continue to remelt, to mold, to flow.

6 When a book enters the pre-press stage, a designer can request a dummy copy from the printer. This copy is a bound and trimmed form reflecting all the material decisions the book will take on, but with the printed matrix not yet impressed upon its pages. The shape is there, but the language is waiting to land.

7 In contrast to alternative, digital methods of proofing, which more often rely on pigment or toner, the wet in wetproof designates that actual offset ink is being applied to an actual photolithographic plate. When running wetproofs for *Sketches*, we mostly examined color and opacity, paying special attention to the black-and-amber duotone images that populate the book's French folds. Seeing and feeling the ink and the paper helped us to confirm that the ways sketching was conceptually and textually playing out in the book were also translating into the haptic and ocular perception of the pages themselves.

8 Once the pages of a book have been printed, but before they are bound, a printer can provide a designer with a set of folded-and-gathered signatures. (A sewn book consists of multiple signatures, or single press sheets printed with multiple pages, which are then folded, trimmed, and bound. If the reader-facing unit of measure for a grouping of pages is—at least in traditional literary publishing—the chapter, then the printer-facing unit of the same type is the signature. It is one constituent section of the book block.) These signatures are affixed to neither one another nor a cover. They mark a moment when the book's first page is left breathing and exposed, when the book's last page is smudgeable, tearable, open to the world. Reviewing these signatures offers one final opportunity for mistakes to be corrected, for a section to be replaced before the book is bound to a cover. A cover defines what is inside, serving as a beginning and an ending to the ideas it contains. A cover protects. It is a frame, a container, a logical skin fixing the book object and its meanings in position.

rendered visible. Xavi L. Aguirre's contribution offers an example: for Aguirre, plastic is a "proofing" infra-structure that dwells underneath, or within, more readily legible surfaces, safeguarding them from our bodies and ensuring an environment's everlastingness.[3] This opposition and interplay[4]—of visibility-invisibility, finished-unfinished, permanent-impermanent—would become of primary importance to *Sketches* as a book object. From early spec-writing[5] to the fabrication of a dummy book,[6] from wetproofing[7] to reviewing F+Gs,[8] we worked closely with Grafiche, and with CBAC, to keep *Sketches* (un)honed.

The ambition for this book that you are reading, *Everlasting Plastics,* is to allow the sprawl of a proj-ect rife with divergence and contradiction. It comprises a partial melting-down and recasting of its prede-cessor, *Sketches*, into an entirely new form. In this

1 After Dexter Sinister's "A Note on the Type."
2 The page count of this book was, in fact, 160. A cursory flip through *Sketches* reveals a sequence of page numbers that run, along the bottom edge of each page, from 1 to 80, though the discerning reader will quickly find that the book is bound with a French fold, meaning that, while the fore and bottom edges are trimmed, the top edge has retained its creases: in effect, each page becomes a pocket. The folds contain various contents, from the exhibition logo to biographies, from duotone images (and accompa-nying captions) to the colophon.
3 By contrast, decisions to leave *Sketches* both coverless and unprotected by shrink-wrap when in-stalled alongside the exhibition would have pre-cisely the opposite effect. From the moment the books were delivered to the pavilion, on a rainy May afternoon, they began exhibiting the intended (and unintended) responses to their environment—responses ensured by these very omissions. The newsprint paper stock yellowed in the sun; the pages warped and tore as pavilion visitors stuffed them into their bags; the still-unset binding glue caused piles of books to stick together at their spines.
4 Another question from our editors: How could we make a table of contents that is not a table of contents, avoiding the finality or formality of a finished book?
5 As provided to Grafiche Veneziane on the following dates:

January 31, 2023
3,000 copies
48 pages
16 by 22 cm
Staple-bound (loop
staples if possible)
Fedrigoni Arena Natural
Rough 100gsm
Printed 2/2 K + PMS

March 21, 2023
4,000 copies
Folded size: 11 by 18 cm
Flat size: 22 by 18 cm
Book of 160 interior pages
Printed 2/2 colors (black +
PMS 131 U)
Onto Holmen TRND 2.0 60gsm
Binding: Thread-sewn with
8pp sections (French
folded) grouped in 24pp
sections
Exposed spine

A Note on Sketching[1]
Normal

Our initial sketch of this volume first lived in Venice as a publication existing within and alongside the exhibition "Everlasting Plastics." Imagined as an entry point into the conversations happening in the 2023 Venice Architecture Biennale's US Pavilion, it was printed by Grafiche Veneziane, a small cooperative located in Cannaregio along the Calle Lunga Santa Caterina. For the exhibition, we produced 4,000 copies of the eighty-page[2] book, titled *Sketches on Everlasting Plastics.* It is the predecessor to the book you read now.

In the early stages of development, Isabelle Kirkham-Lewitt and Joanna Joseph, editors at Columbia Books on Architecture and the City (CBAC) and publishers of the *Everlasting Plastics* project, wrote to us, "Obviously the title is TBD but we're considering these sketches on *Everlasting Plastics.*" In retrospect, this message—brief as it was—offered a prescient insight into the bookmaking process that would follow, and the title would solidify only as far as that first premise: *Sketches.* The exhibition "Everlasting Plastics" emphasized and upheld a space for the provisional, the "TBD," the open-ended. Our approach to the design of these books followed suit, in search of, let's say, a determined indeterminism.

Sketching, in both title and concept, is suggested as an amalgam operation—as several things at once. A sketch is not a full idea: it is an idea tried out in many directions. Sketching is the stage of imagining in which we feel out what *might* work. *Might* is a place where we have paused and considered, around which we have generated, with which we have sat. As designers, the idea that the kind of sketching this project would entail was a contradiction was significant: on the one hand, preparatory; on the other hand, resolutely non-teleological. What would sketching mean if it were not made to presuppose some eventual final form?

Among the central concerns of *Everlasting Plastics* are the ways in which plastics are, or are *not*,

sketch out the personal and political ways in which plastic permeates our bodies and our world. Sketching continues to feel like a consciousness-raising exercise, an invitation to re-encounter our toxic inheritance from a place of non-expertise that aims not to reconcile these entanglements but to stay with their contradictions. "The political act," writes Rania Ghosn, "is in how we deal with what we've inherited... how we stay with the shadow of destructive forces, not to demonize or eulogize, but to craft a life sketch" (p. 93)—one that can help liberate the imagination in favor of new possibilities, relations, worlds.

And so here we are. It's the first word in the project's title. And the longer it's been with us, the more it seems to capture something profound about the book. The authors draw our attention in so many different directions; they write intimately from their own positions—not just as thinkers, scholars, writers, artists, etc., but as people navigating this "synthetic world," to borrow a term from Adam Hanieh (p. 32). Gabrielle Printz writes from multiple orientations: "amateur toxicologist," "millennial," "historian"; as "a consumer, an academic, and a mother" (p. 44); Laleh Khalili journeys back to two sweltering summer internships as a young engineer at BP Amoco's Chocolate Bayou plant in Texas (p. 25); Anjuli Fatima Raza Kolb recounts the technical and psychic world of giving birth (p. 35); Kristen Bos recalls a conversation in a beading circle at the Native Women's Resource Centre of Toronto (p. 57)... just to describe a few.

The contributors not only reach across many personal and discursive terrains but also give new form to the sketch as a genre—RA Washington juxtaposes poetry with scientific data to reveal its biases; Aurelia Guo stages a dialogue between plastic citations; Ilana Harris-Babou and Pallavi Sen interview each other as artists, collaborators, friends, and roommates; K. Jake Chakasim imagines Le Creebusier, an Indigenous Trickster to re-see "twenty-first-century materiality" and the "settler and diasporic ideology that is scattered across the Native American Indigenous landscape" (p. 86).

So, to return to the work of the title. These *Sketches* stage an interaction—and this is where we have learned to lean into and on the preposition a bit more—they revise, broaden, push the discourse *on* and *around* the Biennale exhibition they were created for. *Sketches on Everlasting Plastics* emerges from a series of relations: between authors, institutions, disciplines; between editorial and curatorial practice; between book and exhibition. It refuses to see "Everlasting Plastics," the exhibition, as a static event—just as much as it refuses to see plastics as inherently good or bad, world-ending or -beginning. Rather, *Sketches* is an invitation to evolve the stakes of a shared conversation.

we might also say that worlds have continually been starting. Heather Davis remarks: "'Everlasting' not as a statement of eternity but as a conditioning of the future for so many beings" (p. 23). As editors working with the disciplines of the built environment, we can't help but see this as a critical methodology: a way to trace and record how sites in the present "lazily [meander] through these strata of time and of social relation," as Laleh Khalili writes (p.27), a way to excavate all that "leaden ideology" around us. Khalili, again: "There are layers and layers still to recover."

Sketches on Everlasting Plastics begins to do this work. In asking a range of contributors, from different places, disciplines, practices, to respond to this material, so many other forms of relation, histories, sites, and attitudes emerge. Some beautifully echo one another, while others rub up against one another, challenging and contradicting each other. In this way, the project establishes discursive terrain upon which to be built, at the same time as it certainly draws attention to all the gaps in between. As more authors continue to write within and from these gaps, they grant us new perspectives from which to imagine a present-future of our toxic world that radically embraces alternative ways of being. From "the mundane elsewhere of disposable life," Marisa Solomon writes, "between the sanitation truck routes and the police sweeps of houseless encampments, between looking away and penetrating stares, between the language of 'safety' and the whiteness of sustainability, between garbage bin technologies designed to keep people *out* and the criminalization of broken windows that turn the visibility of poverty into environmental signs of decay, a fugitive map of matter can emerge: a map of abundance" (p. 101).

Sketches

We've always been a bit ambivalent about *Sketches,* the official nickname of this project, in part because the word all by itself is confusing. This is not a compendium of quick drawings or about forms of representation. It's certainly not associated with the damaging myth of the singular, solitary architect-author scrawling masterpieces across napkins. *Sketches* came about as a way of communicating the project and moving it forward, and it always felt like a placeholder, something for which we would surely find a better word.

We offered *sketching* as a methodology to authors as a way to summon quick, short, untidy, and generative writing—to unburden them (and us) from the pressure of producing for the Biennale. And, even as the Biennale came and went, sketching remained a way, through writing, to occupy, witness, record, track not only the life of plastics but also our lives in the midst of it—to

that attend it and other forces of normalization. It is a commitment to repurposing not only things but also words, thoughts, and worth. This goes against the culture formed by and forming plastic: a culture "of disbarment (by the wayside, discarded, packaged, barcoded, and shipped throughout the world)," writes K. Jake Chakasim (p. 86).

And yet, plastics stay with us: they remain, for the foreseeable future, in our oceans, landfills, and walls; in the food we eat, the water we drink, and the air we breathe; in our very bodies. The ways we've learned to live with and depend on plastic are also the ways we'll die with it. And it will outlast us.

Everlasting

What is everlasting? This question courses through *Sketches*, inviting us to look in, through, and beyond plastic—as material, as matter—to the legacies, histories, ideas, attitudes it contains.

When we ask what is everlasting about plastic, it is hard not to think immediately of the indelible impacts of pollution, of the toxic residues of overconsumption and overproduction, of the ecological and biological harm that will extend and evolve over and across generations. Everlasting, of course, denotes a permanence: it has an air of inevitability, and, when applied to the material reality of plastic in our world, it's hard not to feel fatalistic about what this supposed "permanence" portends. "The bottle won't shatter, but the planet will," Naa Oyo A. Kwate writes (p. 51). What is, maybe, less apparent is that plastic entangles and enables the endurance of social, political, cultural beliefs and behaviors that some of us imagine we have left behind.

Through the active and passive circulation of a seemingly inert material, the past lives with us—or what Heather Davis calls the "afterlives" of the past: of regimes for ordering the world and those who live within it, of slavery, of bordering, which condition and commingle with the ever-present realities of settler colonialism, of extraction, of consumerism, and on and on. RA Washington writes, "Memories not mine haunting me" (p. 21). These memories, beliefs, behaviors, institutions have just as tangible, just as persistent consequences... but also, perhaps, just as real possibilities. "There is no escaping this ghost, but it can be a source of transformation," writes Carolyn L. Kane (p. 40).

What possibilities, then, does this question of what is everlasting open up? Considering *everlasting* as a kind of protracted inheritance (biological, territorial, spatial, geological) with different temporal registers insists on *everlasting* as an *unfinished* process, as not a fixed condition, but rather a process of becoming. "Worlds have also continually been ending," reminds Jennifer Gabrys (p. 52). Or

questions of agency, of what to do, of what to make of our own attachments to systems of harm (whether that attachment is a form of complicity, of affection, of maintenance, of reliance, of advantage); and, very importantly, it struggles with and against individual responsibility—with and against the neoliberal and antisocial con that says any one of us, alone, can revert or shoulder the damages wrought by plastic use and consumption. Instead, the book insists that we shift our attention and energy toward collective welfare and away from the cult of individualism which serves to maintain the political-economic status quo, in which profit for some comes at the expense of prosperity for all. It does not make a case for or against plastic. Instead, it follows and evidences how it is life-giving *and* death-dealing, all at once. Ayesha A. Siddiqi writes, "the flow of plastics reveals a historical record too: who eats and who gets shit on" (p. 80).

Of course, plastic is a set of materials. But it is also a set of encounters, a social process, something, Gabrielle Printz writes, that is "born in a lab, multiplied in a factory, and brought home by shoppers and factory line workers alike" (p. 44). It is a promise: "The buildings are upon my back / The land is underneath my nails. / Industry looms along history / We are the descendants of popular notions / Of advancement," writes RA Washington (p. 20). It is an unstable barometer for what is and is not of value, what is and is not human, what is and is not a body: Anjuli Fatima Raza Kolb writes, "Reproductive freedom since the turn of the century has increasingly meant—especially for queers—less body, more plastic. The vial. The injection pens. The dish. The tubes. The romance—so many forevers" (p. 36). It is "a battleground," writes Kyla Schuller (p. 70). It is a racial logic: as Zakiyyah Iman Jackson writes, "Blackness... a plastic, fleshy being that stabilizes and gives form to 'human' and 'nonhuman' as categories" (p. 84). It is a legacy.

Plastics are in us—in our blood, in our breastmilk, in our memories. "When Ruffles Lays came to India," Pallavi Sen shares in conversation with Ilana Harris-Babou, "my grandmother would wash out every bag of chips and save them underneath her oven" (p. 47). Plastics connect us—to other generations, organisms, landscapes, histories, sovereignties. And through these connections, this book holds fondness and antagonism; disposability and preciousness; damage and recovery; micro and macro; wants and needs; possibility and impossibility; past, present, and future; near and far, all together. It tracks our inheritance and what it has cost us. Contending with plastic involves practicing care, a mode of relation that at once emerges out of and liberates us from the harsh realities of the world. It is not a placating abstraction, but a commitment against disposability and the violences

Plastics, Everlasting, Sketches

Joanna Joseph, Isabelle Kirkham-Lewitt,
and Meriam Soltan

The following twenty-four texts, most of which were originally
published, shared, and circulated—but not sold—at the US
Pavilion at the 2023 Venice Architecture Biennale, comprise
Sketches on Everlasting Plastics. *Sketches*, as it appears
here, is not quite a book within a book, but it is also not com-
pletely in sync with the greater volume. Originally devised
as a companion to the "Everlasting Plastics" exhibition to con-
stellate an expanded set of concerns, *Sketches* has always
operated as a refusal of reductive or simplistic conclusions
about plastic—about waste, about our world—and exists
as an invitation to challenge and broaden our own knowledge-
base through the experiences of others. The next eighty
pages unfold according to their own temporalities, their own
formats and ways of writing, their own demands, starting
points, questions, references, ambitions, and anticipations.
The original texts are reconstituted here, accompanied by
later entries, to register and reaffirm the project as something
unfinished, ongoing, and generative.

 By way of an introduction to *Sketches on Everlasting
Plastics*, we have broken down the title, since each word
offers three slightly different, yet overlapping, ways of engag-
ing with what is at stake in this broader book, not only in
terms of our own practice as editors and publishers working
within the discipline of architecture, but also in terms of
what this specific compendium opens up for discourses on
and around plastic matter and thought. Perhaps unconven-
tionally, we have chosen to work backwards through the title
—moving from *plastics*, to *everlasting*, to *sketches*—as a
way of charting the work of this project, and where it might go.

Plastics

This collection accounts for the toxic and tender ways we
have come to depend on plastic; it follows vulnerability and
resistance to the logics and legacies of extraction in and
out, beyond and across different bodies, institutions, territo-
ries, and ecologies; it tells intimate stories and remote
material histories about the stuff of life; it struggles with

Blue barricades outside of the Detroit Institute of Arts, Detroit, MI, January 14, 2024. Courtesy of the artist.

A Conversation with Simon Anton and
Avedis Hadjian

"Everlasting Plastics," United States Pavilion,
Venice Architecture Biennale, May 2023

Avedis Hadjian Can you give me an explanation of your work and how it relates to a modern conception of architecture?

Simon Anton Yes, though, sometimes, I find it easier to speak as a friend and explain from the beginning. My practice is based in Detroit, MI, and is focused on plastics and plastic waste. The Midwest is a center for plastic production in the United States.

AH Because of the auto industry?

SA Yes, and because the auto industry has created the infrastructure for other plastic production. The colorful plastic in my work, for example, is waste from a toy factory in Detroit. I work a lot with children in the North End where my studio is situated, and I also partner with local community organizations for collaborative projects. I'll invite kids to bring plastics from their home, and I'll teach them how to shred, melt, and make the waste into new things—furniture, public art. It's very optimistic. The program is called "Transforming Trash," and looks to plastic as an opportunity to educate Detroit youth on questions of environmentalism, material science, art, design, public space, and to collectively create permanent public installations. But, for this opportunity in Venice, I wanted to tell stories that were more nuanced and critical.

And that this particular context was an Architecture Biennale meant I wanted to explore how architecture, specifically architectural ornamentation, is implicated in plastics as a global commodity and waste catastrophe. Each piece has a different theme. Each approaches this question differently, by focusing on a specific typology from architectural history: clocks, grates, gates, barriers. I took these ancient forms and re-imagined them through a craft process of grafting waste plastic onto steel. Each piece begins with a bent and welded steel skeleton that I wrap in a high-resistance heating wire. I submerge these frames in vats of plastic waste. As they heat up, the plastic melts and forms

AH these stories, some scientific, some experiential or anec-
 dotal. These are stories that come to the top for me.

AH And where did you draw your inspiration from
 for this pattern?

SA There is plastic at the peak of our tallest moun-
 tains. Tragicomic stories of fisherman finding dildos in
 the stomachs of fish. There's plastic in our eyes, microplas-
 tics in our hands, tears, blood. More optimistically, there
 are mushrooms that are adapting to eat plastic.

AH Oh, that's remarkable, and that's not happening
 in a laboratory environment.

SA No, it's greater life learning how to deal with our
 bullshit. So, there are optimistic elements. You see
 Lauren Yeager's pieces in the courtyard. They are made
 of hollow, rotationally molded plastics. These are the
 types of pieces that I gather myself in Detroit, scavenging
 them on the street and then processing them in my studio.
 Cutting them in half with bandsaws, I'll find beehives
 inside. The bees are no longer living there, but there they
 are: fully intact beehives.

AH So that's what that represents. The bee hive.
 Okay, wow.

SA I've been collecting photos of this. It's actually
 very common. Lauren has confirmed she sees the same
 thing. Bees love living in these solid, protected forms.
 It fascinating. I was explaining this story to a moth-
 er and her child about this process, and the girl
 was horrified for the bees. It's very scary to think about the
 impact that plastic waste is having on life.
 But the bees don't care about our mess—they
 are just finding a home within it. They don't have an anthro-
 pocentric understanding of material.

AH Wow. Well, great story. Thank you.

Scavenged plastic sawed open to reveal a beehive. Courtesy of the artist.

Hollow, rotationally molded plastic forms scavenged by the artist in Detroit. Courtesy of the artist.

Federal Reserve Bank of New York, New York City. Photograph by EP Productions.

towers that have been so historically important as symbols of power, conquest, and capitalist logic.

AH How is the piece *After the Federal Reserve* architecturally related?

SA Well, I am generally interested in architectural ornamentation in different historical contexts, and wrought iron work is especially exciting to me for how it connects aesthetics with defense. *After the Federal Reserve* is an interpretation of the grilles that are used to cover the windows of the Federal Reserve Bank in New York City. Their symbolic function aligns so perfectly with their literal function—the control and exclusion of the public from financial institutions. To focus on them was to explore the relationship between architecture, money, and power.

The piece is an imaginary reinterpretation that is warped and distorted by the electrified plastic grafting process and the ability for these plastic growths to contort and fracture while simultaneously being preserved in a non-degradable shell. What conditions have brought these materials together? How long will they survive? I imagine a scenario 100,000 years into the future: New York City is being excavated and these metal skeletons that have become so completely encrusted by plastic are rediscovered by future archeologists. A giant gripping arm has been lowered to pull up these fragments, and they've been displayed as artifacts of the age of plastic. How can a work act as a portal to a different time?

AH Yes, yes. I get that. And this last piece, *FACE: Tales of Plastic Proliferation*, is related closely to the title of the show?

SA The title of this collection of pieces is *This Will ___ Kill ___ That*, which is a reference to Victor Hugo's *The Hunchback of Notre Dame* (1831) and the idea "The book will kill the edifice." "Printing will kill architecture." *This Will ___ Kill ___ That* echoes and reframes these statements as an open-ended and unresolved story rooted in contemporary questions, like: What does plastic waste have to do with architecture? Does it consume? Crystalize? Coopt? What is the relationship between architectural ornament and plastic waste? Does one dictate the other, or is their relationship more synergistic? Fragments of plastic encrusted ornamentation fantasize hyperbolic scenarios in which these worlds are inextricably linked. *FACE: Tales of Plastic Proliferation* was an opportunity for me to reimagine architecture as communication and to tell the contemporary stories of plastic proliferation. I've been studying plastic for years and amassing

St. Mark's Clock Tower (Torre dell'Orlogio), Piazza San Marco, Venice, Italy, 2021. Photograph by Petr Svarc. Courtesy of UCG/Universal Images Group via Getty Images.

Coal shale layer in soil profile, 2013. Photograph by Brendan Howard. Courtesy of Shutterstock.

around the metal, resulting in a colorful, crystalized body. It is an experimental process that results in new aesthetic and material relationships. It's the hope that these objects create space for different perspectives and critical conversations to occur.

AH What about this piece, *Crowd Control?* I heard that these are crowd-control barriers.

SA Yeah, I found these in Detroit. I was inspired by seeing these beautiful, powder-coated, blue barriers sitting in front of the Detroit Institute of the Arts; by seeing these mechanisms of control rendered so aesthetically in front of the white, book-matched marble. I was struck by that juxtaposition. What is the relationship between institutions of art and policing? How do they rely on and support each other?

These barriers, along with the scattered plastic flakes, speak to how communities of color and lower-income communities are disproportionately affected by mechanisms of policing, as well as plastic waste. In addition to where waste is dumped, Black children in industrialized areas of Detroit have much higher rates of respiratory sickness because of factory exhaust. This an environmental violence that can be felt and registered in and across time.

The piece next to *Crowd Control* is called *Orologio (Plastic Time).* It's a clock for plastic time. The materials used to create plastic are over 60 million years old. It's made from decomposed carbon—dinosaurs, ancient forests—elements that have been compressed over millions of years. We extract it as crude oil and, using the most technologically advanced engineering processes, produce millions of containers to be used instantaneously and thrown out.

Theorists say that the plastic waste in our landfills, over millions of years, will change back into oil, but, instead of being stored in deep reserves in the Earth, it's going to be spread out in shallow surface pools and shale. *Orologio (Plastic Time)* speaks to this warped, nonlinear understanding of time—a sense of time defined by material state changes and distributions that condense million-year processes into instants. The rapid and monumental mining and distribution of petroleum-based products wreak havoc on ecosystems past, present, and future. Our use of most plastic materials occurs on a timescale so small that they barely hold space within a single day, yet will result in slow-moving material processes that will be unfolding for thousands of years, a lifetime and lifetimes away—perhaps in some great return to begin again. This is the question at the end of our "everlasting."

It is also playing off of the architectural history of clocks, the hundreds of clocks throughout Venice, the clock